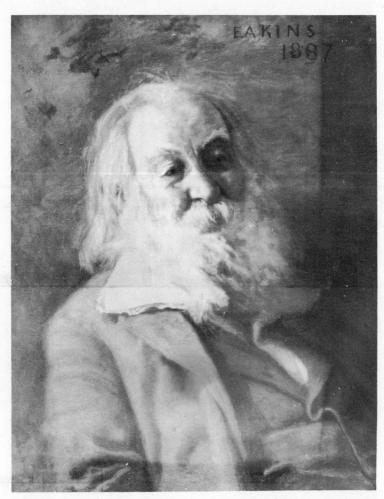

Pennsylvania Academy of Fine Arts

WALT WHITMAN by Thomas Eakins. 1887.

The Brown Decades A STUDY OF THE ARTS IN AMERICA 1865—1895

Lewis Mumford

DOVER PUBLICATIONS, INC. New York Copyright © 1931 by Lewis Mumford. Copyright © renewed 1959 by Lewis Mumford.

Copyright © 1971 by Lewis Mumford.

All rights reserved under Pan American and International Copyright Conventions.

Published in Canada by General Publishing Company, Ltd., 30 Lesmill Road, Don Mills, Toronto, Ontario.

Published in the United Kingdom by Constable and Company, Ltd., 10 Orange Street, London WC2.

The Brown Decades was originally published by Harcourt, Brace and Company in 1931. An unabridged and unaltered reprint, with a new preface by the author, was published by Dover Publications, Inc., in 1955.

The present edition, first published in 1971, contains the complete original text in a redesigned format. The preface to the 1955 edition has been replaced by a new preface by the author.

International Standard Book Number: 0-486-20200-3 Library of Congress Catalog Card Number: 55-14851

Manufactured in the United States of America Dover Publications, Inc. 180 Varick Street New York, N.Y. 10014

Preface to the 1971 Reprint Edition

THE substance of *The Brown Decades*, originally published in 1931, was first presented in the Guernsey Center Moore lectures, given at Dartmouth College in 1929, under the title, "The Arts in America since 1870." On my visit to the Experimental College at the University of Wisconsin in 1929, Professor John Gaus had suggested something I had already begun to feel: my failure in both *Sticks and Stones* and *The Golden Day* to do justice to the creative forces in America after the Civil War. *The Brown Decades* sought to make good this omission. In outlining this theme in a little essay published in *The New Freeman* I described the period as The Buried Renaissance; and this might well have remained the title of the book, had the sombre colors of the generation after the Civil War not dominated the first chapter.

Like Sticks and Stones, this book has both the merits and the defects of a pioneer work. Perhaps its chief service was that it filled in glaring omissions in that younger book, and not merely went sympathetically into the work of Louis Sullivan, John Wellborn Root, and Frank Lloyd Wright, but also showed the importance of the departures in domestic architecture of the eighteen-eighties, begun by H. H. Richardson and W. R. Emerson, and carried through by Wright, Purcell, Bernard Maybeck, the Brothers Greene, and Irving Gill. (See my introductory essay, "A Backward Glance," in *The Roots of Contemporary American Architecture.*) With this went an appreciation, long overdue, of pioneer critics of architecture, like James Jackson Jarves and Montgomery Schuyler. The fact that such a book was needed, showed how little work had been done in this field.

The Brown Decades has been credited by Carl Condit and others for the first recognition of the part played by the Chicago School of the eighties as a living source of contemporary American architecture,

vi Preface to the 1971 Reprint Edition

freed from effete historic forms—the first, that is, after Montgomery Schuyler. But this revival of interest must be dated rather some four years earlier, from my visit to Chicago in 1927, which gave me my first opportunity to inspect on site the great skyscrapers, warehouses, schools, and suburban houses, for which Richardson's Marshall Field Building and his Gessner House had, by their powerful presence, paved the way.

In the course of that visit I also came upon the work of Walter Burley Griffin and Barry Byrne, though even by 1931 I had not yet identified the equally admirable buildings of Dwight Perkins, Hugh Garden, George Elmslie, or William G. Purcell. My first article on the classic design of the Chicago skyscrapers, "New York versus Chicago Architecture," was published in *Architecture*, November 1928. This was followed the next year by a series, "American Architecture Today," which dealt in part with Frank Lloyd Wright's contribution to domestic architecture. The fact that Henry H. Saylor, the editor of *Architecture*, welcomed these articles itself has some historic significance, as an indication that the wind was already beginning to veer away from the then-fashionable eclecticism.

What perhaps is most important to emphasize about this excursion into the past is that its main effort was to find a fresh starting point for future creativity; and in particular it was an attempt to define what we meant by "modern." In the late twenties, "*Was ist modern*?" was a favorite topic for discussion in German esthetic circles, and Ernst Jäckh, in *Die Form*, even outlined an international exposition, influenced by the philosophy of Max Scheler, that would embody the concepts of modernity in every department from science and technics to sport and daily life. At that time Germany, through the Deutscher Werkbund, had established a more continuous modern tradition than either England, its original home, or France. So even before I visited Germany in 1932 and saw the work of Erich Mendelsohn, Walter Gropius, and Hugo Häring, I was influenced in my own definition of the modern by German ideas and German examples.

This German influence will explain the repeated use of the word sachlich—die neue Sachlichkeit was a German catchword of the period —to readers who might be puzzled. Sachlich means simple, forthright, factual, without ornament, glorying in the mechanical and verging toward the brutal: above all rejecting the historic in any recognizable form. At that moment, I am now amused to find, I was

Preface to the 1971 Reprint Edition vii

innocent enough to believe that one could almost define the modern in such crude engineering terms. The similar emphasis on an equally simplistic notion of "orientation"—as if a single criterion, such as southern or east-west exposure, could be laid down for all sites and functions—belongs to the same outmoded school. On these matters it is only decent to urge a certain wariness on the reader. If he cares to, he will find my own corrections and re-definitions in many later articles, and notably in "The Case against Modern Architecture" included in *The Highway and the City* (1963).

Though allowances must be made for these solecisms, I was not altogether unsuccessful in defining the special qualities of modern architecture, even before I wrote *The Brown Decades*. For my essay on "The Wavy Line versus the Cube," published in *Architecture*, December 1930, foretold both the continuation and the transcendence of the two earlier movements, Art Nouveau and Cubism. Though this essay made little impression at the time, it proved cogent enough to tempt the *Architectural Record* to republish it in January 1964, illustrated by a whole series of actual buildings that had in the meanwhile come into existence, almost as if to verify my analysis thirty-three years before. But I doubt if I could have anticipated this transformation, had I not appreciated the historic achievements of Root, Sullivan, and Wright.

Though The Brown Decades was a ground-breaking work in American architectural history and criticism, it performed hardly a less important service in re-stating other parts of the American past, and recalling to mind some of the gifted spirits, like that of Raphael Pumpelly, who were then flourishing. (Pumpelly's twovolume autobiography, My Reminiscences, is still fascinating.) Perhaps its most important service was to direct attention to a long-neglected scholar, George Perkins Marsh, and in particular to his classic treatise, Man and Nature. Strangely, his work had been forgotten, even by American geographers; but my brief sketch of his career and his central theme sufficed to bring him back-for which I was duly rewarded, eventually, by being chosen by Carl Sauer as co-chairman for the Conference on "Man's Role in Changing the Face of the Earth," which produced the book of that title dedicated to Marsh. Here, as elsewhere in The Brown Decades, I have often regretted that I had not done a more thorough job: but possibly the very fact that

viii Preface to the 1971 Reprint Edition

the whole book was only a cursory sketch served as an incentive to many later scholars to fill in the missing details.

My restoration of the forgotten Marsh was accompanied by a revaluation of a man who could hardly have been completely forgotten, Frederick Law Olmsted, since his handiwork as town planner and landscape architect was visible from Stanford University and the Golden Gate Park to Riverside, Illinois, and the Back Bay Fenway in Boston. Yet, though his work was visible, the only systematic account of it was that dealing with his first major success, as co-planner of Central Park; and though he had been a copious writer in his youth, he himself had never given in print an adequate account of either his theory or his practice.

Even now a properly critical appreciation of his work has yet to be published; but more than one scholar has been assembling the relevant evidence, and in time his original contributions as both a planner and an artist will become apparent. While neither Marsh nor Olmsted was able to preserve the American landscape from spoilage and savage desecration, the guiding lines that they laid down for understanding and wisely using our natural resources are now belatedly being followed by awakened conservation and urban renewal groups in every part of the country.

My satisfaction over the chapter "The Renewal of the Landscape" is not, I confess, applicable to the all-too-brief review of painting and photography, though it is perhaps historically significant to note that in spite of Stieglitz' pioneer periodical *Camera Work*, it was still unusual at that late moment to treat photography as coeval with painting. But the sections on Ryder and Eakins only emphasized further what many other critics like Walter Pach and Paul Rosenfeld had already agreed on, that these two were the central American artists of that period, indeed of the nineteenth century, a fact already testified to by the superb exhibitions of their work presented by the Metropolitan Museum of Art. If this chapter turns out to be an anticlimax for the reader, let me assure him it has long seemed equally so to the writer.

The work I did in the twenties followed the lead taken by somewhat older members of my own generation: Van Wyck Brooks, Randolph Bourne, Waldo Frank, Constance Mayfield Rourke, and Paul Rosenfeld. Instinctively we sank our roots deep into the American cultural soil, and well before "American Studies" got a foothold in university curriculums we opened up areas that had long become

Preface to the 1971 Reprint Edition

ix

weedy and wild, indeed almost unvisited by those who, like Henry James and T. S. Eliot, looked first—if not exclusively—to Europe for cultural guidance and example.

Some of us, notably Brooks and Constance Rourke, sought to settle down in the Promised Land whose fruits we had first proudly brought back; and for a few decades I myself kept a file of notes and bibliographic references in anticipation of writing a general cultural history of our country which would have an even larger scope than my youthful essays, as well as, hopefully, the depth that they lacked. Some day, I trust, that book will be written; but if so, it will be by another hand; for a while ago I destroyed that file as too personal for use by anyone else.

The Brown Decades, then, was the fourth, and as it turned out, the last of my historical excursions into American art, literature, and architecture, except for a minor volume, *The South in Architecture*. For long before its influence registered in the work of other scholars, I felt a kind of stepfatherly coldness toward it, though I could not deny my paternity. Perhaps this was because in the very year *The Brown Decades* came out, I was already enlarging my horizon, getting ready to deal with Western Civilization as a whole, to counteract a threat of its already visible disintegration, and to prepare, if that were possible, for its renewal. In the thirties, all too plainly, night was coming on fast, and I had other promises to keep.

After re-reading *The Brown Decades* recently with an aloof and quizzical eye, I must confess that I no longer feel as uncharitable toward it as I once did. True: this work remains only the outline of a book; but sometimes, as in the work of Delacroix, the first sketch has a quality that often gets lost in the more carefully executed painting. At least, to speak personally, this book served as a useful foundation for the criticisms of contemporary painting, architecture and urban design that I did during the next thirty years. And if *The Brown Decades* can no longer serve as a guidepost, it may remain for a while as a milestone—its lettering eroded but still visible—in the study of American culture.

L. M.

Contents

CHAPTER ONE: THE BROWN DECADES, PAGE I CHAPTER TWO: THE RENEWAL OF THE LANDSCAPE, PAGE 26 CHAPTER THREE: TOWARDS MODERN ARCHITECTURE, PAGE 49 CHAPTER FOUR: IMAGES—SACRED AND PROFANE, PAGE 83

SUMMARY, PAGE 113

Sources and Books, page 115

INDEX, PAGE 123

Illustrations

Thomas Eakins: Walt Whitman	FRON	TISPIECE
	FACI	NG PAGE
John A. Roebling and Washington A. Roebling: Brooklyn Bridge		· 44
Henry Hobson Richardson: Crane Memorial Library, Quincy		· 54
Henry Hobson Richardson: John H. Pray and Compa Building, Boston	ny	• 55
McKim, Mead and White: First Methodist Church, Baltimore		. 58
McKim, Mead and White: goo Broadway, New York	k City	v 59
John Wellborn Root: Monadnock Building, Chicago .		. 62
Louis Henry Sullivan: Auditorium Building, Chicago .		. 68
Louis Henry Sullivan, George G. Elmslie, assistant Schlesinger and Mayer Building, Chicago	:	. 69
George Fuller: Boy		. 90
Winslow Homer: On the Bluff at Long Branch		. 91
Albert Pinkham Ryder: The Race Track, or Death on Pale Horse	ı a	. 104

A genuine culture was beginning to struggle upward again in the seventies: a Peirce, a Shaler, a Marsh, a Gibbs, a Ryder, a Roebling, a Thomas Eakins, a Richardson, a Sullivan, an Adams, a LaFarge were men that any age might proudly exhibit and make use of. But the procession of American civilization divided and walked around these men.

The Golden Day

CHAPTER ONE

The Brown Decades

THE commonest axiom of history is that every generation revolts against its fathers and makes friends with its grandfathers. This reason alone might perhaps account for the fact that the generation which struggled or flourished after the Civil War now has a claim upon our interest. In the paintings of Burchfield and Hopper, the very buildings of the Awkward Age come to us with a certain sentimental charm: those mansard roofs, those tall, ill-proportioned windows, those dingy façades which concealed the dreadful contortions of walnut furniture, in fact, the worst emblems of the period no longer afflict us like an inappropriate joke told too frequently by a tiresome uncle. If we are lenient to the worst the Gilded Age can show, are we not perhaps ready to receive the best?

Beneath the foreign trappings of the seventies and eighties we have become conscious of a life not unlike our own: that is the first claim to our sympathy. Like our grandfathers, we face the aftermath of a war which has undermined Western Civilization as completely as the Civil War undermined the more hopeful institutions of our country. The dilemmas, the hopes, the mistakes of the earlier period are so near to our own that it would be a wonder if we did not see its achievements clearly, too. But we need a fresh name for this period, if we are to see it freshly. Shall we call the years between 1865 and 1895 the Brown Decades? If the title sounds vague, it is, as I shall show, not inappropriate.

II

There are occasional years when, after spring has leafed and blossomed, a long series of storms and rains destroys one's sense of the summer. Suddenly one raises one's eyes to the trees and discovers that autumn has arrived: the leaves are sere, the goldenrod stands

brown and threadbare in the fields, the branches of the maples are stripped, and only the red berries of the black alder, or the dull persistent greens of the buttonwoods and poplars, remind one of the summer that never came.

There was such a violent stormy summer, and such a sudden push of autumn, in the period of American history that began with the Civil War. The long winter of the seventeenth century, a sturdy battle with the elements, had given way to the slow spring of the eighteenth: it was then that the ground was ploughed and the country made ready for a new political system and a new relationship to the institutions and customs of the past. Then, in the few warm weeks that elapsed between 1830 and 1860, there had come a quick leafing and efflorescence. In the literary works of Emerson, Whitman, Thoreau, Melville, Hawthorne, new modes of thought and a fresh sense of the human adventure became apparent. If there were few early fruits, the flowers were delectable and their promise abundant.

The Civil War shook down the blossoms and blasted the promise of spring. The colours of American civilization abruptly changed. By the time the war was over, browns had spread everywhere: mediocre drabs, dingy chocolate browns, sooty browns that merged into black. Autumn had come.

The people who had fought through the Civil War were chiefly conscious of the political issues that were decided, or temporarily silenced, by the conflict. Our recent histories have shown in detail all the industrial and financial transformations that were either brought on or hastened by the war: the growth of steel mills, the mechanization of agriculture, the substitution of petroleum for whale oil, the development of the trade union movement, and the concentration of great fortunes, built up by graft, speculation, warprofits, or the outright donation of priceless lands to great railway corporations, acquisitions which were not called theft, and doles which were not denounced as inimical to manhood and independence, only because the sums involved were so huge and the recipients so rich.

While these changes were no doubt as important in their total consequences as the abolition of human slavery, the most visible transformation of all has been forgotten. The nation not merely worked differently after the Civil War: the country *looked* different —darker, sadder, soberer. The Brown Decades had begun. Dead

men were everywhere. They were present in memory: their portraits stoically gathered dust in empty parlours; they even retained possession of their bodies and walked about the streets; they spoiled gaiety, or rather, they drove it to fevers of licence and distraction. In the years that followed the war, three American translations of the Divine Comedy appeared: that terrible, rapturous celebration of the dead was keyed to the best temper of the Brown Decades.

The change was dramatically signalled by the death of Lincoln: it made the deep note of mourning universal, touching even those who had stood outside the conflict. Edmund Clarence Stedman, the poet who was to emerge from the war as a Wall Street broker, has left a memorable description of the event. "You know that a *vulgar* woman appears a lady *in mourning*; and that a lady is never so elegant as when in black. Something of the same effect has been produced on our superb but bizarre and inharmonious city. It looks like an immense black and white flower, with leaves and petals spreading grandly and in perfect keeping, to every point of the compass. Such an effect I never saw, or dreamed of. It is overwhelming, sombre, sublime."

That note did not die out; though the white of the original decoration was soon, in effect, spattered and muddied. In part, the change lay on the outside. Society was adapting its colouration to the visible smut of early industrialism: in the new coal towns, the national banner itself, after a few days' exposure to the air, changed its red, white and blue to brown, grey and black. But even more the Brown Decades were created by the brown spectacles that every sensitive mind wore, the sign of renounced ambitions, defeated hopes. The inner world coloured the outer world. The mood was sometimes less than tragic; but at bottom, it was not happy.

Like all such historical changes, the colour had manifested itself, as a leaf turns here and there on a maple early in July, before the causes of the change itself had become dramatically apparent. Brownstone began to be used in New York on public buildings in the early fifties, and just on the eve of the war it was first used as a facing for brick houses. With this alteration came dark walnut furniture, instead of rosewood and mahogany, sombre wall papers and interiors whose dark tones swallowed up the light introduced slightly later by the fashionable bay window. By 1880 brown was the predominant note. Mary Cassatt escaped these colours and tones in her painting by living in Paris; but Ryder, lyricist that he was, worked within the

prevailing palette, and Eakins, inspired partly by Rembrandt, as well as by the comtemporary mood, ran most easily through the gamut from yellow brown to dark sienna. In the best work of the period these sober autumnal colours took on a new loveliness: a warm russet brown, touched off by a lichen green and the red of red oak leaves marked Richardson's treatment of the shingled house: at the very end of his career he produced cottages that, for the first time in America, brought the landscape and the architecture into the mood of the time.

No period, of course, is uniform in its colour any more than in its morals or manners; there are always gradations; there are likewise always leftovers and intrusions, reminders of a dead past that is not yet dead or promises of a venture into a future still unborn. But the Brown Decades mark a period, a period we have yet to explore intimately and reckon with. If it began with the mourning note of Lincoln's funeral, it ended, like a sun thrusting through the clouds, in the golden portal of Sullivan's Transportation Building at the Chicago World's Fair in 1893. Between the first black and the final brilliance, a whole range of colours and tones was explored and embodied in permanent works of art and thought.

III

It is impossible to see one's own period in perspective; but on the surface, the points of resemblance between our own post-war difficulties and those which followed the Civil War are so numerous that, in going through the records and memoirs of the earlier period, one has the sense of following our own history, told in a slightly foreign language.

There was, to begin with, the sudden absence of youth that one felt keenly in Europe after the last war; the loss of youthfulness was a necessary consequence of this fact. Even those who were left after the conflict, even those who had in one way or another run away from the war, had a doubled sense of responsibility: one sees their grave anguished faces, their bleak troubled eyes, in the portraits of the time and one reads with astonishment the subject's age: it is not fifty but thirty. The younger generation had aged; and during the decade that followed the war, cynicism and disillusion were uppermost. Sometimes these qualities were consciously present; but they were equally revealing when they were unconsciously expressed, as one finds them in the diary of a contemporary poet: Nov. 8, 1864. Stood two hours in the rain and voted for Old Abe. Realized on stocks and made \$1375.

Nov. 9. Yesterday a great triumph for the National Cause. Thank God! The future of America is now secure.

Nov. 10. Fall in gold. I make on everything I manage for myself and lose on the operations of my agents.

The dual motives that ran through the period could not be better expressed.

"When Johnny came marching home," wrote one of his feminine contemporaries, Mrs Rebecca Harding Davis, "he was a very disorganized member of society, and hard to deal with. You cannot take a man away from his work in life . . . and set him to march and fight for five years, without turning his ideas and himself topsyturvy. The older men fell back into the grooves more rapidly than the lads, who had been fighting."

All the hopes that had underlain the gallantry and heroism of the war had been suddenly punctured, partly by their fulfilment and partly by their denial. No abstract ideal can be translated into an actual condition or institution without seeming to undergo a blight: this does not prove that abstract ideals are either unnecessary or delusive: it merely means that one should be acquainted with their natural history and not expect perfection to arise in a situation where, to achieve perfection, all the necessary details and qualifications of history would have to be left out. The preservation of the Union, the freeing of the slaves, were slogans used by the community to rationalize its tragic difficulties: but such shibboleths could not serve, once they had passed into action, instead of humane and intelligent plans. These plans were frustrated after Lincoln's death; and those who had been lured into the conflict by such easy verbal promises felt cheated and abused. The slaves were freed; the union was preserved-what of it?

Moreover, as Mrs. Davis suggests, there was a wide gap between the patriotic fulfilment of a high duty, which so warmed the hearts of Emerson and Alcott, and the actual conditions of the battlefield she herself had observed in Virginia. Under the mere stress of changed conditions, some of the loyal adventurous fellows turned into thieves and rascals: the very method of warfare upset, as it always does, the ideals and rational purposes for which it was fought, leaving greed, arrogance, and vindictiveness piled up behind the bodies of the dead heroes who often enough did not get even their

due six feet of earth. Occasionally, some high purpose, conceived on sentry post under the stars, like Professor Burgess's scheme for an Institute of Politics, to probe into the causes of war and learn to remove them, might eventually find a place; but Emerson discovered speedily enough how badly most of his hopes had foundered in the backwash of war.

"We hoped," he wrote, "that in the peace, after such a war, a great expansion would follow in the mind of the country; grand views in every direction—true freedom in politics, in religion, in social science, in thought. But the energy of the nation seems to have expended itself in the war." That was an old story: in fact, war leaves no other. How often can we ignore it? Some day the fatal inertia and forgetfulness of Western Civilization may occur once too often, and all its potentialities will be exhausted in some fantastic crusade to "save" civilization—even the possibility of material gain will vanish. War does not bring the martial virtues into the subsequent peace: it merely prepares a richer soil for the civilian's vices. One might as well expect a high sense of tragedy in an undertaker, as heroism in the generation that follows a war: meeting death is one thing, and disposing of the remains is another.

IV

No sooner had the Civil War come to a close than, as a writer in *Harper's Weekly* promptly remarked, the reaction from the tension of war showed itself "in a certain public frenzy. Enormous speculations, losses, and consequent frauds; an increase of crime, a curious and tragical recklessness in the management of railroads and steamers; a fury of extravagance in public watering places are all observable." These results were not temporary: the dinners became richer and longer, the gambling stakes higher, and the general spiritual torpor more profound. The social life of the country became a swamp. The decade that saw the Centennial Exhibition, bravely arrayed in cast-iron façades crowned with cast-iron statuary, crowing over the triumphs of the Hoe press and the Corliss engine, saw also the corruption of Grant's administration and the exposure of the Tweed ring in New York.

In their negative and disheartening manifestations one might, indeed, work out a pretty close comparison between the two postwar generations. There was the same open public corruption, in a community that shared so many of the vices of its false officials that even the pretence of honesty was absent: those who were caught red-handed showed shame and indignation, not over their peculations, but over the fact that they were caught. There was the same faith in the Machine Age and the same interest in Adult Education we are now so aware of: in the seventies the first took the form of using iron instead of stone for the columns and cornices of buildings, and even of offering for sale-I have no definite proof that they were ever bought or used-collars and cuffs, to be worn by men, made of painted sheet-iron. As for adult education, it was promoted in the Mechanics' Institutes, now so often empty melancholy shells, that sprang up over the country in imitation of the workingman's colleges in England. Do we look askance at the use of prominent names for the advertisement of sundry wares from cigarettes to bed sheets? The habit was already gaining headway in 1867 when an advertisement proclaimed that Mrs. Henry Ward Beecher of Brooklyn, after using the Ivory Eye Cups, ordered a pair for the wife of the Reverend Charles Beecher of Georgetown, Massachusetts.

It was in the seventies, too, that Colonial Architecture, which had been neglected and contemptuously set aside in the various fashionable adaptions of Gothic churches and Swiss chalets, was first reappraised, and then reinstated as a movement: going out as a habit in the older parts of the country, it slowly re-entered as a fashion, although it never really took on until the nineties. The methods of James Gordon Bennett's newspapers foreshadowed the larger abuses of our tabloids. If Mr. Stuart Chase, contemplating the last war, has depicted for us a nightmarish but tangible future in his Two Hour War, a cartoonist in 1866 showed the progress of the art of war from primitive arms to the needle gun, which reduced the thirty years' war to thirty days, and from then on to the "electric organ gun" of 1880, the steam gun of 1890, and finally the "surprise bomb" (asphyxiating gases) of 1900, with its promise of a three minutes' war, both armies annihilated-and universal peace. If Mr. Chase's prediction approximates reality as closely as that of the Harper cartoonist, the world may well tremble.

The expansion that Emerson had hoped for had indeed taken place; but its dominant effect was on the utilitarian plane. Charles Francis Adams, who had served in the battlefields, now took command of railroads and stockyards: in him, the old Adams tradition of public service was limited to the little town of Quincy, and to such work as he did in later years on the Metropolitan Park Board of

Boston. Mark Twain wasted endless time and energy that should have gone into his own education, trying to make a fortune out of various inventions that took his fancy; while Henry Adams, typical of those who could make no connections with the crass outward scene, after surveying the politics of Washington at close range, took refuge in the South Seas, in Japan, in Europe, in the Middle Ages, one of that large group of disoriented and bewildered Americans, Henry James, Raphael Pumpelly, William Story, Ambrose Bierce, Bret Harte, who could find no sufficient nourishment in the soil where their roots spread, and who had even before the Civil War begun to wander uneasily about Europe—grateful for the contemplative mood it promoted, the one luxury that reckless kings of commerce could not buy, could not afford to cultivate, could not import.

Ten years ago Mr. Harold Stearns wrote an article in *The Freeman*, "What Shall a Young Man Do?" in which the doubts and dilemmas of this generation were curiously re-echoed. Living itself in post-Civil War America was an uphill job; living well, living with integrity, living for the sake of ideas—these things required exceptional stamina and intellectual hardihood.

Make no doubt of it: those who stayed behind needed either a double thickness of skin, or they needed the narrow convictions and the faith in the immediate activities of the country that the industrialist exhibited. Failing such toughness, most of them were forced to retreat into a private world that received little sustenance from the community immediately around them. How could they do otherwise? Conjure up the sordid parade of cut-throats, business gamblers, political mercenaries, short-sighted industrialists, sporting dandies, and demagogic religious preachers who claimed the spotlight during this period. It is impossible to caricature these dreadful figures; pure description sounds like abusive satire. The picture Vernon Parrington draws of these days, in the third volume of his history, is particularly good in its grasp of physiognomy: the obese and bloated masters of this post-bellum America, who shared honours with a handful of shrivelled, neurotic creatures, were beyond even the caricatures of Nash: they would almost have escaped Rowlandson. Even the best men conformed to the mould. Richardson's bulky figure, to say nothing of his huge travelling companions, attracted the attention of European gamins, who thought they belonged to a circus: once they asked outright -When is the dwarf coming?

What triumph of a morbid imagination conceived or remembered -it had been worn by Catholic priests in procession to avert the plague-the costume of the Ku Klux Klan, and turned an idle practical joke into an imposing terroristic organization? What triumphant confusion of values could have persuaded two government clerks in Washington to conceive of dignifying farming, rehabilitating agricultural life, and fostering co-operation by creating a secret order, surrounded with hocus-pocus and called the Patrons of Husbandry -a movement which was as successful at its inception as Terence Powderly's Knights of Labour, both institutions being halfway, as it were, between sound economic strategy and a tawdry adolescent dream. These movements belonged to the Brown Decades, reached their heyday then, and as national influences came to an end before the period itself was over: they made credible the popular art and decoration, the work of the scroll-saw and the lathe, the beauty of the Rogers group and the reality of the dime novel.

There was, without doubt, something pitifully inadequate, indeed grotesque, in the post-bellum scene; and the epithets that have been applied to it, the Gilded Age, the Tragic Era, the Dreadful Decade, the Pragmatic Acquiescence, are too full of truth ever to disappear. But neither epithet nor description, however accurately documented, tells the whole story. Beneath the crass surface, a new life was stirring in departments of American thought and culture that had hitherto been barren, or entirely colonial and derivative; and it is to these growths that we now turn with a feeling of kinship and understanding. For the Brown Decades are not merely a mirror of our vices and infirmities; they are also a source of some of the most important elements in our contemporary culture. If we cannot accept as a whole, with any feeling of affection, a period that so meanly caricatured human decencies and cut short so many fine potentialities, we need not overlook its happier parts, even if these aspects of the age suffered neglect in their own day.

V

It is time that we ceased to be dominated by the negative aspects of the Brown Decades. To dwell upon their ailments, infirmities, mischances, is to show, as in the invalid's preoccupation with his disease, that the remains of the poison are still operating in our own systems. I half-fell into this pitfall myself in treating this generation in *The Golden Day*, even though I was aware of its positive achievements;

for in interpreting the experience of the time one is tempted, even when face to face with individual talents of high merit, to read into their story the history of American society's failure and frustration, and so to belittle aspects of their work that did not reflect the miserable background.

How easy it is to appreciate the weakness of William Dean Howells in literature, his reluctance to deal with human life in its totality, and to forget both his craftsmanship and his patent understanding of the characters that came within his range! How easy it is to see in William James the father of the lower sort of American pragmatist, and to forget the richly endowed mind that wrote the classic treatise on psychology! The mere failure to publish the greater part of Charles Peirce's thought has obscured the fact that, in the very dregs of the Gilded Age, a large and universal mind quietly fulfilled itself, a mind whose depth and impact has still to be felt-and fathomed. If one is to condemn the Gilded Age for Peirce's lack of influence, one must equally condemn the glorious thirteenth century for the comparative obscurity of Roger Bacon, or the sixteenth century for not publishing the remains of Leonardo da Vinci. Doubtless the condemnation would be deserved: but the glory of their positive achievements still remains.

The creative manifestations of the Brown Decades have been overlooked, partly because we habitually seek such impulses in literature: what we cannot read we cannot see. In literature, too, we have judged the age by its roster of popular names; and in reacting against the mediocrity and feeble gentility of Thomas Bailey Aldrich, against the timid conception of life and letters that supported Howells, against the complaisant low-browism of Mark Twain, we have forgotten the few significant men and women whose work is profoundly important to us—to say nothing of the presence of Melville and Whitman—the Melville whose comments on the close of the Civil War should have gained him, if nothing else did, a wide hearing from his countrymen, or the Whitman whose *Democratic Vistas* is still the most fundamental piece of literary and social criticism that has been written in America.

Almost every account of the Gilded Age has suffered from one of two insidious forms of deflation. On one hand, its material advances, its inventions, its technical achievements, have been overpraised, or their contributions to the good life have been brashly taken for granted, without any qualifying sense of their deficiencies, as if

material success could atone for an impoverished life; or—and this is just as bad—the contemporary estimates of its literature, art, and philosophy have been accepted at the Gilded Age's own value, and its fruitful contributions have therefore been ignored.

One does not quarrel with the literary mediocrities of the Brown Decades in themselves: every period has such people as Stoddard and Aldrich in plenty, and they often do meritorious work. Unfortunately, they take it as their duty not only to perform their own task, but to keep work with higher standards, surer perceptions, deeper intuitions of value, larger and more capacious experiences, from getting into circulation: jealously assuming to guard the portals of literature, they are actually supporting their own egos. Now, many of the popular writers and prophets of the period have turned out to be charlatans: the metaphysical booster psychology of Mrs. Mary Baker Eddy seems to us a little less than the inspiration of divinity; the poems of Stoddard, Aldrich, and Bayard Taylor have but a minor claim to our respect; even the generous volatile Mark Twain does not seem to us to be the great universal satirist that Howells honestly proclaimed him to be. But must we condemn the period because its arbiter in letters was Thomas Bailey Aldrich, the author of the now-forgotten Ponkapog Papers, equally minor as critic and poet? To do that would be to forget the fact that those apparently sterile years are redeemed for us by the silent presence of Emily Dickinson.

Granted that the brightest successes of the Brown Decades seem to us, for the most part, to be only muddy failures, it is much more important to realize that many works which were then pushed aside as inept, ludicrous, or eccentric were in actuality genuine successes, emergent elements in a growing American tradition.

VI

The more commonplace minds of the Brown Decades were not affected by the activities of the period that preceded them: they scorned the transcendental doctrines and hopes, in favour of "securities" which, as Black Friday was perhaps to teach them, were as baseless as a passing dream. But almost all the vital and important workers of the period bore the mark of Emerson, Whitman, or Thoreau; and though seemingly neglected, or honoured only as quaint effigies and survivals, these men brooded over the Brown Decades.

Their influence was perhaps smallest in literature, if one except the impression that Emerson made upon Emily Dickinson, or Whitman upon Burroughs; but their doctrines had brought a new confidence to all the other arts: Emerson's gospel of self-reliance and his belief in a fresh start, Whitman's hearty affirmation of the vulgarities and commonplaces of life, and Thoreau's deep sense of the landscape and its influences—all these beliefs were to have their effect upon the painter and the architect and the engineer.

Almost hidden by the dead leaves, the compost, the sour soil of the Brown Decades, a spring flower grew: its tiny bud scarcely peeped through the matted heap above it, and before it had been recognized, before it was given light and air, it had died. Does it belong to the soil or not? Surely it does. This shy flower was Emily Dickinson, whose life and words were known only to a handful of people during the Brown Decades, although the span of her working life almost defines the period. She was a rare flower, and none the worse for being so secluded, so completely overwhelmed by the coarser plants and the earthier foundations of her time: in any age, this sensitive woman would have needed some protection, for within her fine sensorium a breath was as the sound of thunder in the mountains, and the ripple of a trout in the pool might be as powerful as the breaking of the sea.

Emily Dickinson has been treated, even by some of those who admire her, as a victim of her time: if only, they say, she had had the courage and ability to run away with the lover who claimed her, if only she had prospered in the normal life of passion, physical intercourse, children, the fuller domestic cares and joys, if onlysometimes these vain words are used humourlessly-she had been "better adjusted." Let us put aside this misconception. The test of any mode of life is its outcome: how strong and sane and balanced and wise one ultimately becomes by following it. A lover and a baby might have given Emily Dickinson the same fulfilment and satisfaction as her poems: but they would hardly have increased her poise, even if they had earned it more easily. Her ecstasy, her torture, her sorrow, her hope all sprang out of the tensions of renunciation. What Melville had discovered in Pierre, Emily Dickinson was to reveal in the more perfect, fragile medium of her poems: the subtle ironic tragedy that underlies human relationships. If her No was tragic, her Yes would have been tragic, too.

In one sense, Emily Dickinson, secluded behind her high hedge

in Amherst, was out of touch with her age; and in another, no one had expressed its deeper experience more completely. Was her dismissal of her lover in essence different from the spirit in which many another girl had resigned her mate to the battlefield, never to see him again? In Emily Dickinson's poems, even more than in Bierce's stories of the war, even more than in Whitman's Drum-Taps, was the marrow of American experience during the Civil War. Just as Henry James, abroad, felt and expressed the dilemmas of the cultivated American more completely than those who immersed themselves in the local colours of their immediate environment, so Emily Dickinson, silent and unknown, insulated against all the gross contacts with her milieu, felt and expressed the tragic heart of life during the Brown Decades. That it was hidden, that only a few men dared to face the depths of their anguish, does not make the emotion less real, or prove that it was not commonly shared. No one is insulated: plagues and blessings are both blown on the wind, and one can gather the history of a period from the meditations of a recluse almost as fully as one can from a man of the world-more so, perhaps, for the first has time for reflection and sometimes records his experience. What Emily Dickinson was, that also the Brown Decades was in a measure, beneath the fuss and show and tawdriness of its daily life.

Above Emily Dickinson, overshadowing her, lush and rank as the first leaf that opens to the April sun in the swamps, was Walt Whitman. In the years immediately following the Civil War, which terminated with his paralysis in 1872, he carried the conception first revealed in *Leaves of Grass* a little nearer to completion.

It was Whitman's task to confront the hopes and ambitions of his youth for America with the actual fulfilments of maturity. He did not shrink from this work. *Democratic Vistas* was published at one of the lowest moments in the country's life; and no one has presented a more appalling picture of its bottomless corruption and misery than Whitman did in those pages. He found that society "in these States, is canker'd, crude, superstitious, and rotten. Political or law-made society is, and private, or voluntary society is also. In any vigour, the element of the moral conscience, the most important, the verteber to State or man, seems to me either entirely lacking, or seriously enfeebled and ungrown."

The business before the poet was not only, as he at first thought, to crown republican institutions and material prosperity with

authentic and original works of art: by now the task was a matter of setting society moving in a direction opposite to that which it had taken, offering counterpoises to the mischievous and ill-fated institutions that had arisen. Whitman's original faith, though always buoyant, had proved naïve: democracy and the new world, which seemed ready for great consummations, had by 1870 acquired threatening resemblances to the feudalism which the younger Whitman had taken for granted would be left behind. Democracy no longer ensured a new literature: rather "a new literature, perhaps a new metaphysics, certainly a new poetry," were necessary as "the only sure and worthy supports and expressions of the American democracy." Throughout the *Democratic Vistas* one is conscious of an heroic struggle going on in Whitman, a struggle to define and embrace reality, and not to shrink, in any pusillanimous hopefulness, into a private world of his own.

This seasoned and mature Whitman should displace in our minds the feeble, garrulous, sweet, somewhat sly old man of the final Camden days: every mind has a right to be known by its soundest and maturest expression. (Do we judge Plato by *The Laws*?) Whitman had little immediate effect in literature: with the exception of John Burroughs, this was not to happen until our own generation; but in the other arts the Brown Decades harboured a number of men who understood the implications of Whitman's message and resolutely carried it on.

Whitman's "Song of the Exposition," poor though it was, was perhaps the most stimulating work of native art that the Centennial could show. If no poet was able to grasp or use Whitman's meaning, Thomas Eakins was equal to it in painting: there was a rapport between the two men that made Whitman Eakins' chief defender, against the poet's own disciples. William James, too, was influenced by Whitman and quoted him frequently: indeed, it is almost a tribute to Whitman's efficacy, and a re-enforcement of his point of view, to see that his effect was not confined to literature, but spread widely into other channels. Louis Sullivan came profoundly under Whitman's influence: in fact, he carried on into architectural theory and practice even the clichés of Whitman's thought, like the distrust of "feudalism." Emerson supplemented Hegel in the mind of John Roebling, the designer of the Brooklyn Bridge; and Thoreau not merely served as literary godfather to Burroughs, but, what is more important, provided a rational basis in thought for the sub-

sequent efforts to recapture the wild domain and keep the primitive sources of American life from drying up. Neglected by their contemporaries in the Brown Decades for their interest in an earlier America—it was typical that Howells, who had read *Walden* in his youth, confessed forty years later that he had never looked at the book afterward—they were equally neglected by the muckraking generation that followed, because their interests, though at bottom so different, were somehow lumped together with the sordid activities of the post-Civil War decades. Ours is the first generation that can look upon these bedraggled years with a free mind and catch, amid the materialism, the mean ostentation, the barbarous waste of human life, the gleam of an active culture which neither the Civil War nor its consequent activities could overthrow.

VII

It was the contemporary obscurity and neglect of what was best in the literature of the Brown Decades that has made us impatient of the period: that, and the fact that the emphasis of the whole society shifted to the industrial and plastic arts. What caused this shift? Literature can flourish early in a society because of its limited physical demands: even painting, although the physical utilities are slight, requires the stimulus of other paintings and the professional aid of painters-conditions difficult to meet in a new country. Books travel easily; and with only small means, one can still have command of the best: Hebrew literature was available in one volume in the most wretched settlement, and Shakespeare and Milton were not unobtainable. Indeed, where the presses are few and the supply of books scanty, the finest works of literature have perhaps a readier chance of acceptance than they have in a state where books pour forth in great quantities, and bulk conceals quality. So it happened that the first consummation of American life in our culture came through literature in the writers of the Golden Day: it was only after the Civil War that a similar process took place in the domain of the other arts.

The means of life were changing rapidly from the fifties onward: there was a necessity for inventive adaptation which turned men from the inner life to the outer one, and to such manifestations of the inner life as had a plastic or structural equivalent. For lack of an harmonious system of concepts and feelings, this necessary change did not lead to an intelligent adaptation of the environment: in the planning

of cities and the layout of railroads, highroads, farms, in the exploitation of mineral resources and the utilization of the land, a good part of our soils and cities were ruined: indeed, the new industrial towns were ruins from the beginning. But the necessity for invention was present, and if it was passed over by the vulgar profiteers in all walks of life and industry, it was nevertheless a challenge and a stimulus to the best minds. It turned farmers like Andrew Jackson Downing and Frederick Law Olmsted into landscape architects; it turned agricultural colonists like John Roebling into engineers, and men with strong musical talents like John Root into architects.

Added to this was the direct stimulus of new inventions; for in the beginning they were still almost toys, and before their potentialities had been transformed into slick routines, they had a power to stir the mind, out of all proportion to any of their later effects. The telephone, the electric light, the phonograph, the improved camera, the gas engine, the typewriter, all belonged in their inception, if not their full development, to the Brown Decades: they had something of the profound fascination that the Leyden jar had in an earlier century: they were wonders of nature, before they became utilities.

A good part of all this manipulation and invention came to no good end: let us confess that. The influence of the scroll-saw or the sheet-iron cornice on architecture was no better than the application of the lathe to the decoration of furniture in the seventeenth century; and the reproductive processes which produced the cheaper chromolithograph only increased the amount of futile work in the world, helping printers to flourish whilst it encouraged the original artists to starve. Mark Twain praised the typewriter because it promised to save paper; but it would be quite as just to condemn it because it increased the temptation to waste it: no one has yet fully balanced up the gains and losses that came in with this exuberant technology. and possibly no one ever will. But though the common products of industry were pretty generally bad-it is hard to conceive anything lower than the architecture of the Centennial Exposition or the fashionable Newport villas of the same period-the impulse to manipulate materials, the atmosphere of work, the interest in technique, were all helpful to the serious artist: if they did little for literature, these interests had a legitimate contribution to make to the other arts. The Brooklyn Bridge, for example, could scarcely have been built before the Civil War-if only because the iron foundries were hardly capable of supplying sufficient iron to build New York's

Crystal Palace on schedule in 1853. The steel-framed or skeleton skyscraper, too, could not have been devised before the Brown Decades: it needed the invention of the elevator in the fifties and its improvement in the seventies, together with the cheapening of steel through the Bessemer process. The architect, the engineer, the landscape architect, the painter, all rode in together on the rising tide of industrialism: the very disorder it produced was a challenge.

The challenge would perhaps have been disastrous, were it not for the feeling of confidence that advances in scholarship and science made during the Brown Decades: this gave an impetus to the arts, and put solid ground under them; and one would scarcely understand the vigour of creative effort in both dominant personalities, like Richardson, and obscure, somewhat lonely pioneers, like Ryder and Eakins, if one left out of account the scholars and the prophets.

VIII

The chief works of scholarship before the Civil War, like the histories of Motley and Prescott, were the achievements of brilliant individuals, operating in what was almost an intellectual vacuum: the importation of books, to say nothing of finding and getting access to documents, was something of a feat. After the Civil War scholarship ceased to be the handmaiden of Christian apologetics or the rag-tag-and-bobtail of ancient classical interests; and in every department young Americans began to have firsthand relations with the whole province they sought to explore.

Raphael Pumpelly had gone abroad before the war to learn mining engineering; he returned and became, like Clarence King, an exploratory geologist. Stanley Hall studied in Germany to become, after William James, America's foremost psychologist, and one of its foremost educators. In Cambridge Chauncy Wright, who unfortunately died in the seventies, and Charles Peirce, were concerned with mathematics, the physical sciences, and philosophy, treated as a unity; Lester Ward was studying Comte, and William Graham Sumner received in 1875 the post in which he was to make his classic study, *Folkways*; Fiske left his derivative scientific studies to make his more important explorations of American colonial history; while Henry Adams, modestly disclaiming his competence to teach mediaeval history, not merely acquired a position of authority in that field, to top his work on the Federal period in America, but he sought to lay the foundations for a scientific concept of history.

Adams at least succeeded as a dramatist of the Middle Ages, even if he failed in his more ambitious project to carry past sequences into future probabilities. In the same period, Willard Gibbs wrote some of the most memorable pages in the history of physical science in America, buried in the transactions of the Connecticut Academy, even as Peirce's papers were buried in early numbers of the Open Court; while in 1877 Lewis Morgan made the first important American contribution to ethnology in his *Ancient Society*.

It was the decade after the Civil War that saw the renewal of our universities, with the appointment of Charles Eliot to Harvard. Andrew White to the newly founded Cornell University, and Daniel Coit Gilman to Johns Hopkins, conceived in 1867 and opened in a few improvised dwelling houses, like the more ill-fated Brookings School in our own post-war period, in 1876. Through the leadership of such men the American university was transformed from a higher type of secondary school to an institution that had some pretensions to ranking with its European equivalent. The complete Lernfreiheit which Eliot introduced through the elective system was, we can see now, better adapted to mature students, well grounded in the fundamentals of thought and culture, than it was to the ordinary American lad who came to it enfeebled in will through the shackles of an empty formal education, but with only a little of the toughness and disciplined application that this system at its best gives. But any one who does not appreciate the drastic necessity of Eliot's elective system in its own time does not realize the sterility of the old type of American college, nor the importance of completely transforming a system devised to cultivate gentlemen and clericals in a period that needed a more comprehensive type of education than the old humanities offered.

We have still to build up a satisfactory equivalent for the old classic curriculum: that is a task for the philosopher, nor alone for the educator, and men like Patrick Geddes have laid down more than a hint for the way in which this problem must be approached. But the point to remember is that the new synthesis was impossible until the old one had been effectually broken down. It was better to suffer from the bias of specialism, unrelated interests, and incomplete development, than it was to tolerate the gentlemanly inanition of the old type of curriculum, a curriculum that had been established in substance before Descartes. No doubt we suffered even more than Germany in our monkeylike imitation of German methods, for their

overemphasis on the speciality was in part compensated for by their rich communal life and their cultivation of music; but the gains outweighed the losses—or would have done so if fixation on a low level of specialization had not been demanded by our later business institutions. It needed a man of principle and conviction, like President Eliot, to see such a complete transformation through. If the student became dispersed, the curriculum was enriched; and the efforts toward synthesis that are now being made have provinces of life and knowledge to draw upon that did not exist in the seventies, when Professor Sumner conducted the first course on Sociology to be given at Yale, and Norton took over the first chair in Art at Harvard.

The powerful group of men that Harper later drew together at the new University of Chicago, or the smaller but equally significant group that Stanley Hall called around him at a post-graduate institution like Clark, would have bee. inconceivable had it not been for the pioneer work of Eliot and Gilman in promoting disinterested scholarship. One grants this freely, even while one realizes that the old type of college had a definite end in view, a certain type of mind and man, certain disciplines and modes of character, and that in abandoning this system, the leaders of education have often lost sight of any ends at all, and have succumbed to the pressure of external institutions, as Mr. Thorstein Veblen sardonically pictured in The Higher Learning. What is now called optimistically and euphemistically "adaptation to changing conditions" is often an excuse for subservience to money, or complete lack of intellectual integration. The servile specialist, eloquently ignorant of any department of thought but his own, and therefore fundamentally ignorant of essential relationships in his own field, was undoubtedly a product of the Brown Decades: but it is our fault, not that of the earlier period. that he has become a chronic malady of our intellectual life, instead of a passing maladjustment. The work of the Brown Decades in education was necessarily destructive. Not to recognize the beneficence of that effort is to overlook the very conditions of growth. It is better to face chaos courageously than to cherish the dream of returning to an outworn synthesis.

In dealing with all these tangible products of the Brown Decades, intellectual and material, one must not forget the immensely stirring

work of its major prophets, diffuse and difficult to estimate though their influence was.

Let us put to one side the figure of Mrs. Mary Baker Eddy, though in some ways she was the most influential prophet of all: she represents the shoddier part of the period, the part symbolized by the stock prospectus and the booster and the growth of credit operations in finance with no tangible assets to confirm the values that were produced and inflated. Her own particular combination of astute financial practice and lofty spiritual pretensions, her mixture of the psychology of suggestion and Berkeleyan metaphysics and Emersonian transcendentalism and faith healing and Christian theology into a working system makes her a unique figure in both religion and finance. Incidentally, her first successful classes date from the worst period of post-Civil War depression and deflation, and she exploited the tendency to ignore inconvenient realities to an extent which should make her the patron saint of our leading financiers and politicians today. But Mrs. Eddy, for all her influence, for all her perfect congruity with the worst aspects of the Gilded Age, does not belong to the positive side of our picture: she was, after all, only a more refined type of "pain-killer." The two prophets who count most for us were Henry George and Edward Bellamy.

In dealing with the American landscape and with landscape art, I shall have occasion to discuss the change that took place during the Brown Decades in our attitude toward the land. Henry George gave this change a political and economic underpinning. Rediscovering the physiocrat's notion that all wealth comes ultimately from the land-and whoever denies this denies the solar and chemical and organic basis of life-Henry George was struck by the contrast between the free lands of California, where he had settled, and the misery that attended the individual pre-emption of the land in the East. There was no lack of timeliness in Henry George's observations. In Our Land and Land Policy, National and State, he said: "We are giving away our lands in immense bodies, permitting, even encouraging, a comparatively few individuals to monopolize the land to which the coming millions of our people must look for their support. In a few years, the public domain will all be gone; in a few years more the homestead law and the pre-emption law will serve but the purpose of reminding the poor man of the good time past. We shall find ourselves embarrassed by all the difficulties which beset the statesmen of Europe-the social disease of England and the

seething discontent of France." His first pamphlet on this subject was published in 1871. George argued that control of the land by individual monopolizers meant ultimately a burden upon all subsidiary activities and processes, and he held up the logical alternative to this condition, in the form of land nationalization or the single tax. Without such a revolutionary change, George pointed out that further "progress" meant a more and more demoralizing poverty, possibly a catastrophe.

The general argument against the individual appropriation of rent for the use of common utilities does not apply only to water power or coal or rentable space: it applies equally to other common factors like the social heritage itself, and is therefore true of monopolies in the form of patents for inventions. Perhaps George's chief defect was that he wished to slip in a revolutionary proposal without touching any of the other dominant activities of American society; whereas, once his principle was admitted, many other institutions and ways of life besides the rent of land and its appropriation would have been affected. He wished to produce by political sleight-of-hand what was in fact a moral conversion. But George's awareness of the political importance of the land, his clear perception in 1870 of dangers that were to be fully demonstrated by 1890, and the stir that he made in the torpid political and economic thought of his day by introducing into it a vital idea-all this cannot be discounted. Henry George challenged the complacencies of bourgeois economics in terms that the bourgeois economist could partly understand. Less than fifteen years after George's Progress and Poverty (1879) was published, Professor Frederick Turner pointed out some of the social and economic implications of the passing of the frontier. From this point on, any one who ignored the rôle of the land either in American history or in our current institutional life was guilty of convenient forgetfulness: the fact was established.

More popular even than Henry George, in the closing years of the Brown Decades, was Edward Bellamy, the author of *Looking Backward*, the best of a series of strange utopias that those uncertain days brought forth. In Bellamy, who was born in Chicopee Falls, Massachusetts, in 1850, the New England strain was running out, perhaps, but it was still active: his literary affiliations were with Hawthorne and Emerson. His chief work, *Looking Backward*, came after he had served as a newspaper editorial writer and written a few novels. In writing it, he had, on his own confession, no idea of

attempting a serious contribution to social reform: the idea was a "mere literary fantasy, a fairy tale of social felicity. There was no thought of contriving a house which practical men might live in, but merely of hanging in midair, far out of reach of the sordid and material world of the present, a cloud palace for ideal humanity."

Looking Backward became, almost in spite of itself, one of the most important political pamphlets of the Brown Decades: its successor, Equality, is little more than an economic and social treatise, which amplified the points left undeveloped in the first book. This was one of the first attempts to think out a logical conclusion for the processes of mechanical organization and monopoly, for the national expansion of great industries like steel and the stockyards, that were taking place under men's noses. Bellamy's picture was naturally derided by the hardboiled Marxians of his time as an unimportant piece of utopianism: had not Engels demolished that sort of thing? The curious fact remains that Bellamy's society reminds one, not of an impossibly abstract and ideal humanity, but of the United States during its late period of "prosperity" combined with Soviet Russia as it operates and envisages itself today. Bellamy prophesied telephonic broadcasting and the abolition of the corset: he pictured a nation conscripted for work, as in Soviet Russia today, and he had a foreboding of at least the physical outlines of the modern woman: if one is amazed by Bellamy's utopia now it is not because he was so wild but because he was so practical, so close to actuality.

In short, Bellamy's utopia was a real looking forward: it showed both the promise and the threat of actual conditions. More realistically than Henry George, Bellamy saw that one could not have land nationalization or its equivalent without a similar planned and resourceful use of all the other instrumentalities of production and consumption; or rather, that socialization in one department was incompatible with unlimited individualism in every other. Progress and Poverty and Looking Backward, both realistic, both forward-looking, were part of the essential atmosphere of the Brown Decades. After one has reckoned with the actual depression and sordidness, one must not forget the measure of intellectual hope that these men stirred in their more generous-minded contemporaries. Riots, strikes, lockouts, assassinations, brutalities, exploitations, marked the economic life of this period: at no period in American history has the working class in America been more desperately enslaved. The conditions that exist today in the milltowns of New England and

the South, or in the steel towns and coal fields, were during the Brown Decades almost universal. But ideas were stirring; and if the dawn itself proved false, the hope it offered nevertheless was real.

Now that we begin to appraise the Brown Decades as a whole we can see why what was positive and creative in this period usually worked against the grain of its major activities. Its best works were often produced in obscurity, like the paintings of Albert Pinkham Ryder and Robert Loftin Newman, like the poems of Emily Dickinson, or the philosophic reflections of Charles Peirce. For this reason, I originally called this era in American culture the Buried Renaissance: the laval flow of industrialism after the war had swept over all the cities of the spirit, leaving here and there only an ashen ruin, standing erect in the crumbled landscape. The notion that there was anything of value buried beneath this debris came tardily, for what our elders pointed to with generous delight was obviously not very valuable.

In our haste to remove the debris, unfortunately, we have already destroyed much that was precious in the Brown Decades; and unless we rapidly recover a little common sense we shall doubtless destroy much more. Every work in the period, even the magnificent productions of Richardson, has been treated as an out-and-out monstrosity—a habit which points to the fact that the desecrators are aware of epithets but impervious to realities. The houses that Richardson built for John Hay and Henry Adams in Washington and his even more important Marshall Field building in Chicago have all been torn down during the last five years: his best residence in Chicago, probably his best anywhere, the Glessner house, will be saved only by the generous bequest which will turn it into an architects' club.

The shingle houses that Richardson first established on such sound lines are in even greater danger, for they are built of wood: yet they brought an indigenous comeliness into the suburbs of the eighties, and nothing we have done since, with the exception of Mr. Frank Lloyd Wright's prairie houses, has touched so authentically the very colour and atmosphere of the landscape: incidentally, they represent the peak of spaciousness and comfort in our American domestic facilities. Beside these houses the best formal "colonial" work, which we think of as our own only because we ignore similar

buildings as far apart as England and South Africa, is manifestly a foreign and unassimilated style. Just as factory buildings were once automatically called ugly, so a snobbish fashion of thought automatically called the architecture Richardson instituted "monstrous," and it was condemned as a social error without being examined as an aesthetic object. One trembles in Cambridge, for example, over the fate of Austin and Seaver halls, in the face of the growing popularity of such heavy caricatures of colonial architecture as the Chemistry Building and the Widener Library, or such pasteboard imitations as the Business School—all of which inept productions are supposed to have added to the architectural harmony of Harvard.

In other fields, however, a great deal of material remains, preserved by the inertia of attics and libraries; and our main concern must be to see that it is not permanently neglected; for the complete history of the times, on its social and cultural and intellectual side, has hardly been approached by even the best of the current accounts. Some of the finest wood engravings of the seventies and eighties are buried in American magazines like *The Century* and *Harper's Weekly*; and if the residue of Eakin's paintings were preserved by his widow until the taste of critics and picture-buyers again caught up with him, we owe that splendid treasure to luck and piety as much as to popular understanding: many of his subjects could not bear to have his portraits around the house.

The manuscripts of Emily Dickinson have been guarded with a jealous but not intelligent care. The principal custodian of them has even alluded to the possibility of destroying some of them, and has not greatly increased one's optimism by dismissing it-as if it were ethically within the province of any individual or family to exercise such discretion over the work of a writer who belongs, we now definitely know, to the world. The legend of Emily Dickinson's love affair has been allowed to grow like a fungus, for lack of a little decent directness in revealing it: but for the suspicious air of concealment, no legend could have grown. The same holds true of some of the letters, if not the manuscripts, of Charles Peirce, an unconventional soul, who followed his own track, and whose reflections on life and the moralities were not merely out of harmony with those of his own generation but are equally remote, apparently, from the notions held by some of the present possessors of his letters. Even the publication of Peirce's collected papers has lagged for lack of a few thousand dollars to guarantee the initial expenses of publication.

The Brown Decades did better than this by their own: Richardson's biography, a compendious description and criticism of his buildings, appeared within a few years of his death: another sumptuous monograph followed Fuller's death in the eighties, and a similar biography, by Miss Harriet Monroe, capped Root's untimely end. Unfortunately, the existence of these works perhaps discouraged others from going over the same ground; and it is now doubtful if a satisfactory first-hand account of Richardson's life can be pieced together, so few are the survivors who could have known him. And how much has already disappeared! The possibility of recovering a complete account of the life and personality of John A. Roebling seems to grow more and more remote. If an engineer whose main life is lived in public can so easily disappear, the obscure inner existence of a Ryder must be even more inaccessible to usunless one boldly gather the story from his paintings. When the shallow fashion of de-bunking comes to an end, here is obviously a whole gallery of interesting personalities to work upon-if only the necessary material itself is available. Louis Sullivan's life was only partly told by himself: it leaves off at the critical moment of the World's Fair; and a complete monograph on the man and his work would be a precious key to the Brown Decades and the subsequent years.

There is a danger that both the works and days of the principal figures of this period will vanish before either has been properly evaluated or fully assimilated. This would be a grave gap in the story of American culture, and a real loss. If these artists and poets and thinkers are imperfectly remembered, our own generation may perhaps pride itself a little more completely on its "uniqueness"; but it will lose the sense of solidity that a continuous tradition, actively passed on from master to pupil or disciple, supplies. Enough perhaps if we at last realize that the Brown Decades, with all their sordidness, their weaknesses, their monstrosities, are not without their contribution to our "usable past." Through all the dun colours of that period the work of its creative minds gleams—vivid, complex, harmonious, contradicting or enriching the sober prevalent browns. The treasure has long been buried. It is time to open it up.

CHAPTER TWO

The Renewal of the Landscape

THE influence of the land is sometimes looked upon as significant only in primitive conditions of life. With the coming of "civilization," that is to say, trade and manufacture and organized cities, the land is supposed to diminish in importance. As a matter of fact, the importance of the land increases with civilization: "Nature" as a system of interests and activities is one of the chief creations of the civilized man.

In a state of complete savagery, man's presence on the land is scarcely visible: if he lives off the land, he nevertheless makes little impression upon it. An open clearing or a midden of bones and broken crockery is all that marks his presence. As man learns to control his environment, his relationship with the land becomes more complicated: the plough and the axe and the hammer and the spade leave their mark on every feature of the landscape, from mountain top to valley bottom: the river bank is straightened, the harbour is dredged, the hill is terraced, the torrent is bridged, the natural vegetation is improved or altered by new importations: the whole aspect of the earth is changed. City life does not diminish these relations: it rather adds new ones.

The bridge, the garden, the ploughed field, the city, are the visible signs of men's relation with the land; they are all means of ordering the earth and making it fit for all the varieties and modes of human habitation. If man's exploitation of the land becomes reckless, then the interdependence of soils and civilizations is demonstrated by the gradual sapping of the civilization itself: if it is intelligent and thrifty, as in the agriculture of China and the hydraulic engineering of the Netherlands, then the civilization has some prospect of endurance. To understand the land, to appreciate the landscape, to turn to it for recreation, to cultivate it for food and energy, to reduce it to an

27

orderly pattern for use—these functions belong more to an advanced state of society than they do to a primitive one. The continued culture of the land, and the culture of the mind through the land, is the mark of a high civilization.

Now, there are three main ways of modifying and humanizing the visible landscape. One of them is by agriculture and horticulture; it involves the orderly arrangement of the ploughed field and the wood lot, the meadow and the pasture, the road and the enclosure. When these functions are undertaken consciously and intelligently, as they were by the country gentlemen of England in the eighteenth century, for example, they lead to landscape design. The second method is by city development and architecture; and the third is by works of engineering—bridges, viaducts, canals, highroads, docks, harbours, dams. These three modes intermingle, and it is impossible to neglect one without spoiling the effect of the others. What is a beautiful city with bad drains, or a fine concrete highway in a barren landscape?

Before the Civil War, the works of engineering in America, though modest in scale, were among the most genial that had been produced: around New York alone the High Bridge, a viaduct which carried the Croton water across the Harlem River, and the Croton system itself, with its lane of verdure carried against the side of the hills, with occasional breaks, from Croton to below Yonkers, was as fine in design as anything that had been produced within the city. In other parts of the country, the canals with their quiet towpaths, their little toll houses and bridges and locks, were happy improvements of the landscape; so that the reckless filling up of some of these canals in our own time, with their conversion into traffic highways, a wanton abandonment of all their recreative possibilities for summer and winter, is a black disgrace to the regions in which such misuse has occurred. At all events, the engineering of the wood-and-water stage of industrial economy, the stage marked by the water wheel and the local mill, the dirt highway and river and canal transportation and numerous agricultural villages, was aesthetically effective in its results. At its worst, it still left the landscape clear; and at its best, it gave the land comeliness.

With the coming of coal and iron and railroad transportation in the fifties, the whole picture altered. Railroad cuts were made with no thought of their effect on the landscape; the use of soft coal as a fuel cast a pall over the whole landscape and covered the cities into

which the railroads nosed with grime; the slatternly habits of the pithead, the mine, the smeltery, and the blast furnace made their way into remote regions: indeed, wherever the railroad penetrated, it brought with it the characteristic paleotechnic disorder. Compare the actual physical landscape that surrounded the canal and the railroad: one is an elysium and the other is an inferno. The bargeman was notoriously a rough fellow, even poor Tom O'Leary who lost his dearie on the Erie Canal: but his vices did not extend much beyond the hailing distance of his oaths. Compare the coal-town of the post-Civil War Era, Altoona or Scranton, with the agricultural town of the canal and river era, Lancaster or Newburgh: the differences are no less striking than they are in a single community, like Bethlehem.

Rivers filled with refuse, inimical to fish and vegetation, flowed past cities covered with soot, which added to the industrial pollution of the streams by thus wasting, instead of utilizing for fertilizer, their human excrement. Mountain sides, first denuded of trees, lost their soil to the local torrents of spring that captured the run-off of the winter snows, now no longer retained and slowly seeping into the soil. Blight and waste came in with the boasted prosperities of the early industrial period: and at first the advantages and the defilements were so closely associated that people even prided themselves on the smoke of the thriving town—boasted, that is, of low efficiency in heating, wastage of carbon, and inability to make use of various useful gases and by-products! But this assault on the landscape was not confined to the industrial city: a parallel ruin went on in the countryside.

II

Millions of acres of arable land were thrown open at the two poles of Europe: America and Siberia. On to this land scrambled a horde of hungry people. Like men who had been starved too long of food, their impulse was to pluck ravenously at the first morsels that offered themselves, and not to concern themselves with either the manner in which it was cooked or its likelihood of eventually sitting well on the stomach. The result was a shiftless agriculture and an unstable rural life: two conditions that work against the slow permanent improvements that must be made in a cultivated landscape. Singlecrop farming was characteristic of the new lands that were opened up in the West and the South: a method unsound economically and

monotonous in its aesthetic results. Nathaniel Shaler tells in his autobiography how as late as the middle of the nineteenth century in Kentucky there was no systematic rotation or manuring, while as a result of timber-mining one half of the arable soil of Northern Kentucky became unremunerative to plough tillage. The same story was written everywhere: the destruction of the forest, the depletion of the soil, the extirpation of wild life, the upsetting of the natural balance of organisms. It was in vain that the American proclaimed to the heavens that he loved his rocks and rills, his woods and templed hills: his actions were a derisive commentary on those pious words.

Land-hunger is one thing, and love of the soil is another. It is scarcely an exaggeration to say that it was only in the Brown Decades that the second attitude began to replace the first. This was not a process of romantic idealization: romanticism of the most touching sort was not, apparently, incompatible with bad farming and the general desecration of the wilderness: who could be more romantic today than the taxpayer who votes to build a concrete highway to a lonely mountain-top-making accessible that which is valuable only through its inaccessibility? On the contrary, the new sense of the land was scientific and realistic; it was chiefly the work of a handful of naturalists, geographers, and landscape planners. In Uncle Vanya, Chekhov presents a dissolute doctor whose one real passion is the restoration of the landscape to its fullest uses: undoubtedly, there were minds of this order, suddenly alive to the holocaust and disaster that had attended the vast land colonization of the nineteenth century, throughout Western Civilization.

The United States had its share of these men: Henry Thoreau, John Burroughs, George Perkins Marsh, Frederick Law Olmsted, John Muir, Charles Eliot, Jr., Nathaniel Southgate Shaler. The leaders of this movement here, the poet Thoreau and the scientific observer Marsh, by birth belonged to the Golden Day; but their influence did not begin to be effective until after the Civil War. The concern for the soil of America, as distinct from its republican institutions, was one of the genuine marks of the Brown Decades. In the compendious survey of the country which closed the period, the book Shaler edited on the United States, the land was for the first time given its due place.

As the foundation of this whole movement, one cannot overestimate the part played by Thoreau: for unlike the artificers and

decorators, he liked nature plain, and he showed the rewards that awaited a fresh attentive study of our local qualities and capacities. As a national influence, he belongs more properly to the period after the Civil War than to the days in which he lived: up to the time he died, only two of his books, *Walden*, and *A Week on the Concord and Merrimack Rivers*, had been published. Thoreau was not a naturalist like Audubon nor a scientist like Agassiz and Gray: his mission was not to find out the habits of wild creatures but to acclimate the mind of highly sensitive and civilized men to the natural possibilities of the environment: to make them see, smell, breathe, feel, touch the objects around them, and to find out how much nature could give that culture and civilization had left out of account.

This was different from the practical exploration of the wilderness that the pioneer was making: in fact, it was the diametric opposite. Any one who has looked for mushrooms knows how the pleasure and excitement of the hunt leads to a complete exclusion of every other trait of the landscape except the property of bearing mushrooms: the eve never rises from the ground, and it sees nothing except white umbrellas. The settlement of America was a largescale mushroom hunt: in the pursuit of a single object, urban sites, coal mines, gold, or oil, every other attribute of the landscape was neglected. Thoreau concentrated on the totality of the natural environment-which, one may say almost without paradox, was the part that his contemporaries had forgotten. He observed the fields around Concord and knew when the wild flowers would bloom in them; he dallied with the fish in the river and boated slowly up the quiet waters; he took trips through the Maine woods; he explored the seashore and waded through the sands of Cape Cod; in short, he tasted the land.

This exploration did not lead to anything; it was not a preliminary step but an enjoyment in itself. Thoreau was not of course alone in testing these pleasures: but he was perhaps the first person in the country to devote himself to it systematically, and to touch every part of the natural environment with equal fervour and gusto. He not merely knew the land: he had also a political sense as to what should be done about it, and pointed out the necessity of following the noble example of the kings of England, in publicly preserving the wild places of the continent for our own enjoyment, lest, in the ruthless quest of possessions, men should lose a greater part of what

was worth possessing. In Thoreau, the landscape was at last entering into the American's consciousness, no longer as potential quarter sections, no longer as "territory" dedicated to a republican form of government, but as an inner treasure—one thing for the mountain man and another for the river man and a third for the beach man. The Currier and Ives prints of the forties and fifties show, in their naïve way, a similar interest: a definite school of landscape painters. the Catskill School, had at least a sense of locality, if only a feeble power of personal absorption and transmutation; and in the paintings of George Inness this feeling was more deeply expressed. Thoreau's influence was felt by the country boys around him. One of them, Myron Benton, in Dutchess County, New York, took a trip down the Webutuck in imitation of Thoreau and wrote rural verses: another, John Burroughs, devoted a good part of his life to writing upon nature and country life-proving himself Thoreau's disciple (despite the superior personal magnetism of Whitman), even when he criticized his master for inaccuracies of observation.

Thoreau died during the Civil War; but the ripples of influence spreading from his positive and self-contained personality are still expanding. In our own day one of the most able advocates of regional planning is Mr. Benton MacKaye, an avowed disciple of Thoreau. In *The New Exploration* Mr. MacKaye attempts to show the implication in terms of modern techniques and objectives of the sort of life and polity for which Thoreau had built the ideal framework. In his essay on "Civil Disobedience" Thoreau outlined the policy of noncoöperation, that powerful weapon which Mahatma Gandhi has used to effect the paralysis of mere physical force. Thoreau's moral force, his political acumen, cannot be separated from his studies of nature: the man was a whole, and his thought cannot without undue violence be dismembered. To fancy that Thoreau has been made irrelevant by the Machine Age is to lose sight not merely of the point of his criticism, but of his actual historical position.

The naturalistic and biological influences which Thoreau expressed were, one must remember, later in getting started than the world of mechanism in which we now move: Descartes antedated Goethe, the first modern philosopher with a well-grounded intuition of the web of life, by almost two hundred years. Instead of looking upon Goethe and Thoreau as survivors from the past, to be finally obliterated by the relentless spread of a venal and mechanical civilization, it is perhaps more accurate to think of them as

the forerunners of a fresh line of effort and action. It was, in fact, the reckless waste of life, the unbalancing of natural conditions, and the destruction of natural resources which followed the introduction of the machine and the migration of peoples that made imperative a new philosophy of nature: so long as nature was unspoiled we needed no philosophy.

Thoreau, more than any one else in America, acknowledged this need and gave expression to a positive philosophy. His Walden, his A Week on the Concord and Merrimack Rivers, his Cape Cod, to say nothing of his journals, were both directly and indirectly the starting point of a whole movement. At a time when the cockney and the pioneer were dominant, both with a strong impulse against any fine use of the natural environment, Thoreau helped to set the tide moving in a contrary direction. He did not work alone; but his words must be put alongside the practical works and the concrete political programmes which followed during the Brown Decades: it is doubtful if these latter would have found themselves so quickly but for the help and popular understanding which his writings gave.

"Who would not rise to meet the expectation of the land?" That was a new challenge in the United States, where, at the opening of the Civil War, the expectations of political democracy, the expectations of bourgeois freedom, the expectation of equal opportunity and success under a system of private monopoly, had already grown sour and hopeless.

III

For the pioneer, the land existed to be acquired, to be devoured, to be gutted out, to serve for a hasty turnover of profit. The conception that each man had a legal right to do as he would with his own far outbalanced any sense of the common weal. George Perkins Marsh was the first man to sense the destruction that was being wrought, to weigh its appalling losses, and to point out an intelligent course of action.

Marsh was one of that group of capacious, perceptive minds who were the miracle of American scholarship before the Civil War. He was born in Vermont in 1801: Hiram Powers, the sculptor, was a contemporary of his in Woodstock, and one of Marsh's first memories went back to drives with his father in a two-wheeled chaise over the hills, his father stopping occasionally and pointing out the topograph-

ical features. Marsh was admitted to the bar in 1825; though he had a brisk practice, he also went into various business ventures which terminated unsuccessfully in the forties; and he went to Congress for a term during Polk's administration and protested against continuing the Mexican War. In 1850 he was appointed minister-resident at Constantinople; and though relieved of his post by the next administration, he went back into the service on Lincoln's appointment as minister to the new kingdom of Italy, and remained there till his death in 1882.

Neither Marsh's legal activities, nor his diplomatic career, nor his tremendous facility with languages-he was master of six European living ones, and had a cursory acquaintance with Arabic and Persian-nor his works upon the history and development of the English language, which he published before the Civil War-none of these activities and abilities would account for his chief work on geography: but they were sufficiently important to give him his reputation among his contemporaries, and the biographical sketch of him in the National Cyclopedia barely mentions his geographical contributions. Marsh had a voracious mind and large capacities for experience. Despite his isolation in Vermont, by 1849 he had acquired not merely an excellent library but an admirable collection of prints, which latter were unfortunately destroyed by fire at the Smithsonian Institution. The years he spent travelling in Asia Minor, in Egypt, and in Italy were important for his later intellectual development: not less so because a lecture tour he had made through the Middle West in the fifties strengthened the contrasts and similarities between the old lands and the new. Marsh turned to a subject that had hardly yet been opened up for scientific study: the earth itself as the home of man. In 1864 he published his own contribution to the subject: Man and Nature.

"The object of the present volume is," said Marsh in his Preface, "to indicate the character and, approximately, the extent of the changes produced by human action in the physical conditions of the globe we inhabit; to point out the dangers of imprudence and the necessity of caution in all operations which, on a large scale, interfere with the spontaneous arrangements of the organic or the inorganic world; to suggest the possibility and the importance of the restoration of disturbed harmonies and the material improvement of waste and exhausted regions." Marsh's subject was the planet itself; and he had mastered, with a rare degree of thoroughness, the existing literature

on the subject; but his implicit point of reference was the United States: the country could draw its own moral.

"All human institutions, associate arrangements, modes of life," Marsh pointed out, "have their characteristic imperfections. The natural, perhaps the necessary, defect of ours, is their instability, their want of fixedness, not in form only, but even in spirit. The face of physical nature in the United States shares this incessant fluctuation and the landscape is as variable as the habits of the population. It is time for some abatement in the restless love of change which characterizes us, and makes us a nomade rather than a sedentary people. We have felled forest enough everywhere, in many districts, far too much. Let us restore this one element of material life to its normal proportions and devise means for maintaining the permanence of its relations to the fields, the meadows, and the pastures, to the rain and the dews of heaven, to the springs and rivulets with which it waters the earth. The establishment of an approximately fixed ratio between the two most broadly characterized distinctions of rural surface-woodland and ploughland-would involve a certain persistence of character in all the branches of industry, all the occupations and habits of life, which depend upon or are immediately connected with either."

These specific deductions and recommendations are not the most important part of Marsh's work. The fact was that, despite the work of Montesquieu in the eighteenth century, and, more definitely and scientifically, Alexander von Humboldt, Guyot, and Ritter in the nineteenth, Marsh's conception of human geography was still radical and strange. He treated man as an active geological agent. Like other agents, he could upbuild or degrade. One way or another, however, he was a disturbing agent, who upset the harmonies of nature and overthrew the stability of existing arrangements and accommodations, extirpating indigenous vegetable and animal species, introducing foreign varieties, restricting spontaneous growth, and covering the earth with "new and reluctant vegetable forms and with alien tribes of animal life." Geography, for Marsh, embraced organic life. Man, during the nineteenth century, had played the part of an irresponsible, destructive being-as he had, to his own misfortune, in classic times. It was time for him to become a moral agent: to build where he had destroyed, to replace where he had stolen-in short, to stop befouling and bedevilling the earth.

The only serious lack in Marsh's book was his failure to consider

the exhaustion of natural resources. In excuse, one must remember that the use of coal came in slowly in America, and the opening up of natural gas and petroleum wells came after the Civil War: so that the destruction of the forest far outweighed any other current evil. Ten years after the first publication of Man and Nature, Marsh published a revised edition, coincident with its translation into Italian: two years later it went into a third edition. The book was an influence both at home and abroad. Since Marsh's time the partnership between man and his environment has become a commonplace of geography, and the work done in human ecology has turned the subject from a barren descriptive science into a dynamic interpretation of basic social and economic relationships. All these scientific results add to Marsh's credit; but he was interested above all in the practical application of his theories, and his book, one of whose sections is headed "Importance of Physical Conservation and Restoration," was the fountainhead of the conservation movement.

The year that Marsh's book came out marked a turning point in public policy: the National Government ceded Yosemite Park to California, along with the Mariposa Grove of Big Trees, on condition that it be maintained as a public park. Marsh's book doubtless helped to crystallize the opposition to the Government's disastrous land policy. In 1872, our first National Park, Yellowstone, was set aside; and in 1880, the Hot Springs Reservation, which had been nominally retained by the Federal Government, was bounded and dedicated: before the Brown Decades came to an end, the Sequoia Park had been established, and the dedication of wild lands to forestry and recreation went on with gathering acceleration.

No one man was responsible for this work; no one intellectual influence can be singled out. Thoreau had in *Walden* advocated the preservation of the wild spaces, as a habitat for man's soul as well as for the wild creatures themselves. Marsh's writings gave this proposal an extra economic and geographical justification, and the fact that Horace Cleveland quoted from Marsh in his essay on "Forest Planting on the Great Plains" shows that the moral of his book was not lost on his contemporaries. But the movement which was gathering headway in the sixties received a powerful impetus from the work of an experimental farmer and landscape planner: Frederick Law Olmsted. That an effort to make reparations to nature and to establish a friendly basis for intercourse should have made any headway at all against the reckless gambling instincts of

the post-war period was due to the fact that Olmsted gave to Thoreau's and Marsh's principles the benefit of an active demonstration. The conservation movement and the parks movement are among the chief bequests of the Brown Decades—and they were never so important before as they are in our own day.

IV

If the countryside ran down, as the result of the misappropriation and misuses of the land, the city was no less debauched. This was not for lack of good precedent. The original New England village had been planned as a definite communal unit: the pattern of common, school, church, town hall, inn, and houses had been worked out in relation to the need to exercise the direct political and economic functions of the community, and the result was as fine, on its limited scale, as anything the Old World could show. But the precedent was ignored. The greed to own land and profit by its increased increment outweighed the desire to build permanent and useful habitations.

While every city from the beginning of the nineteenth century looked forward to continued growth at an accelerating pace, the place of the city in the social economy was neglected, and its aesthetic aspect was forgotten. The American method of building cities during the nineteenth century was well pictured by Horace Cleveland, who, with Olmsted, was a pioneer landscape architect. His criticism could not be improved upon today.

"Before the introduction of the railroads," Cleveland pointed out, "the settlement of the West was by a process of accretion, a vanguard of hardy pioneers keeping ever in advance, enduring hardships and privations which could only be borne by men unaccustomed to the ordinary comforts of civilization. The better classes who followed were necessarily governed to a greater or less extent on whatever further improvements they attempted by the works of their predecessors, and nothing approaching to scientific or artistic designs or arrangements of extended areas, based upon wise forethought of future necessities, was attempted. The government survey of public lands formed the only basis of division, the only guide in laying out country roads or the streets of proposed towns; and if the towns grew into cities, it was simply by the indefinite extension of straight streets, running north, south, east or west, without regard to topographical features, or facilities of grading or drainage, and still less

of any considerations of taste or convenience, which would have suggested a different environment. Every western traveller is familiar with the monotonous character of the towns resulting from the endless repetition of the dreary uniformity of rectangles which they present; yet the custom is so universal and offers such advantages in simplifying and facilitating descriptions and transfers of real estate that any attempt at the introduction of a different system encounters at once a strong feeling of popular prejudice."

The man who challenged this prejudice most successfully, and who almost single-handed laid the foundations for a better order in city building, was Frederick Law Olmsted. When Charles Eliot Norton said of him, towards the close of his career, that of all American artists he stood "first in the production of great works which answer the needs and give expression to the life of our immense and miscellaneous democracy" he did not exaggerate Olmsted's influence. From Central Park in New York to the Golden Gate Park in San Francisco, Olmsted dotted the country with parks: in the last twenty years of his career four town sites and twelve suburban districts were laid out by him. If, as Olmsted pointed out, the movement towards urban parks was almost an instinctive one throughout Western Civilization, after the middle of the nineteenth century, in reaction against the depression and misery of the industrial city, Olmsted gave it a rationale.

This remarkable man was the son of a Hartford merchant; and he was born in that city in 1822. In his youth, he boarded around with various ministers, to obtain his formal education: but a weakness in the eves kept him from books, and he formed the habit of rambling about the countryside by himself. In 1842 he attended lectures at Yale; but the most important part of his early education was the three pilgrimages each a thousand miles or more that he made with his father, by horse, stage-coach, and canal-boat. The landscape itself was the first great influence on his mind: then came the popular writers of his day, Emerson, Lowell, Ruskin-that Ruskin whose paeans to Nature, the voluptuous worship of a starved voung man, made the better part of Modern Painters more useful as a guide to scenery than to painting. As a boy he picked up in the public library two eighteenth century books that influenced him profoundly: Sir Uvedale Price's The Picturesque and Gilpin's Forest Scenery. He always treasured them.

Before settling down, he sailed in the forecastle to Canton (1843):

the physical misery and brutality sated only temporarily his lust for travel, but he spent the ten years from 1847-1857 as an experimental farmer—not before he had served an apprenticeship with one of the best scientific farmers in New York State. In 1850 Olmsted made a tour of Europe, part of which he described in a book published in 1852, *The Walks and Talks of an American Farmer in England*. After this he made three journeys in the South: two through the slave States and one in Mexico and California. Olmsted had none of the prepossessions of the Abolitionist, and his report on the state of the South before the war is one of the most valuable first-hand Northern documents we possess: his very temperate picture of the beating of a young negress, calmly, coolly, by a matter-of-fact overseer was far more damning than the violent melodramatics of Mrs. Harriet Beecher Stowe. Olmsted's account of the ante-bellum South has well been compared with Young's picture of France before the Revolution.

This combination of wide travelling, shrewd observation, intelligent reading, and practical farming formed Olmsted's education: it was plainly a far more substantial discipline than the courses he had taken intermittently at Yale, never long enough to receive a degree. This was the American education at its best—when dispersed and fitful, lacking an inner core, it created the shiftless and all too adaptable pioneer: but, when integrated, as it was in literature by Whitman and Melville, in economics by Henry George, and in landscape design by Olmsted, it must be compared to the very best culture of the Renaissance for an equivalent. The proof of its efficacy lies in both the men and their works.

Meanwhile, Olmsted had gone into the publishing business with G. W. Curtis, and in 1855 and 1856 had edited the ill-fated *Putnam's Magazine*. What would he do next? Within two years he had found his centre. In 1857 he accepted the position of superintendent of Central Park; and the following year, having obtained the permission of his superior, the author of the first plan of Central Park, he joined with Calvert Vaux in submitting anonymously a new design for the Park—a design which won the prize. From that time on his work, as the saying is, was cut out for him.

The development of the farmer into the landscape architect took place in the healthiest manner possible. On his farm in South Side, Staten Island, Olmsted had entered fully into the rural life, serving on school committees, helping improve the highways, raising prize crops of wheat, turnips, fruit, importing an English machine, and

establishing the first cylindrical drainage tile works in the country. He had found in travelling through the remoter parts of the country that carelessness or ingenuity in placing barns, stables, outbuildings, laundry yards, or in providing for conveniences to bring in supplies and carry out wastes, could help or hinder a farmer's life: even matters like the placing of a kitchen garden, or the determination of outlook or inlook, had a direct effect. Olmsted acquired a reputation among his neighbours for good judgment in these matters. He would be called in to give advice. Gradually his fame spread. Downing's partner at Newburgh, the young Englishman, Calvert Vaux, had the intelligence to see Olmsted's possibilities. To say that Olmsted was not unprepared to plan and build Central Park hardly does justice to his qualifications: perhaps no one could have been better prepared.

V

The planning and planting of Central Park was the beginning of a stormy but fruitful public life. Born of the cosmopolitan knowledge and rural tastes of William Cullen Bryant, who viewed with alarm the encroachment of buildings on his country walks, Central Park was in 1851, when it was conceived, a monstrosity, a challenge, an affront.

Up to this time, with the exception of the New England commons, and a few parades like the Battery in New York and the Battery in Charleston, South Carolina, there was nothing that could be called a park in America. The park was an aristocratic symbol of the Old World: it cost money and it withdrew building lots from speculation: some opponents even believed that the pleasure ground would be used only by ruffians and gangsters, who would rob decent citizens or drive them out by their bawdy antics: others thought that the park would never be reached or visited by the common people. Even those who favoured the reservation of the land distrusted any efforts to improve it. Landscape architecture was an effeminacy: what was the country coming to?

One by one these objections were silenced, these anxieties allayed, these prejudices removed: but the process was a tedious one, and it was aggravated by the fact that the park was a convenient ball to kick around in party politics. The greater part of the construction and planting was done in the four years between 1857 and 1861: eight hundred acres, chiefly rocks, swamps, barren pasture, were

eventually transformed into lakes and meadows, wooded heights and grottoes, a fine mall and promenade, and a highroad and pedestrian walk system which, until the metropolis reached its present pitch of congestion, was ample to all the requirements of its use. But Olmsted had done something more than design a park, battle with politicians—he resigned at least five times—struggle with insolent and rascally city appointees, and protect his plantations against vandals: he had introduced an idea—the idea of using the landscape creatively. By making nature urbane he naturalized the city.

The American, a romantic by inheritance, had been stunned by large and awful phenomena of Nature: the Mammoth Caves of Kentucky, the sinuous length of the Mississippi, the high peaks of the Rockies. Olmsted taught him he could be pleased with a meadow and a few sheep-or a bare outcrop of schist with a summer house facing a small grove of pines. The landscape park had a right to exist by itself without museums, rinks, theatres, side-shows, or any of the other paraphernalia of "civilized life": its whole justification lay in the fact that it promoted the simple elementary pleasures of breathing deeply, stretching one's legs, basking in the sun. Such a notion was as deep an affront to the prevailing ideology of business as Herbert Spencer's defence of billiards: it seemed as crazy as the new landscapes of Monet, which sprang out of the same natural and healthy impulses. Olmsted fought for this idea: he gave it a setting: he provided it with a rational justification. The landscape could be enjoyed, and the enjoyment could sometimes be heightened by the deliberate efforts of the designer. This notion seems ridiculously self-evident today; at the time Olmsted began his career neither the art nor its object were acknowledged. But the idea took on. Forest Park, St. Louis; Fairmount Park, Philadelphia; Prospect Park, Brooklyn; and Franklin Park, Boston, soon followed.

But Olmsted did something more than introduce the cultivated landscape as a means of urban recreation: those who have sought to protect this aspect of his work, particularly in Central Park, have too often forgotten that in 1870 he had laid down the lines of a complete park programme on excellent social and hygienic grounds. By means of shade trees to line the street, wider malls and promenades and open squares, and a system of small recreation parks meant chiefly for the active forms of sport, he sought to make particular functions, not available in the landscape park because of either its character

4I

or its remoteness, play a part in the everyday life of the city. Moreover, he saw that the park could not be treated as an afterthought or a mere embellishment of a utilitarian plan otherwise complete.

"A park fairly well managed near a large town," he pointed out, "will surely become a new centre of that town. With the determination of location, size, and boundaries should therefore be associated the duty of arranging new trunk routes of communication between it and the distant parts of the town existing and forecasted. These may be either narrow informal elongations of the park, varying from two to five hundred feet in width and radiating irregularly from it, or if, unfortunately, the town is already laid out in the unhappy way that New York and Brooklyn, San Francisco and Chicago, are ... then we must probably adopt formal parkways. They should be so planned and constructed as never to be noisy and seldom crowded, and so also that the straightforward movement of pleasure-carriages need never to be obstructed, unless at absolutely necessary crossings, by slow-going vehicles used for commercial purposes. If possible, also, they should be branched or reticulated with other ways of a similar class. . . . It is a common error to regard a park as something to be produced complete in itself, as a picture to be painted on a canvas. It should rather be planned as one to be done in fresco, with constant consideration of exterior objects."

In short, by 1870, less than twenty years after the notion of a public landscape park had been introduced in this country, Olmsted had imaginatively grasped and defined all the related elements in a full park programme and a comprehensive city development. Between 1872 and 1895 he had a man-sized share in making this programme effective; but, despite the great improvements that have gone on in Washington, Chicago, Kansas City, Boston, there is not a large city in the country that has caught up with him.

Two final features in Olmsted's actual planning remain to be commented on. One was his respect for the natural topography. This was unusual enough in current American thought to make it the chief base of a suit for payment brought by his erstwhile superior, General Egbert Viele, who was also a Central Park competitor. Olmsted carried this respect from the park proper into the design of country estates and suburbs: he implanted it in pupils and collaborators like Horace Cleveland and Charles Eliot, Jr., to say nothing of those who succeeded to his practice. This utilization of the natural features of the landscape accounts, along with generous tree planting,

for the surviving charm of the old-fashioned suburban development: such charm as was achieved, notably, in Roland Park, Baltimore, in the nineties.

A second characteristic of Central Park's design is perhaps even more important: the separation of the footways from the roadways and bridlepaths. It is only at inescapable intervals that these two different kinds of traffic artery even parallel each other: wherever there is the slightest possibility, Olmsted separates them by means of the overpass and underpass. Three considerations must have been in his mind: the safety of the pedestrian, the convenience of the driver, and the desirability of avoiding bustle and noise in parts of the city designed for relaxation and repose. In our own day, this essential principle has been carried a step further: into the residential neighbourhood. The best European and American town planners make the same differentiation between wheel and foot traffic as Olmsted did: indeed, in Radburn, New Jersey, Mr. Henry Wright has laid out a town in this fashion, with an internal park system completely out of the range of traffic. This modern design only adds to one's appreciation of Olmsted's power as an inventor. He had, without doubt, one of the best minds that the Brown Decades produced.

Olmsted lived to a ripe age. His crowning task was the design of the World's Fair at Chicago; two years later he retired from practice, and in 1903 he died. His art was brilliantly carried on by Charles Eliot, Jr., in his comprehensive plans for the Metropolitan park system of Boston—another great work which belongs to the period. Eliot accentuated Olmsted's respect for the indigenous flora and for our characteristic landscape. "Our country," he pointed out, "has her Russias, her Silesias, her Rivieras, and many types of scenery which are all her own besides. Are we to attempt to bring all to the English smoothness? Rather let us try to perfect each type in its own place."

One can regret nothing about either Olmsted or Eliot, except the fact that their ideas and achievements had not even larger influence than they did: had Eliot's warnings about the Maine coast been heeded twenty years ago, that handsome stretch of land from Newburyport to Portland need not have been turned into a middleclass slum: the beaches and headlands and heaths would have been preserved for common enjoyment, not desecrated by cottages and obliterated. But one cannot exaggerate the actual importance of

these men in the Brown Decades. Between them, they contributed more to the improvement of town and country than any dozen of their contemporaries. One may, indeed, seriously question if anything like their work has been relatively accomplished by later schemes of civic improvement—however elaborate their technique, however systematic their propaganda.

The point is that Olmsted attended to first things first. It is no exaggeration to say that the best city planning in America and Europe today centres around the park. That lies in back of the Garden City in England; and the preservation of open spaces characterizes the best Siedlungen of Germany. In differentiating the functions of the park, Olmsted was well in advance of the great Austrian city planner, Camillo Sitte. In enlarging the functions and uses of the park, as now exemplified from the great natural reservations of the Yosemite to the aboriginal antiquities of Mesa Verde, from neighbourhood playgrounds in parks, as in Chicago, to the chains of parks and parkways Westchester County has become famous for, the planners of the Brown Decades projected the goal and set the pace. They renewed the city's contact with the land. They humanized and subdued the feral landscape. Above all, they made their contemporaries conscious of air, sunlight, vegetation, growth. If we still defile the possibilities of the land, it is not for lack of better example.

VI

From the standpoint of art and nature, the gross inefficiencies of industrialism in its earliest stages were recorded in the general loss of form in the landscape and in the various works of man that appeared on it. Was industrialism synonymous with ugliness? Could steel be used as effectively as stone? Up to the middle of the nineteenth century there was no sure answer to these questions. Cast iron had been used in bridge construction in London with a little practical success, but with no decisive aesthetic results. The great glass and iron conservatory that Paxton built for the London Exposition of 1851 seemed to promise something; but a similar building, done a little later in New York, made the issue seem dubious.

A stunning act was necessary to demonstrate the aesthetic possibilities of the new materials, and to give people confidence in that side of engineering which the engineer had least concerned himself

43

with: its human and aesthetic effect. That act was the building of the Brooklyn Bridge—not merely one of the best pieces of engineering the nineteenth century can show anywhere, but perhaps the most completely satisfactory structure of any kind that had appeared in America. Coming into existence in an "era of deformation," it proved that the loss of form was an accident, not an inescapable result of the industrial processes.

The Brooklyn Bridge was the conception and achievement of two men: John A. Roebling and his son Washington, loyally supported by a corps of workers whose dangers and difficulties they intimately shared. In order to understand the monument itself, one must know a little of the characters and personalities that stood behind it.

John A. Roebling was born in Mühlhausen, in Thuringia, in 1806. He received his degree as an engineer at the Royal Polytechnic Institute in Berlin in 1826, after having studied architecture, bridge construction, and hydraulics: according to another biographical memoir, he studied philosophy with Hegel, "who avowed that John Roebling was his favourite pupil." After spending three years in obligatory service with the state, as Superintendent of Public Works in Westphalia, John Roebling emigrated to the United States in 1831. He had \$3000 in capital, and with a few fellow immigrants he founded the village of Saxonburg, about twenty-five miles from Pittsburgh. Here Washington Roebling was born in 1837.

Those were the days when the canal boats made their way through the Alleghenies by means of long overhill portages, the whole boat being pulled up the steep incline: the ordinary ropes used in such hauls frayed too quickly, and Roebling, whose first job was that of assistant engineer on the slack-water navigation of Beaver River, invented the steel cable to take the place of the weak hemp, and set up a cable manufacturing plant. Roebling had first seen a chain suspension bridge on a student tramp at Bamberg, and suspension bridges formed the subject of his graduation thesis. He presently invented a suspension aqueduct to make the portage of a canal over a river, using cable instead of chains; and he built it in record time. Another step brought him to the first cable suspension bridge at Pittsburgh in 1846. In 1849, he removed his wire-rope factory to Trenton, New Jersey. Without these wire-ropes vertical transportation would have come tardily and been more dangerous.

Roebling was the architect of his own plant; he designed every piece of machinery in it. Like many other early industrialists-

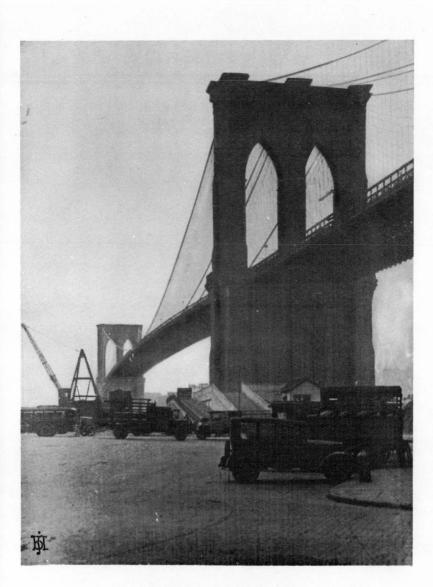

THE BROOKLYN BRIDGE by John A. Roebling and Washington A. Roebling. 1869–83.

people like Robert Gair, the paper-box manufacturer, for example— Roebling was a man of iron regularity and inflexible will: he would call off a conference with a man who was five minutes late. He disciplined his family, apparently, with equal rigour. Indeed, he anticipated the customs of Erewhon by regarding illness as a moral offence and penalizing it severely. But he was also an eager student of the new scene: in the midst of his inventions, he read Emerson and wrote a long Ms. volume entitled Roebling's *Theory of the Universe*. His son, after being graduated from the Rensselaer Polytechnic in 1857, assisted his father on the Allegheny suspension bridge. During the Civil War Washington built suspension bridges for the Union Army and did balloon observation.

Manhattan Island needed a bridge connection with Long Island to supplement the ferries. The bitter winter of 1866-67, which froze over the East River entirely and blocked ferryboat traffic, brought to a head the plan for a bridge, which John Roebling had broached in 1857. Nothing but Roebling's experience, his personal power, and his immense authority could have made this plan go through: a suspension bridge with towers 276 feet high and almost 1600 feet in the central span had not been built anywhere in the world: Stephenson, one of the great English engineers, had declared against this form. By 1869 the design had come into existence. Unfortunately, as a result of an accident on a ferry, John Roebling acquired lockjaw and died, leaving behind little more than the outline that Washington was to work up into their masterpiece, provided he had the power to grapple with the many unsolved problems of tactics and construction.

Washington Roebling's heavy bullet head reminds one a little of Grant's: what it lacked of his father's granite intellectuality was made up for by an equally massive will. Washington threw himself into the work. In 1871 the foundations for the Brooklyn tower were sunk. The building of the New York tower involved a drastic decision: should he waste a year and possibly many lives in digging to bed rock, or should he let the sand distribute the weight of the caisson on the uneven rock, a few feet away? He risked his reputation and his fortune on the decision; but he boldly faced the possibility of seeing his tower slip into the river. That possibility cannot have been absent from his mind until the cable and span were set.

The whole work of building the bridge was full of martial decisions, heroic sacrifices: the Civil War itself had been easier on Colonel

Roebling. A fire broke out in the caisson in 1871; and Roebling, who had spent more time than any other workman under pressure, and who directed the fighting of the fire, acquired the bends, or caisson disease. He retired to a house on Columbia Heights; his wife sat at the window with a telescope and reported on the progress of the work; and from his bed Washington Roebling directed every detail through letters. In 1872, fearing that he might not live to finish the bridge, and knowing how incomplete all the plans and instructions were, he spent the winter writing and drawing in all the details; and a year later, after a cure in Wiesbaden, he was still too weak to talk for more than a few minutes. Such heroism was not lost: the work went with a will: the little man on a white horse who commanded at Austerlitz never had a more devoted army. When the carriage for winding the cable was ready for trial, the first man to test it out was not a common workman, but Frank Farrington, the master mechanic. As many as 600 men were employed at one time. More than twenty were fatally hurt. Several succumbed to caisson disease. But the granite towers rose: the nineteen strands of cable were spun and anchored: the girders were riveted: the bridge stood. Cars and processions passed over it. It still stood.

VII

In 1883 the battle was over. The bridge was opened, and the Brooklyn Bridge took its place with the Eads Bridge at St. Louis and the Pont Garabit in France as one of the victories of modern engineering. But it was more than that. If any one doubts that a bridge is an aesthetic object, if any one doubts that it reveals personality, let him compare the Brooklyn Bridge with the other suspension bridges on the same river. The first bridge is in every sense classic. Like every positive creative work, the Brooklyn Bridge eludes analysis, in that its effect is disproportionate to the visible means, and it triumphs over one's objections even when it falls short of its highest possibilities.

I know no better appreciation of the bridge than Montgomery Schuyler's contemporary estimate. His whole appraisal, in *American Architecture*, is worth examination; but here is the nub of it. "It is an organism of nature. There was no question in the mind of the designer of 'good taste' or of appearance. He learned the law that struck its curves, the law that fixed the strength of the relation of its parts, and he applied the law. His work is beautiful, as the work of a ship-builder is unfailingly beautiful in the forms and outlines in

which he is only studying 'what the water likes,' without a thought of beauty.... Where a more massive material forbade him to skeletonize the structure, and the lines of effort and resistance needed to be brought out by modelling, he has failed to bring them out, and his structure is only as impressive as it needs must be."

Still, to say that the masonry might have been better is a different thing from being able to point out a single architect who might have done it better: the Richardson of 1885 might have qualified, but the young romantic architect of 1870 would, I fear, have made a horrible botch of it. Schuyler objected to the towers on the ground that the stone does not reflect the passage of the cables over the cushions on which they rest: but perhaps the greatest weakness is in the heavy rustication of the granite and the character of the stone cornice. But, particularly from the waterfront below, the piers are simple and convincing: at all events, they are the highwater mark of American architecture in the period between the design of the Washington Monument and the last phase of Richardson. The stone plays against the steel: the granite mass in compression, the spidery steel in tension. In this structure, the architecture of the past, massive and protective, meets the architecture of the future, light, aerial, open to sunlight, an architecture of voids rather than solids.

The Brooklyn Bridge was both a fulfilment and a prophecy. In the use of steel in tension it disclosed a great range of new possibilities: for the great mission of steel as a building material is essentially to span and enclose space, and to remove the inconvenient bulkiness of bearing walls and stone columns. In its absence of ornament, its refusal to permit the steel to be other than its own unadorned reality, the Brooklyn Bridge pointed to the logic and aesthetics of the machine; and it did this far more rigorously than its later rival, the Eiffel Tower in Paris, with its early Art Nouveau treatment of the base. Finally, the bridge existed in its own right, independent of its influences and potentialities, as a work of art, a delight to the artist and the poet, but equally well appreciated by the man in the street.

This was not the first work of engineering to be a work of art; but it was the first product of the age of coal and iron to achieve this completeness of expression. It needed a man of John Roebling's intellectual and philosophic capacities to conceive such a clean, untrammelled work; it needed Washington's courage to make it an actuality. Washington Roebling lingered on, once his great life-work was fulfilled, a soldier who had not the good fortune to die on the

battlefield: he collected minerals, and found life a little bitter and sardonic, according to reports, in the final years before his death in 1926. The firm that these men founded remains, too; but the heroism and the exploit of an untried problem has been diminished a little by routine: the new Hudson River bridge is doubtless a mighty work, but in comparison with the knowledge, experience, and mechanical powers available in 1869, the first is still the grander accomplishment.

If the lesson of the Brooklyn Bridge has been less potent in our engineering and architecture than it should have been, it is perhaps because our engineering schools have had a narrower conception of the engineer's vocation and culture than John Roebling had. Their simple factual statements, their respect for materials, their willing anonymity, are all fine qualities: in them is the making of a modern architectural vernacular. What is needed is an application of the method and attitude to something more than the bare mechanical problem. But the lesson of the Brooklyn Bridge has not altogether been lost: far from it. Dams, waterworks, locks, bridges, power plants, factories—we begin to recognize these as important parts of the human environment. They are good or bad, efficient or inefficient, by something more than quantitative criteria. The Roeblings perhaps never used the word aesthetics in this relation; but it was their distinction to have made it visible.

CHAPTER THREE

Towards Modern Architecture

WHEN the Civil War broke, architecture in America had been sinking steadily for a generation. Order, fitness, comeliness, proportion, were words that could no longer be applied to it: construction was submerged in that morass of jerry-building, tedious archaicism, and spurious romantisicm that made up the architectural achievement of the nineteenth century.

In the American farmhouses, the open fireplaces were already being boxed up to permit the more efficient operation of the iron stove, with its bulgy firebox and its ornamented legs; the simple Windsor chairs were retreating to the attic; the newly added porches were presently embellished with scroll-saw caprice; the fine proportions of wall and window were lost; and in the seventies, the mansard roof came, a crowning indignity. In the eastern parts of the country a chocolate-coloured sandstone replaced brick for dwellings, while cast-iron façade became the synonym for modernity in office buildings and department stores.

Partly under the pressure of higher land values, the rooms in city houses became narrower, as the house crawled over the remaining backyard space; and the interiors became dark and airless: instead of being two rooms deep, as was the practice in the provincial city, they were now three and sometimes four deep on the lower floors: in New York the very rich even achieved back-to-back houses. If the upper classes did not fully realize the dreadful housing problem that existed in the slums of every large city, to say nothing of many small ones, where a multitude of poverty-stricken people lived in damp, sunless, airless rooms, it was partly because they were gaily and rapidly building slums of their own, with almost as little concern for their own hygiene as they showed in their tenement properties.

Beauty was defined in terms of visible possessions: no house was

thought fit to live in that did not contain truckloads of ornament and bric-à-brac. With the steady growth of European travel among the richer classes, the acquisitive spirit throve; and presently the most fashionable architect of the Gilded Age, R. M. Hunt, was building French châteaux on Fifth Avenue, while less eminent rivals were designing Rhine castles for brewers, or weird combinations of architectural souvenirs—an eclecticism that reached its climax in a brilliant design, unfortunately not executed, for a building exhibiting a different historical style on every storey.

II

Before the Civil War no one had emerged who was capable of facing the problems of building in the spirit that Walt Whitman had sought to face those of poetic expression. There was a great deal of loose talk about an architecture appropriate to industrial society; many people thought that iron and glass were the coming materials; but it was almost useless to look to the architects of the day for leadership in such experiments: they had forgotten even to use stone or brick with any confidence and adroitness.

Nevertheless the early experiments in cast iron cannot be peremptorily dismissed. In New York in the forties James Bogardus, for example, had advocated cast iron as a structural element. In 1848 he built a five-storey building on Center Street with two outside faces made of it: the iron garniture was classic, but the windows were separated only by narrow columns, and an unusual amount of light was introduced. Bogardus circulated a pamphlet that showed by a diagram how this building would have looked with many of the uprights and interties taken away. He was eager to prove the value of a construction of iron posts and ties, all firmly knit together. The cast-iron fronts that were so common between 1860 and 1875 made no improvement on Bogardus's first building. While no single person deserves the honour for anticipating the application of iron to building, the credit must largely be divided between the designer of the market halls of Paris, Joseph Paxton in England, and Bogardus in America.

But before the Civil War the iron age had still to await its expression—if only because the first rolled beams to be used for floors were not cast until 1854, in Peter Cooper's mills at Trenton. Meanwhile, the brittle classicism of the eighteenth century had broken and the vernacular had become corrupt: nothing positive had taken

Towards Modern Architecture 51

their places. Looking back over the previous hundred years to the time when there was but one professional architect in the whole country, one might have made the generalization that, as the number of architects increased, the number of satisfactory buildings had proportionately diminished. The generalization might be misleading; but the facts were indisputable. Architecture, on the down grade since the twenties, had by 1860 touched bottom. Before every new manifestation of industrial society in cities and buildings, the word "ugly" became inescapable.

III

Within thirty years the situation had changed: the foundations of a new architecture had been laid. Architecture was reunited to city development in the boulevards and parks designed in New York, Baltimore, Boston, Chicago, Kansas City, and many other communities; and in the eighties, for the first time if one excludes such happy accidents as the mills at Manchester, New Hampshire, the problem of architectural comeliness was considered in relation to workers' housing in the well-intentioned but misdirected plans for Pullman, Illinois. Sculptors, painters, and workers in glass and iron appeared as accessory to the architect in a country where only sixty years before a poor wretch was released from jail since he was the only person in New York competent to cut the marble for the City Hall.

More than this: between 1880 and 1895 the task and method of modern architecture were clarified through the example of a group of American architects whose consistent and united efforts in this line antedated, by at least a decade, the earliest similar innovations in Europe. Modern architecture had its beginning in this period; and though no one has taken the trouble to investigate the totality of work done during these years, one needs only to walk about the central business portion of Boston, or, a few years ago, the Loop of Chicago, or to keep one's eyes open here and there in almost every centre, to see beneath years of grime, many alterations, and the disfigurement of competitive advertisements, the first experimental efforts to work out the form of an office-building, an urban factory, a hotel, in terms of their inherent needs and their new possibilities.

How did this change come about? In back of it stands a colossal man, Henry Hobson Richardson, an architect who almost singlehanded created out of a confusion which was actually worse than a mere void the beginnings of a new architecture. No single mind

since Wren's has perhaps left such a large impress of his own personality, not alone through his work, but through that of his disciples and successors; and no one has demonstrated better in practice the qualities that are necessary for a complete orchestration of all the personalities and forces concerned in building. His life merits a brief recapitulation.

Richardson was born in Louisiana in 1838. His mother was a daughter of Joseph Priestley, the famous eighteenth century radical; and Richardson would have entered West Point had he not had, like his grandfather, an impediment in speech. He was graduated from Harvard in 1858, and in 1859 he went over to France to prepare himself for the Ecole des Beaux-Arts, to which he was admitted in 1860. Being out of funds during the war, he never left Paris; but he had the good fortune to gain a living working under Labrouste while he pursued his studies. When Richardson came back to America in 1865 he brought with him, unlike R. M. Hunt, no obvious French tags or labels: what he had absorbed was a method of analysis and a capacity for intense work.

Richardson was an architect in his bones: a solid worker with a respect for all his fellow workers, making his presence felt in every department of building. In stature, ideas, and habits of mind he was a curiously close counterpart of William Morris: he had the same bulky figure and large head and bluff, full beard-the build and driving force of a bison. All his appetites were as positive and gargantuan as the great stones he first played with. His love of good food, his capacity to drink champagne, his yellow waistcoat, his tireless energy, became bywords in the Brown Decades. Unlike Morris, however, Richardson did not write; and such ideas as he had about his art were articulated chiefly in the act of building. But though the makings of a great architect were in young Richardson, he had much to learn; and during his first ten years of practice, he went through the usual Victorian experience of working in Gothic, from which he felt his way back to the more elementary masonry forms of the Southern French Romanesque. The Trinity Church in Boston, his most important achievement before 1880, still belongs to the period of preparation.

Richardson had escaped from the dominant styles of his period, those which a later critic facetiously referred to as the Victorian Cathartic, the Tubercular or Queen Anne Style, and the Cataleptic Style, with its complete suppression of all that would indicate life;

Towards Modern Architecture 5.3

but he had still to find a modern idiom, and meanwhile his own efforts with the heavy Romanesque earned, not altogether unjustly, the epithet "dropsical." The most obvious features of his design were the heavy courses of rough-finished stone, often in contrasting colours; the rounded arches for entrances and the romantic towers. It is these marks, which were taken up by architects like Halsey Wood, L. H. Buffington, and W. R. Emerson and often caricatured by less capable men, that have remained in the popular mind as definitely Richardsonian. He was, without doubt, for the greater part of his life purely a Romantic architect, seeking to create by traditional devices an effect comparable to that produced by other cultures and remoter ways of life: the effect of age, antique strength, endurance, religious energy.

So far Richardson was on the wrong track. Had he died before 1880, he would have to be classed with Pugin, Scott, Viollet-le-Duc, and Cuypers, men who respected sound building, who adored the early Middle Ages, and who wished to renew other than classic harmonies and proportions—an honest but wholly derivative architect, the precursor of that vast tribe of eclectics who now beg and borrow from the ragbags of the past the details and feelings which will cover up their own inability to conceive strictly or carry out competently any genuine aesthetic problem. His influence would still have been respectable: his design for the Albany Cathedral curiously anticipates the Kaiser Wilhelm Gedächtnis Kirche in Berlin; but it would not have been capable of development.

But Richardson grew steadily both in architecture and in his comprehension of the needs and opportunities of modern life: he was still growing when his career was cut short by his death in 1886. His latent powers are even more important for us than his achievements.

Richardson was the first architect of distinction in America who was ready to face the totality of modern life. As soon as he began to design railroad stations for the Boston & Albany line in 1881, he was already on the road towards a new conception of architecture, since, search where he would, he could find nothing in the nature of a suburban railroad station even dimly to remind him of other architectural solutions. In designing such a structure one was forced either to face the elements and work with them, or become stultified.

It was part of the "Victorian compromise" to evade this problem

by confining Gothic architecture to churches and schools, to use classic or Renaissance motifs on public buildings, and to turn over structures like factories, offices, and railroad stations to engineers and contractors who had no particular concern with beauty. Richardson rejected that compromise. In a series of designs, he showed that such a rejection was not merely inevitable, but that it afforded the starting point for a new architecture which, like all the valuable examples of the past, would belong to its own day and grow out of current needs.

Richardson was already at the beginning of this conception in his interior plans for public libraries; he went farther in his railroad stations, with their emphasis upon the covered platform and their bold effort to achieve a maximum of daylight in the waiting rooms. In a similar spirit, he turned in 1880 to the simple cottage of wood and created one that, for the first time, blended with the reds, greens, and browns of the Northern landscape. Domesticity and industry, culture and work, were in Richardson's mind on a common platform: the utilitarian and the romantic emerged from their futile and crippling opposition.

The criticism of Richardson's architecture as purely romantic is not correct even when it is applied to his earlier and, from the standpoint of his later achievements, weaker buildings. It comes, indeed, from critics who are themselves more romantic than the architect, for they are put off by literary allusion and symbolism, and neglect to examine the evolution of Richardson's plans, the bold functional disposition of the parts, and above all his highly inventive use of the window. Richardson, more perhaps than any other architect, was responsible for abandoning the window as a repetitive unit, as in Renaissance design, and making it an integral part of the interior development-placing it and establishing its dimensions by the needs of the interior, rather than by the purely formal requirements of the façade. In the Glessner house in Chicago, on an L-shaped corner plot, Richardson designed a street façade with a minimum of windows, in order to keep out the dust and noise: in his libraries, the stacks are properly lighted and well disposed: this factualism, this attention to the basic programme, characterized even his outwardly romantic period. In the fenestration of Austin Hall, at Harvard (1881), he established the standards of a functionalist architecture. One can comprehend now what Richardson meant when he said, in his circular to inquiring clients: "In preparing the architec-

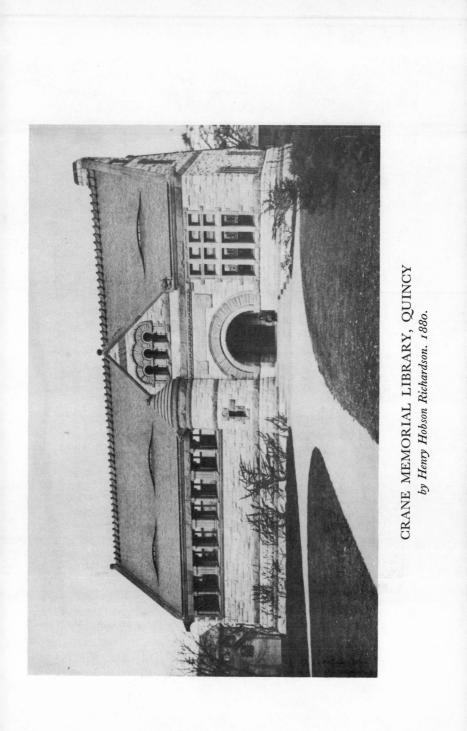

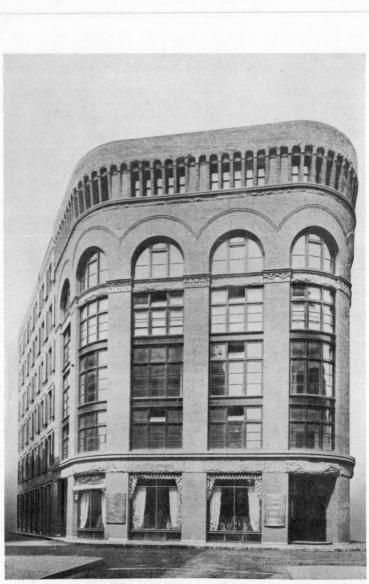

American Architect and Builder

JOHN H. PRAY AND COMPANY BUILDING, BOSTON by Henry Hobson Richardson. 1886.

tural design I agree, after consultation with the owner, to use my best judgement. I cannot, however, guarantee that the building, when completed, shall conform to his ideas of beauty or taste, or indeed to those of any person or school. I can only agree to examine and consider this matter well and carefully, and to recommend nothing which is inconsistent with my own ideas upon these subjects."

IV

When one begins to make a tally of Richardson's qualities, one discovers that he had uniquely all the elements that make up a great architect. What other architect before or since in America has had such a complete equipment? This armoury of qualities included a strong sense of colour, which perhaps tempted him too far in his use of contrasting stones; it embraced a hitherto unique sense of place, so that he himself said that architecture "cannot be fully judged except in concrete shape and colour, amid actual lights and shadows and its own particular surroundings," a sense which placed him apart from the designers whose work is always best on the drawing-board; and it even extended to an appreciation of the ancillary arts, so that he had the taste to recognize and use some of the best artists his time offered: Saint Gaudens, La Farge, W. M. Hunt. More than this: Richardson worked equally well with his clients, the municipal officials and industrialists and business men, as difficult a collection of patrons as ever an artist was blessed with. If one looks for the secret of Richardson's success here, one will not be too easily satisfied with the explanation that his love of good food and good wine brought them swiftly on a common footing; although one cannot doubt that it helped. The main point was that Richardson had an authentic intuition of his society and his age. Mr. Charles Moore in his biography of Richardson's pupil, Charles McKim, says curiously that Richardson's style was not adapted to American conditions: but what is the mark of adaptation? Contemporary jobs? Richardson had them. Durability? His works have lasted better than his successors'. Power to serve as a foundation for later work? That is Richardson's eminent claim to our attention. Richardson did not grovel before practical conditions: he did not think of himself as a mere handyman of business interests, enclosing rentable space: nor did he view the practical needs of his day with contempt.

Louis Sullivan expressed the matter well in one of his Kindergarten

Chats: "To vitalize building materials, to animate them with a thought, a state of feeling, to charge them with a subjective significance and value, to make them visible parts of the social fabric, to infuse into them the true life of the people, to impart to them the best that is in the people, as the eye of the poet, looking below the surface of life, sees the best that is in the people—such is the real function of the architect." This eye for a potential and achievable best was precisely Richardson's great quality—that, and his doughty courage.

Mr. Royal Cortissoz, writing on Richardson in Art and Common Sense, managed to say about as many stupid things about him as were possible in the short space he allowed himself: but one must remember that he was only expressing the spirit of the elegant but derivative men who followed Richardson when he said: "Most if not all the enthusiasm he once excited has gone down the wind ... No one fallen under the Richardsonian spell took account of the little disintegrating force even then working at its centre. This was the too exotic nature of the architect's inspiration ... It was his misfortune, not his fault, that he encouraged exoticism, redundancy, and an unexpressive florid kind of swagger, at a time when the one thing needed was discipline." A careful analysis of Richardson's achievement shows that just the opposite of this is true. The wind is rising again in Richardson's point of the compass; for what he brought to architecture, finally, was an interest, not in an exotic past, not in dead forms, not in the external flourish, but in the inherent nature of the building itself and its relation to society. I cannot, again, forbear to quote Sullivan on Richardson, this time on the Marshall Field Building:

"Four-square and brown, it stands, in physical fact, a monument to trade, to the organized commercial spirit, to the power and progress of the age, to the strength and resource of individuality and force of character; spiritually, it stands as the index of a mind large enough, courageous enough, to cope with these things, taste them, absorb them, and give them forth impressed with the stamp of a large and forceful personality; artistically it stands as the creation of one who knows well how to choose his words, who has somewhat to say and says it as the outpouring of a copious, direct, large, and simple mind." But an even more important evidence of Richardson's disciplined grasp of the contemporary problem is to be found in a building not included in Mrs. Schuyler van Rensselaer's monograph:

the store of John H. Pray in Boston, designed probably in 1886. One has only to compare it with a contemporary office building of Adler and Sullivan's, their building for Martin Ryerson at 45 Randolph Street, Chicago, to see how far in advance the Eastern architect was.

In Sullivan's structure there are three bays, with panels of triple windows, bowed out slightly: between the bays are heavy stone columns, badly proportioned at the bottom, and ornately carved: there is more carving in stone at the top of the building, and the total impression is a confused one. How much more sure and resolute is Richardson's touch: the bays are given their full width and the spandrels are only as wide as the floor is thick; the windows are unbroken, except for the band that separates the stores from the upper panels; even the unfortunate features of the upper storey, the round arches and the castellated windows at the top, are carried through with great simplicity. Though this building antedated the skeleton form of construction, it already has the feeling of lightness, and the readiness to welcome sun and air, that this departure should have brought in: in the shallow reveals, the design is already miles from stone construction. This conception of an office building dates less than ten years after the clumsy romantic office buildings Richardson himself had designed in Hartford and Boston: but it was more than a generation in advance of current work. One can almost agree with a young American critic of architecture when she says: Richardson was the real founder of the neue Sachlichkeit: there are no connecting links.

V

One can see the potential effect of Richardson's attack in a series of buildings that were put up near the time of his death: the premises of the West Publishing Company in St. Paul, done by J. Watts Stevens, is a good example, and the old De Vinne Press Building in New York, by Babb, Cooke and Willard, is another. His influence came out even more effectively, perhaps, in some of the earlier work of his own pupils, Messrs. Charles Follen McKim and Stanford White, done while they were still under his influence. Only a few of these buildings are shown in the otherwise exhaustive monograph on the work of McKim, Mead and White: in the later years, they were apparently ashamed of an excellence that had no definite stylistic historical label, that was guilty of originality! The Tiffany

mansion in New York is a thoroughly Romantic building in a good part of its external effects, its high-pitched and excessive roof, above all: but even here the architects still had the courage to improvise and invent without troubling to find a precedent for their divagations, and the windows of various sizes and shapes that they threw about the façade, including the great glass conservatory on an upper floor, have that hardy respect for function which the relapse into Renaissance correctness was so soon to lose.

A much better example of Richardson's potentialities was 900 Broadway, in Manhattan. This is one of those office buildings that McKim, Mead and White, out of disdain for the practical limitations that had been imposed, never signed; it was, possibly, the work of their chief designer, Joseph Morrill Wells, and in its positive qualities it far outweighs the learned eclecticism for which these architects became popular and famous. Nine Hundred Broadway carries on the story of the Pray Building: its chief defect, the division into horizontal segments, was due to the fact that only part of the building was erected at first. Here again was a building above fashion. That nothing so fresh was done in New York for a whole generation is a manifold cause for astonishment. Did the architects themselves fail to realize how far they had gone? Certainly, their fellow-workers were unaware of it: down to our own day they still design mullions and buttresses for curtain walls. This office building had its counterpart in stables and small offices and occasional dwelling houses built in the same period: they were the essence of Richardson's influence, as distinguished from the tags and clichés that were derived from his earlier work.

But the freedom which Richardson had begun to teach this generation to use on commercial and industrial structures was not lost in buildings of more conventional type. The church at Stockbridge is evidence enough of this fact; but an even more interesting effort is the relatively unknown First Methodist Church in Baltimore (1887), likewise by McKim, Mead and White. The tower is surely one of the finest that has been erected in America, a long leap ahead of Richardson's own Brattle Street Church tower, and in its freedom from stale tags of ornament this church has more than a negative virtue. Here was a solid beginning, a building tradition, not a copybook tradition, architecture, not literature. Unfortunately, Richardson's influence dwindled away even more quickly here than it did in the wooden cottage. Abandoning the modern development

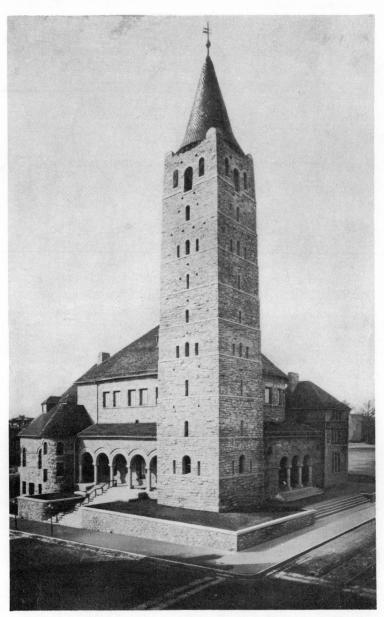

American Architect and Building News

FIRST METHODIST CHURCH, BALTIMORE by McKim, Mead and White. 1887.

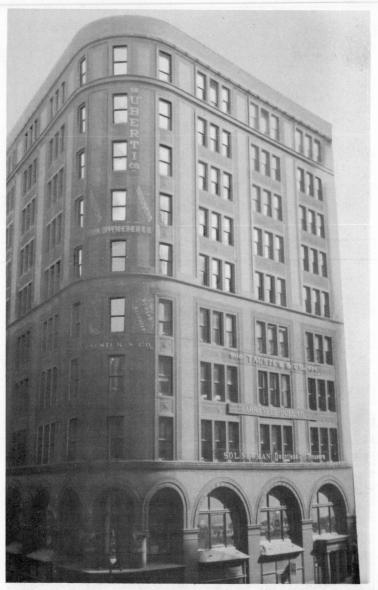

Photo by Catherine K. Bauer

NINE HUNDRED BROADWAY, NEW YORK By McKim, Mead and White. 1886.

that Richardson's later efforts presaged, the fashionable set in the East went in for the only kind of architecture it could recognize or enjoy without the uncomfortable feeling that it might be committing a social error: foreign fashions. Rich people had the bad taste to value nothing but duly certified good taste; and their architects cheerfully met their timidity and snobbishness halfway.

Richardson died just as the transition from masonry to steel frame construction was being made: he died too early to carry this transition beyond its first stages, and to apply to it his own powerful masculine imagination. But there is little doubt that the man who welcomed the problem of the railroad station, whose pencil was busy with sketches for ice plants and similar industrial establishments, who wished to design the interior of a river steamboat, who had already, on the Marshall Field Building and the Pray Building, reduced the cornice and subordinated ornament to the expression of the whole—there is little doubt that this man would have made the transition from one system to another with even more decisiveness than his successors. The gap between stone and steel-and-glass was as great as that in the evolutionary order between the crustaceans and the vertebrates. One sees in the Pray Building how well Richardson could have spanned it.

Unfortunately, Richardson's architectural contemporaries largely muffed their opportunity. They had not yet caught up with his latest work, and while they acknowledged that he had solved the problem of masonry expression for them, they mistakenly thought that steel construction nullified his achievements—and they hastily abandoned their dead master at the moment when he could have taught them most. The fact was, we can now see, just the opposite of their impression: in his final years Richardson was already seeking in masonry qualities that could be triumphantly incorporated only with the aid of steel.

Richardson beheld the promised land, and as the most influential architect of his time, he tasted the grapes of success; but he did not enter it. That realization was granted to a group of architects in Chicago, through three of whom the tradition for which Richardson laid the foundation was widened and modified until it became, in effect, the basis of modern architecture throughout the world, uniting with similar movements and initiatives that had started up in Austria under Wagner, in Holland under Berlage, and in Germany under Messel and Van de Velde and Behrens. Richardson's influence in Chicago was a happy one. There were, in particular, two architects who had felt it when it was for them chiefly a tendency toward Romantic expression, and who, in the eighties, encountering Richardson's mind in its most mature phase, drew from it the inevitable lesson.

One of these architects was John Wellborn Root. Root was, like Richardson, a Southerner. His father, a New Englander, had wished to study architecture, but had instead opened a dry-goods shop in Lumpkin, Georgia. Born in 1850, Root was trained in the office of one of the leading exponents of Gothic architecture, that of Renwick, the designer of St. Patrick's Cathedral in New York, and like Daniel Burnham he was drawn to Chicago in response to the vast opportunity created by the Chicago fire. In 1873, Root and Burnham, who had been working in the same office, formed a partnership on the prospect of doing a large suburban development for a realty company; and the firm of Burnham and Root, combining the adroit business imagination and practical enthusiasm of one with the sound aesthetic ideals of the other, rapidly rose to eminence.

John Root's life as an independent architect was even shorter than Richardson's; and his original training and culture were not nearly so broad, although he had studied for a while at New York University and had a deep love for music. His many city mansions and officebuildings do not show the steady logical progression of Richardson's enlarging imagination. But Root was intellectually more articulate than Richardson, and he took part in that general ferment of ideas which made the better architects of Chicago conscious of their civil mission and willing to impose upon themselves the discipline necessary to its fulfilment. The Cataleptic Style, the trance of dead forms, had never taken root in that city; if the architecture was often crude and barbarous, it was nevertheless alive.

"In America," Root said once in a lecture, "we are free of artistic traditions. Our freedom begets license, it is true. We do shocking things; we produce works of architecture irremediably bad; we try crude experiments that result in disaster. Yet somewhere in this mass of ungoverned energies lies the principle of life. A new spirit of beauty is being developed and perfected, and even now its first achievements are beginning to delight us. This is not the old thing made over; it is new. It springs out of the past, but it is not tied to it; it studies the traditions, but is not enslaved by them. Compare the

VI

61

best of our recent architecture—some of Richardson's designs, for example—with the most pretentious buildings recently erected in Europe. In the American works we find strength and fitness and a certain spontaneity and freshness, as of stately music, or a song in the green woods."

Root's observation was not far-fetched or inaccurate; it was echoed, too, by the one real critic of architecture that America had produced, Montgomery Schuyler, whose American Architecture is a neglected landmark in architectural criticism. In the Monadnock Building, still working in a masonry tradition, Root took Richardson's example one step farther, and carried the design of the tall building —it was fifteen storeys—as far as it was possible to go without reconstructing the terms of the problem. Its actual design shows the important part that was played in establishing a sound foundation by the business men who corrected the architect's whimsies and vagaries by a strong sense of practical needs. I quote from Miss Harriet Monroe's biography of Root:

"For this building [the Monadnock] Mr. Aldis, who controlled the investment, kept urging upon his architects extreme simplicity, rejecting one or two of Root's sketches as too ornate. During Root's absence of a fortnight, Mr. Burnham ordered from one of the draftsmen a design of a straight up-and-down, uncompromising, unornamented façade. When Root returned, he was indignant at first over this project of a brick box. Gradually, however, he threw himself into the spirit of the thing, and one day told Mr. Aldis that the heavy sloping lines of an Egyptian pylon had gotten into his mind as the basis of this design, and that he thought he would throw the whole thing up without a single ornament."

It was a wise decision; even the gradation of the bricks from a deep brown at the bottom to a yellow at the top, which Root was prevented from doing only by a lack of time, might have marred the fine severity of the design, whose sole interest, apart from the strong silhouette, was derived from the projecting bays of windows that increased the sunlit space in rooms that would have been lost in darkness behind piers fifteen feet thick at the bottom. At the time, Montgomery Schuyler pronounced the Monadnock Building the best of all tall office buildings. He was right. It was by far the best thing done in masonry; and its windows were more inventively planned than those of the Auditorium Building, which followed close on its heels.

Schuyler's words on the Monadnock Building are so just, and so applicable to the neue Sachlichkeit in general, that I must quote them: "In the description all this is of no more architectural interest than a box, or rather, than a honeycomb, and would be dismissed as a mere factory. In fact, although it by no means impresses all beholders alike, it impresses many, including the present writer, as precisely the most effective and successful of the commercial structures to which the elevator has literally 'given rise.' This, one cannot help seeing, is the thing itself. It may seem easy enough to leave off all ornament from a tall building and to employ in it but one form and almost one size of opening, and so indeed it is. That is a common scheme in factories which are not works of architecture at all. The point is to produce, by means or in spite of this extreme austerity, an architectural work which shall be as impressive as it clearly is expressive. This is the rare success which seems to me to have been attained in the Monadnock Building. Whoever assumes that it must be very easy to do and that it requires no more than merely the omission of architecture makes a great mistake. On the contrary, the success of it comes from a series of subtle refinements and nuances that bring out the latent expressiveness of what without them would in truth be as bald as a factory."

VII

While Root had finally stripped the face of the office-building, making it as austere as a steamship, as nicely adapted to its purpose as the elevators that had begun to glide up and down in the eighties, after many experimental makeshifts and failures in the seventies, a final clarification of the structure was going on from within. The heavy masonry walls necessary for a fifteen-storey building took away both light and valuable space. Meanwhile, the cheapness of cast iron and later rolled steel had suggested the use of steel beams for floors and steel columns to assist the masonry piers. Two Chicago architects, Messrs. Drake and Wight, contributed the invention of steel columns with air chambers and fire-clay around them; finally, the complete steel skeleton was articulated in William Le Baron Jenney's Home Insurance Building (1885), and the outside walls, instead of being supporting members, became only a fireproof curtain, each segment supported at each floor.

The priority for the invention of steel frame or skeleton construction has been disputed; it was claimed by, among others, L. H.

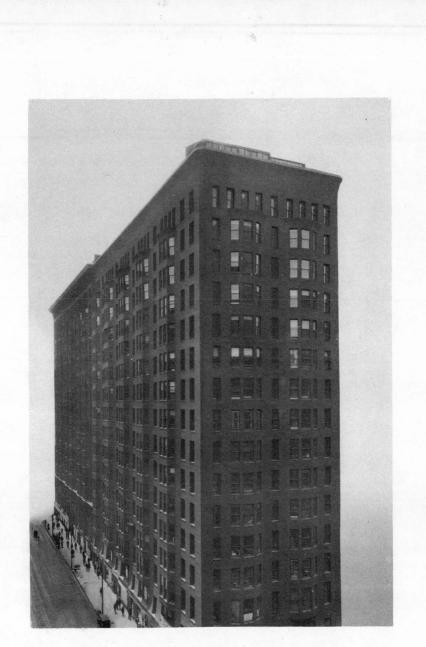

THE MONADNOCK BUILDING, CHICAGO by John Wellborn Root.

Buffington, Minnesota architect, who applied for a patent; but the whole question becomes a little absurd when one remembers that the traditional American frame house is based on an exactly comparable method of construction. The new elements were the fireproofing of the component materials, and the more exact calculations made possible through the use of steel, along with the opportunity of increasing the height of the structure, which was limited only by the strength of the foundations and the expense of vertical transportation. Socially, the skyscraper gave encouragement to all our characteristic American weaknesses: our love of abstract magnitude, our interest in land-gambling, our desire for conspicuous waste: it did this to such an extent that it is almost heresy to call attention to the defects of the tall building: the dubious economy of vertical transportation at the magnificent maximum rate of nine miles per hour: the waste of cubage in the unused sections of express elevator shafts-to say nothing of the shutting out of sunlight and air, and the intensification of congestion on the streets and in the subways.

But the skyscraper is one thing, and steel-framed construction, though it was first developed for use in this type of building, is quite another. To admit the manifold deficiencies of the skyscraper under our present system of credit, land-increment, and unregulated city growth is not to lessen the boldness and inventiveness which characterized the Chicago architects and the steelmasters and engineers who aided them. It was one with the spirit that created the grain elevators, the continental railroad systems, the great bridges, the steel-works themselves. Root formulated the aesthetic of these new structures. "In them," he said, "should be carried out the ideals of modern business life-simplicity, stability, breadth, dignity. To lavish upon them profusion of delicate ornament is worse than useless, for this would better be preserved for the place and hour of contemplation and repose. Rather should they by their mass and proportion convey in some large elemental sense an idea of the great, stable, conserving forces of modern civilization."

From the point of clarified expression that Root formulated, and that he and Richardson and Wells had demonstrated, there has been little real advance. Every later effort to evade the logic of modern civilization by insincere gestures of respect to the culture, the feelings, the ornamental systems of previous ages, or to simulate their effect by "modern" systems of ornament merely reduces the dignity and sincerity that these older structures achieved. Attempts

to make a business building a cathedral or a temple deny the order that belongs to the essential function: the Chicago Tribune Tower is miles below the best office buildings of the eighties in all that constitutes aesthetic rightness and good form. Business, and not the fake religion of business, was what the earlier skyscrapers expressed. Their conception can be summed up in a word: the builders *meant business*. Could one give either the architects or their clients higher praise?

The fact is that the architects of the Brown Decades reached an appropriate solution for the office building more quickly than they knew, or any one could anticipate. This solution had no equivalent in the aesthetic vocabulary of the age; and instead of clinging to it, developing it, bringing out to the last degree the virtues of simplicity and directness, and playing only with the fundamental units of construction, the architects of America, having scaled the heights too quickly, poised for a dizzy moment and then fell—fell into the easy mechanical duplication of other modes of architecture, frigidly predicted by the Chicago Exposition of 1893... turning out a rapid succession of Roman temples and baths, Florentine villas and French palaces and Gothic churches and universities, to say nothing of office-buildings which retained ill-chosen souvenirs from all these crumbled civilizations.

So low had American taste sunk in the generation after the World's Fair that people habitually characterized as an advance what was actually a serious retrogression. Had Richardson lived, had Root lived another fifteen years, the results might have been different: one original man can lead, two men of the same mind are an army, and three men directed toward a single objective might possibly have conquered the dull and inert forces that stood in their way: at all events, they would have made a glorious fight. But in 1891, only one of this early trio was left. His name was Louis Sullivan.

VIII

Louis Sullivan. The name has become a symbol, and the symbol has been one to conjure with. I approach this man with reverence; for even his enemies have respected the fierce sincerity of his mind and his passionate affirmations of life and art: they have called him the father of the modern skyscraper and they have paid tribute to the originality of his ornament, even when they had no desire to emulate it.

As an architect and a man, Louis Sullivan is a figure for whom one must make allowances, and correct for both enmities and partialities, before coming to a just estimate; but he remains an important personality, even when full justice has been done. The influence of his example was almost as wide as Richardson's; that of his writings was far more important than Root's. His Kindergarten Chats and his Autobiography of an Idea, for all their turgidities, will long remain a witness to his spirit. He was wilful, capricious, sometimes grandiloquently mystical; even before poverty and defeat created compensatory needs, his belief in his own unique illuminations kept him from having the most fruitful contact with other men; and his weaknesses were accentuated in the solitude of his last years, spent miserably in a third-rate Chicago hotel, with only a few unimportant jobs coming his way, sometimes through the kindness of despairing friends. But Mr. Frank Lloyd Wright still habitually refers to him as der Meister -and he was all of that.

Sullivan's was perhaps the first mind in American architecture that had come to know itself with any fulness in relation to its soil, its period, its civilization, and had been able to absorb fully all the many lessons of the century. One might call him the Whitman of American architecture. If his vision outstripped his own accomplishment, it was large enough to outstrip any immediate programme; for it had the force and drive of a whole civilization.

Louis Sullivan was of French-Irish ancestry. He was born in Boston in 1856. After studying at the English High School under a redoubtable master, Moses Woolson, in 1870 he took examinations for the Massachusetts Institute of Technology and passed them: he showed precocity. Very early in life he decided upon architecture as a career, and he went from the Institute to the Ecole des Beaux-Arts in Paris, by way of the office of Furness and Hewitt in Philadelphia. Frank Furness was the designer of a bold, unabashed, ugly, and yet somehow healthily pregnant architecture. It was of work such as his that Montgomery Schuyler remarked: "It is more feasible to tame exuberances than to create a soul under the ribs of death. The emancipation of American architecture is thus ultimately more hopeful than if it were put under academic bonds to keep the peace. It may be freely admitted that many of its manifestations are not for the present joyous but grievous."

The panic of 1873 robbed Sullivan of his job and sent him to Chicago; in 1874 he sailed for France, and stayed there almost four

years. It was a heady experience for this sensitive young man; and in his autobiography he has given only one aspect of it, the effect of French logic and discipline upon an eager self-confident American. Sullivan's mathematics was at first inadequate, and he studied it under a French master. This man, M. Clopet, scanned the mathematical textbook that Sullivan had purchased in advance and said: "Now observe: here is a problem with five exceptions or special cases; here a theorem, three special cases; another nine, and so on and on, a procession of exceptions and special cases. I suggest you place the book in the wastebasket; we shall not need it here; for our demonstrations shall be so broad as to admit of no exceptions!"

These words, however they were uttered or repeated, made a deep impression on the young man. Here was the voice of a real teacher, and he had crystallized for Sullivan, in a sentence, the aim of a genuine system of architecture—to arrive at a method so broad as to admit of no exceptions. "If this can be done in mathematics," said Sullivan to himself, "why not in architecture? The instant answer: it can and it shall be!"

Louis Sullivan returned to Chicago, a thriving city, busy, hospitable, building itself out of the wreck of the fire, a brutal network of industrial necessities, railroads, grain-elevators, bridges, stockyards, business offices, brutal and chaotic, but full of an electric vitality which, if it made the errors grosser, made its triumphs even more colossal. The pressure of financial interests in the Loop was already creating the gratuitous congestion of the skyscraper; vast railroad yards swung across the lake front in blithe contempt for any other uses than the convenience of iron and wheels; but grappling with this brawling ugliness were men equally huge, and the architects of the day were not dwarfed by the business men, but stood shoulder to shoulder with them, supplementing their deficiences and sharing their strength. In this environment, an idea might be an act.

There were other men, like John Edelman, to share Sullivan's interest in the historians of art like Taine, in such poets as Whitman, the Whitman who had said: There is no more need of romances; let facts and history be properly told. These sentiments took hold of Sullivan. In 1879 he went into the office of an able architect and organizer, Dankmar Adler, and in 1881, at twenty-five, he became Adler's partner. A rapid rise, in all probability too rapid: Sullivan was not toughened like Richardson by a long period of probation, but suffered from an elation of ego that made him perhaps too easily

satisfied with his own philosophy and his own achievements—the psychology of the spoiled child. The world was at his feet. At the age of thirty he began to work on the enormous Auditorium Building and Theatre, a work so huge and difficult that it took almost four years to finish. That building, like the Monadnock, stands at the parting of the ways between the older forms of Richardson's masonry and the lighter, more supple forms of steel construction. It is a great pile. Following Richardson's precedent in the Marshall Field Building, the face is notably devoid of ornament, although the auditorium itself and other parts of the interior exhibited the delicate lacy stuff that Sullivan's hand turned out so quickly. It was Adler and Sullivan's strongest and best-integrated building—though, unlike some of Sullivan's later buildings, it opened no new paths.

In the World's Fair that followed, this healthy native growth was cut down: the joe-pye weed and the swamp maple and the locust tree were extirpated in favour of a few elegant, sickly shrubs which could not flourish in the common soil of our life. It is conceivable that had Root been the master-designer, as was at first projectedhe was partly responsible for the choice of a park site with watercourses and he contemplated the use of colour more lavishly than had hitherto been attempted-it is conceivable that Louis Sullivan would with Root have dominated the situation. The Chicago architects were, however, largely crowded out by the suave Classic and Renaissance practitioners whom Burnham brought in, and Sullivan was notable in the Fair only for the Transportation Building, the one structure that departed from precedent in its golden portal, its obviously plaster façade. Incidentally, his work resulted in the award of a gold medal, on the recommendation of the French government commission, by the Société Centrale des Arts Décoratifs.

IX

Up to this time, Sullivan and Root had ridden on the crest of the wave. The minor arts themselves began to reflect their efforts: the Yale and Towne Lock Company employed them to make designs for hardware; and as late as 1897 these designs were still popular. In 1891 Root died, and in 1895 Sullivan and Adler parted company. This was to prove a great misfortune; for, unlike Richardson, Sullivan alone lacked some of the necessary ingredients for architectural mastery: he was at his best with the tactful, practical, painstaking Adler at his side, to serve as buffer between the imperious artist and

his clients. Sullivan's buildings, though often original in conception, began in a subtle way to disintegrate: the masculine and the feminine elements, form and feeling, drew apart; and finally, in the work of his declining years, Sullivan's ornament often ruined the logic of his design. Social changes accented these individual deficiencies. Building revived slowly after the panic of 1893. Two large skyscrapers, designed by Sullivan at the end of the decade and approved by his clients, were abandoned for lack of financial resources. The breaks were against him. Some of his closest clients and old friends lost their faith in him when their own taste deteriorated. The tide set against sound design. Styles took the place of style, as the builders of industry gave way to the salesmen and financial manipulators. Thorstein Veblen's Theory of Business Enterprise reflects a conflict that was written with particular clearness on the stones of Chicago. Buildings and furnishings did not call for creative effort: they demanded vulgar waste, costly antiques, historic loot. Sullivan refused to deal in these cheap-jack wares. So his detractors damned him as an "expensive" architect.

Like Root, Sullivan formulated a theory of the tall office-building, and tested it out on the Wainwright Building in St. Louis (1891), the Prudential Building in Buffalo (1895), and the Schiller Building (1892) and the Gage Building (1898) in Chicago. Let us examine his analysis. "The practical considerations," said Sullivan, in an article in Lippincott's Magazine in 1896, "are, broadly speaking, these, Wanted-First, a storey below ground, containing boilers, engines of various sorts, etc.-in short, the plant for power, heating, lighting, etc. Second, a ground floor, so-called, devoted to stores, banks, or other establishments requiring large area, ample spacing, ample light, and great freedom of access. Third, a second storey readily accessible by stairways-the space usually in large subdivisions, with corresponding liberality in structural spacing and in expanse of glass and breadth of material openings. Fourth, above these an indefinite number of storeys of offices piled tier upon tier, one tier just like another-an office being similar to a cell in a honey-comb, merely a compartment, nothing more. Fifth and last, at the top of this pile is placed a space or a storey that, as related to the life and usefulness of the structure, is purely physiological in its naturenamely, the attic.... Finally, or at the beginning, rather, there must be on the ground floor a main aperture or entrance common to all the occupants or patrons of the building.... What is the chief

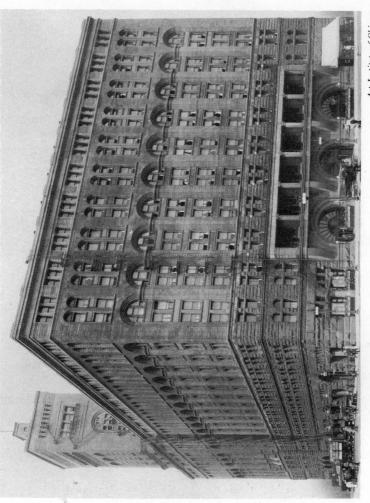

Art Institute of Chicago

THE AUDITORIUM BUILDING, CHICAGO by Louis Henry Sullivan. 1889.

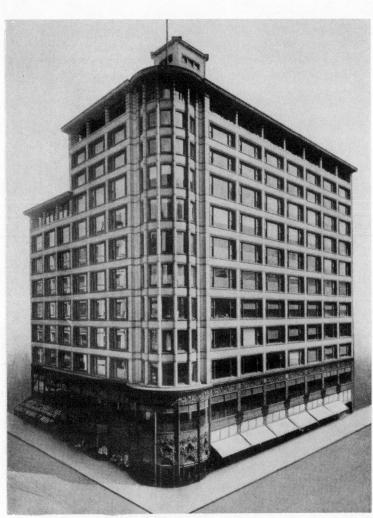

Art Institute of Chicago

THE SCHLESINGER AND MAYER BUILDING, CHICAGO by Louis Henry Sullivan. 1899 and 1903.

character of the tall office building? And at once we answer, it is lofty. This loftiness is to the artist-nature its thrilling aspect. It is the very open organ-tone in its appeal.... It must be every inch a proud and soaring thing, rising in sheer exultation that from bottom to top it is a unit without a single dissenting line—that is the new, the unexpected, the eloquent peroration of most bald, most sinister, most forbidding conditions."

Between Sullivan's fine factual analysis and his desire for a romantic thrill there was a conflict, and this division is written upon his office-buildings. Sullivan was one of the first architects to emphasize the vertical lines of the skyscraper: in the Wainwright Building he did this by inserting a pier between the main columns of each bay, even though there was nothing in the actual function of the building to dictate this arrangement. This accentuation of the vertical was in both its immediate and its ultimate effects an unfortunate solution: I say this with due deference to such excellent critics as Mr. Claude Bragdon, who have hailed Sullivan as the first adequate designer of the skyscraper. The objections are manifold.

For one thing, the steel cage is not in itself a vertical system of construction: it is rather a system of articulated cubes. A brick wall will stand after a fire though the connecting beams have been gutted away: without its horizontal ties a steel wall must come down. The temptation to accentuate the vertical leads to the use of piers or mullions which indicate masonry construction; whereas the curtain wall, with shallow reveals, as forecast by the Pray Building or 900 Broadway, expresses the system of construction. Again: the vertical lines conflict with the need for unbroken window space on the lower two floors; hence on Sullivan's skyscrapers the horizontal accent at the base contradicts the vertical system above; and the result, taken with the overhang that caps the Wainwright Building, or the outward curving at the top as in the Prudential Building, is curiously like the classic conception of base, column, and capital-which has precious little to do with the logic of the tall building, and is full of dissenting lines.

More than anything, the mischief lay in the notion that on the foundation of practical needs the skyscraper could or should be translated into a "proud and soaring thing." This was giving the skyscraper a spiritual function to perform: whereas, in actuality, height in skyscrapers meant either a desire for centralized administration, a desire to increase ground rents, a desire for advertisement, or

all three of these together—and none of these functions determines a "proud and soaring thing." It was but a step from Sullivan's conception to the grandiose and inefficient tower buildings that mark the last two decades of American skyscraper development. These towers accentuate the vertical lines well enough: but they cannot be compared, as practical economic plans and elevations, with the Monadnock Building.

Just as the idea of accentuating the vertical lines spoiled the logic of the tall business building, so the desire to embellish the façade was a step backward from the solution indicated at such an early date by the Monadnock Building, to say nothing of Sullivan's own Auditorium Building. Ornament, however, was Sullivan's claim to originality as distinguished from great technical competence: he represented that surviving tradition in architecture which differentiated buildings as much through their symbolic effects in ornament as through their structural means of expression. Sullivan's ornament was frequently not related to the forms and materials of the building: it was as arbitrarily applied as acanthus leaves. It was, moreover, a drafting-room ornament. Although not derived from books and pictures, it represented the architect's originality, not that of the painter, the modeller, the sculptor; and it was restless and assertive, without being in a sculptural sense entertaining. Sullivan found a justification for these lacy forms of his in nature: if one objects to their use it is only because nature, at first hand, in trees and bushes and flowers, is so much more delightful than stone or iron-and where there is no place for nature, the pressed or carved designs are less exhilarating than an unbroken surface. Ornament was for Sullivan the great realm of individuality. If his ornament means less to the present generation than any other part of his work, it is only because we have begun to see that the nineteenth century quest of "individuality" and "personality" in architecture was a last step in disintegration, since architecture is a social art, and must stand or fall by its collective achievement. "Individuality" cannot be the foundation of a common rule: it is only the irreducible residue that remains after the common rule has been established.

But one cannot call the roll of Sullivan's works without paying a tribute to the one outstanding building of his later years: the Schlesinger and Mayer Building, now that of Carson, Pirie and Scott. This is a department store, and the date of its first unit on Madison Street is 1899; that of the second unit, on the corner of

State and Madison Streets, is 1903. Here Sullivan used a bold system of horizontal windows and gained a legitimate accent at the corner by a rounded glass bay: a clean, logical solution for the problem, more decisive in every way, it seems to me, than his skyscrapers. In departing from this logic on the lower two storeys, to the extent of using a lacy snowflake grille, he destroyed the unity of expression and distracted attention, by his own exhibition, from the exhibitions behind the windows. Despite this weakness, the design was an expressive and salutary one: nothing comparable to this appeared in department stores in Europe until after 1920. The final section of the building, it is true, was taken from Sullivan by D. H. Burnham, when the store changed hands; but that architect recognized, apparently, the work of a superior hand, and he kept in the main close to Sullivan's design.

The neglect of this precedent, like the neglect of Richardson's last office-building twenty years before, pointed to the essential shallowness of architectural practice in America, to say nothing of the life it enthroned. It was not for lack of adequate appreciation that this work went so long for nothing: Montgomery Schuyler, although a little tamed by the overwhelming omnipresence of the eclectic school, and far too kind to such manifestations of it as the Woolworth building, was still as alert in 1912 as he had been in Root's day: "It is hard," he said then, "to see how an unprejudiced inquirer can deny that such designers as Mr. Sullivan and Mr. Wright have the root of the matter, and their works are of good hope, in contrast with the rehandling and rehashing of admired historical forms in which there is no future nor any possibility of progress."

I have granted a little more freely than most of Sullivan's critics or admirers his own personal weaknesses: I have not attempted to conceal the fact that they accounted in part for the mean and bedraggled ending of what had set out as a great career. But there is a continuity between the individual and society which will not let any honest analysis stay at this point: one must point out that the Brown Decades, for all their sordidness, had certain healthy characteristics which were lacking in the more refined but no less rapacious society that followed. What Sullivan said as a critic of social architecture was correct: "What the people are within, the buildings express without; and inversely, what the buildings are objectively is a sure index of what the people are subjectively. In the light of this dictum, the unhappy, irrational, heedless, pessimistic, unlovely,

distracted, and decadent structures which make up the great bulk of our contemporaneous architecture point with infallible accuracy to qualities in the heart and mind and soul of the American people that are unhappy, irrational," and so forth.

Sullivan's original observation in the *Kindergarten Chats* is true for the longer span that we have been examining: it is true for the two generations that have followed the Civil War: "We are at that dramatic moment in our national life wherein we tremble evenly between decay and evolution, and our architecture, with strange fidelity, reflects this equipoise. That the forces of decadence predominate in quantity there can be no doubt; that the re-creative forces balance them by virtue of quality and may eventually overpower them is a matter of conjecture. That the bulk of our architecture is rotten to the core, is a statement that does not admit of one solitary doubt. That there is in our national life, in the genius of our people, a fruitful germ, and that there are a handful who perceive this, is likewise beyond question."

One sees these forces, balancing, thrusting, fighting, sometimes clear and sometimes confused, in Sullivan's own work: no one can lift himself up by his bootstraps, and the best architect survives or stifles in the same milieu that surrounds his lesser contemporaries. Even when he stands out against these forces, as Sullivan sought to do and as Wright in a measure did by turning to the design of country houses when more critical and important works of architecture were denied to him, he pays almost as great a price for his recalcitrance as he would for his submission. For architecture is, through and through, a social art, and all its interesting and valid answers must be couched in response to the demands of society. The only kind of tower that the architect must deny himself the privilege of building is a Tower of Ivory.

х

In his old age Sullivan was reduced to designing little country banks in the Middle West. They are scattered over mid-America from Columbus, Wisconsin, to Sydney, Ohio. Mr. Sinclair Lewis's portrait of Gopher Prairie, veracious though it may be, did something less than justice to the many little country towns that generously atoned for the neglect of the master in the big metropolises by giving him a series of such commissions. For Sullivan, even when he was farthest from his own ideal, that of an architecture so broad as to

admit of no exceptions, was still head and shoulders above most of the men around him: his attack on the elements of his problem was still bold and frontal; and it was only his inability to work with others, his tendency to take refuge in ornament as a grateful intoxicant, and in intoxicants as a last distracting ornament on the bare walls of reality, it was by these lapses that he brought upon himself some of his misfortunes. Were they perhaps due as much to the uncompromising strength of his talent as to his shortcomings?

I have not seen any of Sullivan's banks on the site; and it is hard to judge them from photographs. Among the best of them are his Land and Loan Office in Algona, Iowa, and the bank in Grinnell, Iowa. That in Owatonna used a round arch for both the portal and the window on the side: it has distinction and individuality, as did Sullivan's tombs, but it is not as full of useful precedents as a savings bank in Cedar Rapids (1911), perhaps the most factual of all Sullivan's later buildings. The last is a brick building, surmounted by a low clerestory. A long bank of horizontal windows illuminates with daylight the teller's quarters: the windows of the clerestory give daylight to the centre of the building; while four chimneys form uprights at each corner of the clerestory, one a chimney proper, and the others serving as ventilators. The plain use of materials, the absence of effusive ornament, the plain tesselation of the floors, the employment of the best factory models for desks and office furniture -all these things make the Cedar Rapids Bank a model for such buildings: an intelligent builder anywhere could carry on such a tradition. Unfortunately, the spirit that evoked this building did not last long. In addition to the original chaste lettering that Sullivan left on the face of the building, there are now nine preposterous signs which announce that the building is the People's Savings Bank, one sign so large that it almost blanks out the clerestory: a pious tribute to the original work of a great American architect.

If the Cedar Rapids bank in its original form was the high point of Sullivan's contribution to a new vernacular, the lowest point of his disintegration was the Home Building Association in Newark, Ohio; but there is no need to linger over the master's weaknesses. In the Capital and Loan Association Building in Topeka, in the Court House in Sioux City, and in the bank at Winona, Minnesota, the letter of Sullivan's teaching was ably carried on by his one-time assistant, George G. Elmslie, who was closely identified with most of Sullivan's designs after the partnership with Adler was broken.

But it is not by the letter alone, nor even by his actual monuments, that Sullivan will finally go down to posterity.

What, then, was Louis Sullivan's contribution? Sullivan was the first American architect to think consciously of his relations with civilization. Richardson and Root both had good intuitions, and they had made effective demonstrations; but Sullivan knew what he was about, and what is more important, he knew what he ought to be about. "Once you learn," he said, "to look upon architecture not merely as an art more or less well or more or less badly done, but as a social manifestation, the critical eye becomes clairvoyant, and obscure, unnoted phenomena become illumined." Sullivan had this sense of the forces at work in society, in industry, in the human personality. He "found himself drifting into the engineering point of view, or state of mind, as he began to discern that the engineers were the only men who could face a problem squarely; who knew a problem when they saw it. Their minds were trained to deal with real things, as far as they knew them, as far as they could ascertain them, while the architectural mind lacked this directness, this simplicity, this singleness of purpose-it had no standard of reference, no bench-mark one might say."

Sullivan saw that the business of the architect was to organize the forces of modern society, discipline them for humane ends, express them in the plastic-utilitarian form of building. To achieve this purpose, the architect must abandon the tedious and unmeaning symbolism of older cultural forms: a modern building could no more wear the dress of the classic than the architect could wear a peruke and sword. The whole problem of building, Sullivan saw, must be thought out afresh, and the solution must be of such a nature that it would apply to every manner of structure, from the home to the factory, from the office to the tomb: no activity was too mean to escape the ministrations of the architect. While Sullivan manfully faced the problem of the tall building, he saw that the spirit that produced such congestion was "profoundly antisocial . . . these buildings are not architecture but outlawry, and their authors criminals in the true sense of the word." So, though Sullivan respected the positive forces of his age, democracy, science, industry, he was not a go-getter, and he refused to accept an architecture which showed a "cynical contempt for all those qualities that real humans value."

Sullivan's own relative failure in carrying through his conceptions

does not vitiate them. In his final years, his thought sometimes became misty and vague; there are passages in The Autobiography of an Idea in which an eloquent and obsessive rhetoric conceals a certain emptiness, in which a platitude is put forward as with a fanfare of trumpets announcing a puppet king. But Sullivan was not simply a creature of his environment. He had absorbed the classic discipline of French thought, he had lived with Michelet, Whitman, Taine, Darwin, and this fusion of the romantic, scientific, and classical impulses in the man gave him a special power to react upon his environment. Breaking loose from the romantic phase of Richardson, Sullivan made a real beginning. On Richardson's solid foundations, he laid the cornerstone of the new organic architecture. Sullivan was the link between two greater masters, Richardson and Frank Lloyd Wright; and with the development of Wright's architecture the last stage in the transition was made: modern architecture in America was born. From that point on the Chicago school entered into the general stream of a world movement. In Wright, Sullivan's best ideas found actual expression more completely and convincingly than in his own work.

XI

To understand better the immense accomplishment of the Brown Decades in architecture, one must be aware of the two continuous lines of movement which were started then, but which have become more visible and better defined in our own day. One involved the application of the machine to architecture-the introduction of new utilities for heating, ventilating, cooling, bathing, cooking, communicating, and the creation of new materials and methods of construction. This has changed both the problem and the outlook of architecture. The other movement, typified by the work of Richardson, Sullivan, and Wright, has been a conscious orientation of architecture toward new forms of expression, forms which comprehended, not merely the automatic developments of the mechanical age, but the rôle of the land itself, human habits, human desires, human institutions. Imagination disciplined by necessity, new necessities carried through to a final clarification in the mind: these are the poles of the modern spirit in architecture.

While Sullivan was finishing the Auditorium building, he took on a young draftsman, Frank Lloyd Wright, who had just been a student in the engineering school at the University of Wisconsin.

Wright was born in 1868, and he worked in the office of Adler and Sullivan from 1889 to 1895. Like his master, Wright was one of the few American artists who, in the face of the snobbishness and timid taste of the well-to-do in America, refused to participate in the revivalism and eclecticism that followed the World's Fair: he continued to seek an organic architecture.

Wright took the fashionable American house of the early nineties, with its high-pitched roof and spindly chimneys, its numerous dormer windows and its crazy turrets and towers, and brought this wild, shambling, pseudo-romantic creation, half Pegasus and half spavined selling plater, down to earth. On his very first house, he widened the windows and introduced more light: after that, pursuing more zealously Richardson's lead in treating the window as the original component of sound design, he fashioned the window in horizontal banks, doing away with the guillotine sash window. Wright called the houses he built during the next twenty years in Oak Park and the various tributaries of Chicago "prairie houses": with their low-pitched roofs, their rambling plans, their marked horizontality, they were deliberate adaptations to the landscape. At the very time when the archaic note of colonialism was being emphasized by the fashionable architect, Wright was showing his respect for the actual landscape and the actual problems of his day and locality.

Out of the ground, into the sun, has been the emblem of his work: no one, up to this time, had torn down the wall as a dividing unit and had dared to introduce so much glass and sunlight. His façades, instead of consisting of masonry walls punched with windows, were rather windows backed or connected by concrete, steel, or brick. Wright carried this essential principle to its logical conclusion in his design for the apartment house for St. Mark's-in-the-Bouwerie, where the supporting steel serves as a spinal column and the glass walls are the skin of the building; but the principle was implicit in the work he did in the nineties, and in the Steffens house and the Roberts Cottage it became manifest.

Wright has embodied in his work two qualities which can never permanently leave architecture—a sense of place, and a rich feeling for materials. This sense and this feeling have been momentarily lost in architecture, under the stress of clarifying form; but, boldly or surreptitiously, they are bound, I think, to make their way back into building; and Wright has left the way open for them. His architec-

ture, though he has pioneered with modern methods of construction and delighted in mechanical techniques, is not merely a passive adaptation to the machine age: it is a reaching toward a more biotechnic economy, better grounded in the permanent realities of birth, growth, reproduction, and the natural environment than is the dominant order of paper values and merely mechanical efficiencies.

A hygienist has pointed out that our boasted mechanical age, with its knowledge of physical science and its control of delicate industrial processes, has not in the course of a hundred years yet learned the proper height for a toilet seat—with the result that sanitation and constipation are almost synonymous terms. One could criticize the latest achievement in mattresses in the machine age on similar grounds: the manufacturers seem unaware that the soft resilience of their product, if possibly conducive to sleep, is an obstacle to satisfactory sexual intercourse, and, paying attention to the physical processes of manufacture, they have not reckoned with the complete set of biological conditions their product must meet. No architecture can be efficient in the total situation which forgets the essential character of our humanity: human impulses cannot be flouted without their taking revenge in unexpected places. Frank Lloyd Wright's strong sense of human needs is a necessary complement to technical innovations.

One can sum up the effect of Wright's many innovations in design by saying that he altered the inner rhythm of the modern building: effecting these alterations on the most traditional form of building, with the most stable and traditional requirements, he opened the way for a fresh attack on all the problems of modern architecture. His own opportunity to work upon the school, the office-building, the factory, the hotel, has been limited: his most powerful influence has therefore been effected in the domain of the country or suburban house, and with respect to the mass of building this represents only a minor problem-in some respects one that is tangential to our civilization. Those who think of Wright, however, solely in terms of the country house forget that as early as 1915 he had made a series of designs for type houses, whose parts were to be factory-made: here, as elsewhere, he was in advance of European precedent, and his failure to exert more influence has come from the inability of his fellow-countrymen to make sufficient demands upon him. For this reason, it is all the more important to keep in mind

Wright's fundamental contribution, which has nothing to do with the specific forms in which he worked.

Wright kept alive the tradition of experiment. He introduced sunlight and the glass opening, to take the place of the opaque and light-belittling wall: he widened the gamut of materials with which the architect worked; and at a time when all the successful practitioners were doing their best to revive handicraft, or to find some way of imitating by machinery and standardized methods the texture or finish of handicraft, Wright deliberately embraced the machine and the new products which were being added to the architect's store by the manufacturer. His speech on behalf of the machine, delivered at Hull House in 1903, was the first whole-hearted word that was said in its favour, the first hint that the results which Morris hoped to achieve by going back to the Middle Ages might be attained by going forward to a new destination.

No American architect, not even Richardson, has had the command over materials that Wright has exercised, or the understanding of the specific use and beauty of each material, steel, copper, glass, concrete, brick, stone, wood. It may well be that the way towards a coherent form in the work that lies ahead will be through the deliberate restriction of materials and the methods of building: but before we establish narrower limits, it is important that some one should have ranged over the whole field and explored the whole range of possibilities in structure, function, and ornament: and more than with any one else, this has been Mr. Wright's function.

Wright was ahead of his time. He lacked, therefore, the support of an underlying convention, and the actualization of each building required not merely an individual conversion of his clients to his particular method and point of view: it required equal adaptations on the part of the building trades and the manufacturers: resistance in this department is almost as fatal as lack of understanding or courage on the part of the patron. Wright's very originality and fertility of imagination were something of a handicap, and possibly, in reaction against the resistance he met, he accentuated the element of idiosyncrasy in his work. As the vigorous impulses of the Brown Decades slackened, Wright found himself more and more alone. Though he had disciples and imitators, his buildings were individual solutions. From these solutions, a hundred important lessons can be learned: the beauty of earth colours and natural finishes: the manifold possibilities of glass: the importance of living plants as a

final element in decoration: the principles of horizontal composition —lessons from which Wright's foreign admirers derived invaluable suggestions.

There is, however, one great weakness in Mr. Wright's architecture, a weakness inherent in the transitional state of his society: far too great a burden rested on the architect. It was not merely necessary that he should design the building: he had to invent the methods of construction, alter established rules of procedure, create new types of furniture, rugs, chinaware; everything, from the foundation table to the roof, must bear the imprint of his personality. A man of genius delights in such a load: but architecture as a social art cannot depend upon the existence of men of genius: when it is in a healthy state it relies upon the commonplace efforts of the carpenter, the builder, the engineer, the manufacturer, and the task of the architect is not to usurp the work that is done in these departments, but to organize it intelligently and to create out of it an orderly composition. Mr. Frank Lloyd Wright's genius carried architecture as far as any single man could carry it. He was the seed bed of the new architecture in America. Some of his young shoots would live; others would die; others would undergo unexpected mutations and start a new species; but living or dving, stabilizing or changing, efflorescing or seeding, no work in modern architecture has been more necessary and significant.

XII

Meanwhile, throughout Western Civilization, architecture during the first two decades of the twentieth century stirred on the verge of a great change. The monumental building, the individual structure, ceased to set the problem of the architect. From the establishment of Bourneville and the Hampstead Garden suburb in England, from the industrial housing developments at Essen, from Letchworth Garden City and Frankfort, a new orientation came: the rehabilitation of city and countryside and the development of new communities as integrated wholes. The isolated country house, designed to meet the tastes and interests of a small class of people, and set in the midst of a large tract of land, insulated from its neighbours, perhaps remained the ideal of house-design, even among the classes that were forced to accept mean bungalows or shanties five feet from their neighbours as equivalent: but wherever the social and economic condition of modern society was faced realistically, the major problem

became that of integrating a modern community, treating the individual building as a mere unit in the larger design.

Up to the Great War, in America only a handful of architects and city planners had worked on this problem. One of the most important of these was Mr. Irving Gill, whose work on the Pacific Coast during the first decade of the present century, together with that of Bernard Maybeck, carried on the experimental tradition in American architecture. Mr. Gill's houses, some of the best of which were designed for a miners' community in California, faced the problem of meeting the actual limitations in cost that the mass of mankind, no matter how equitably income may be divided, nor how much the standard of living may be raised, will have to confront in all probability during any period that the houses now built can serve. His houses at Sierra Madre, four rooms and bath, of smooth stuccoed hollow tile with concrete floors, waxed originally with hot paraffin, are some of the best early statements of the essential or sachlich house: in his deliberate absence of ornamental effect, he anticipated both the polemics and the practice of Le Corbusier and the De Stijl group -although Mr. Wright's early houses had been, it is well to remember, equally severe. During the war, communal operations on housing were carried on in the East on a great scale; but unfortunately few fresh contributions were made, except by way of social and economic precedent. Every real advance in improving and cheapening the modern house awaited the union of an experimental imagination with a new industrial aesthetic. This brings us to the second important stream of influence that had its origin in the Brown Decades: engineering.

XIII

Whereas in architecture one can characterize the leaders and innovators and to some extent isolate their contributions and influences, no such sorting out is possible in the field of engineering and the industrial arts. The greater part of this work has been anonymous: it was in the current of our civilization and our needs, and almost any one could have done it. Who built, for example, the great grain elevators of Duluth or Chicago or Buffalo? Occasionally one runs across a name like that of Denkmar Adler, who was associated with some important Chicago engineering after his break with Sullivan; but for the most part the designers have remained unknown.

What pressure of ideas led to the systematic improvement of the

component parts of the bathroom—toilet, basin, tub, shower, fixtures —and to the steady integration of these separate units into the harmonious bathroom of 1920–1925, before competitive salesmanship with its period designs or its equally offensive "modernique" had ruined the handsome product of the factory? How was the kitchen turned into a slick and convenient and orderly laboratory for the chemical transformation of raw food into edible meals? These questions are almost impossible to answer in detail: not until each great branch of industry publishes its own history will the student have the necessary data for judgment; but the point is that, in defiance of the current traditions of taste and architecture, a steady improvement went on in all these departments. The costs of production were reduced; the products were made available to lower economic groups; the objects themselves became aesthetically integrated.

While the path towards an appropriate modern architecture was kept open by the excellent individual work of Frank Lloyd Wright, a corresponding communal advance was being made by the engineers who standardized building processes, invented new units of heating and plumbing and occasionally, almost without knowing it, threw up fine engineering structures of their own, such as the Ford Plant at Baton Rouge or the ventilator units of the Holland Tunnel in New York. Conscious of quantitative relations alone, impervious to the human effects of their processes, innocent of the aesthetic result, the engineer nevertheless had a real contribution to make. It was through his inventions and processes that architecture ceased to be the concern solely of the carpenter and the stone mason: a new battalion of trades and techniques entered it.

It was the engineer who hastened the use of the steel skeleton building; it was he who made possible the building with open walls. Despite Richardson's precedent and Wright's efforts, the architect had battled against the engineer and belittled his achievements: when he could not do without his iron and glass structure, as in the railroad station, he hid it behind an imposing masonry front. Fortunately, there were other exceptions besides Wright and Sullivan during this period; some of Ernest Wilby's designs for Albert Kahn showed a happy recognition of the inherent possibilities of the new materials. But it is only in our own day that the integration has begun to go farther and to touch the problem of the dwelling-house itself. Since every new mechanical utility, however indispensable,

has increased the cost of the modern dwelling, by diverting to machinery energy and money that used to go into the bare shell, the critical problem of modern architecture has become:

How to restore by good design in the community the spaciousness, the colour, the interest that is lacking in the environment of the individual house? Once we face the problem of housing decently the great mass of the population-a problem which Western Civilization has flinched from during the entire industrial periodwe must recognize that the means are strictly limited. Sunlight, air, gardens, play-space, outlook: these are the main requirements of the modern house; and in providing these elements on a communal scale, the architect can no longer work for the single individual: his individual house will be a type-unit, adapted to the special whole in which it functions. Plainly, then, the integrated modern house cannot be created by a single hand; above all, it cannot be integrated merely from within. It requires an adequate type of community plan, properly oriented to sunlight, with publicly maintained open spaces and gardens and insulation from unnecessary traffic and movement: its bare severe interior-so necessary for simplified housekeeping-requires the presence of sunlight and living plants, pictures, and people to be fully humanized. The way to the new architecture requires the weaving together of the several lines of initiative which were first started during the Brown Decades: the attempt at community planning which marked the building of Pullman, Illinois, the experimental effort towards new forms which was exhibited in Richardson, Sullivan, and above all Wright, the effort to integrate the playground and the park with the city as a whole which characterized the work of Olmsted and Eliot, and the effort to raise standardized industrial production to a higher aesthetic level which marked the work of the last generation of plumbing and kitchen utility manufacturers. No one of these elements by itself is sufficient to create a fine architecture; but once they are comprehensively united and directed, once the new architecture becomes the medium, not of some one individual's tastes and desires. but the informed, positive consensus of the community, form will cease to be a sporadic possibility and become instead the mark of our whole civilization. Such a change implies a real revolution in our economic and social ideas; and no revolution would be worth working for if it did not imply, among other things, such concrete and comprehensive changes.

CHAPTER FOUR

Images—Sacred and Profane

"IN America, the present is an epoch of monstrous plaster figures, daubed with crazy paint; of mammoth cast-iron wash-basins called fountains; of cast-iron architecture and clumsy gateways to public parks; of shoddy portrait statues and inane ideal ones; of ornaments, pictures, and sculpture made to gull and sell."

With these words, the foremost American critic of art before John La Farge summed up the character of the fine arts in America during the Civil War. The writer was James Jackson Jarves, the founder of the excellent collection of primitives at Yale; the time was 1864. In one way, his words availed nothing: during the next generation the Civil War monument made its appearance, cast iron in material, cast iron in pose, bad in scale, disgracefully lettered; while the best painters did not emerge from a narrow circle of appreciation into popular approval. Nevertheless a change took place. Within thirty years American painting rose for the first time in the nineteenth century to the level of our literature.

The rise of the fine arts after the Civil War was forecast by the appearance of a new interest in aesthetics itself. It is doubtful, indeed, if the theoretical interest in art had any direct influence upon the work of the painters and sculptors and decorators; but the fact that the two appeared together indicates that the ground was ready. In John Bascom's treatise on aesthetics, the first president of the University of Wisconsin put forward the Crocean theory of art as expression in a very acceptable form: a departure all the more significant in America because of the moralism that irrelevantly surrounded every discussion of beauty and pleasure; while Jarves's efforts as a student and connoisseur, though unappreciated in his own day—his collection was transferred to Yale for a pittance under pressure of his financial distress—broke ground for

the work that Charles Eliot Norton and Berenson were later to accomplish.

Jarves's observations upon the sources of American art anticipate the interests and discoveries of a later generation. "The American," wrote Jarves, "while adhering closely to his utilitarian and economical principles, has unwittingly, in some objects to which his heart equally with his hand has been devoted, developed a degree of beauty in them that no other nation equals. His clipper-ships, fire-engines, locomotives, and some of his machinery and tools combine that equilibrium of lines, proportions, and masses, which are among the fundamental causes of abstract beauty. Their success in producing broad general effects out of a few simple elements, and of admirable adaptations of means to ends, as nature evolves beauty out of the common and practical, covers these things with a certain atmosphere of poetry, and is an indication of what may happen to the rest of his work when he puts into it an equal amount of heart and knowledge."

Jarves, again, detected the spurious quality of the current revivalisms in art, in words which no later writer has improved upon: "A fact that has had its natural birth, growth, and death, eludes resuscitation; but the principle which was the germ of the fact belongs to whoever can detect and apply it. Modern practice overlooks the law of nature too much. Instead of seeking to inform itself of those subtle laws which were discovered and applied to decoration by the ancients and mediaevalists, it spends its means and labour in futile attempts to repeat their works by the cheapened processes of manufacture. We get heaps of classical and mediaeval designs, without the informing life of the originals, and their conscious sympathy with their own times. Far better is it to preserve the models for instruction in museums than to debase their forms and pervert their spirit by mechanical enterprises for our adornment. Animated by their beauty, we might then hope to see invented forms no less appropriate and beautiful, as regards our civilization, than theirs appeared in the light of antiquity. No great work has ever been written in a dead tongue. Whatever mind there is in the production of antique ornaments, it is a voice from the tomb of nations, which comes to us as hollow as the language of ghosts."

The simple arts that Jarves had bravely praised went into decay during this period: the clipper-ship was supplanted by the steamer and the hooked rug was put aside for the machine-made Philadelphia

article; the handwoven coverlet retired to the outlying regions of the country. But the Art Museum and the Art School came into existence: the wood engraver flourished; the crafts of glass-making and stonecutting were restored. Of the lesser art of the Brown Decades one might say what Emerson said of the singing- and dancingmasters that followed the pioneer into the West: It is nothing in itself, but the more piano the less wolf. In the art of painting, however, one is not limited to such negative praise.

Stirred by the slightly more genial atmosphere after the Civil War, aided by the general decay of Puritanism and quickened by contacts with Paris, Düsseldorf, and Munich, the fine arts underwent a swift transformation. A group of authentic talents appeared, whom one groups in retrospect about two major figures, Thomas Eakins and Albert Pinkham Ryder. With Ryder belongs Robert Loftin Newman, who painted for forty years before he was given a public exhibition, to say nothing of George Fuller, whose work may be taken as a symbol of a whole school, including later men like Twachtman and Abbot Thayer. Around Eakins one may group that excellent landscape painter, Homer Martin, the versatile and eclectic decorator, John La Farge, the illustrator, Winslow Homer, and above all, Mary Cassatt.

Whistler falls in between Ryder and Eakins, poorer in imagination than one, unable to attain with his charm and facility and cosmopolitan knowledge the austere strength of the other, although he had a wider technical range than either: while Sargent remained to the end an illustrator who had the misfortune to choose a permanent medium, like the walls of the Boston Public Library, for graphic conceptions that had no real pictorial depth or lasting power. The most adroit appearance of workmanship, the most dashing eye for effect, cannot conceal the essential emptiness of Sargent's mind, or the contemptuous and cynical superficiality of a certain part of his execution.

This grouping of the painters of the Brown Decades was not, one need hardly explain, the contemporary one: it is only during the last ten years that criticism has reduced the overblown reputations of that period and fixed a proper value on some of its obscurer talents. But as the years go on, the overwhelming importance of Ryder and Eakins becomes more and more indisputable. When Auguste Rodin said of the art of the Brown Decades: "America has had a Renaissance, but America doesn't know it," he was not far from the truth. To understand the appearance of Ryder and Eakins, their struggles,

their achievements, one must also say a word about the careers and interests of some of the lesser artists who surrounded them. Even the greatest solitary figures owe a debt to their society—and not less because society repudiates the compliment.

II

Outside the meagre province of the decorative arts, there had been two forms of genuinely popular art in America. One was the portrait, and the other was the illustrative print. The first kind had achieved its highest expression in the paintings of Copley in the middle of the eighteenth century; the men who followed him, like Gilbert Stuart and Jonathan Trumbull, were as far behind him as Lawrence and Gainsborough were behind Hogarth in England. Though the portrait tradition was carried into the nineteenth century by Samuel F. B. Morse, who was no mediocre artist, his concern with the invention of the telegraph can partly be explained by the disappointing lack of patronage that attended his career as a painter.

By the middle of the nineteenth century the portrait tradition had almost died out: the decay of the landed family and the coming of the daguerreotype shared responsibility. When it partly recovered after the Civil War, it was no longer on its colonial basis, deferentially submissive to the principles of Sir Joshua Reynolds and the English canons of good taste. What remained of this tradition was carried on by that surviving craftsman, the itinerant painter. He peddled his skill through the countryside, sometimes equipped with canvases that had already been painted in job lots with fashionable costumes and backgrounds, in which, for ten or fifteen dollars, the amiable artisan would insert a head, flattering, prettified, usually quite wooden.

The other living form of the graphic arts was that of the woodcut and the lithograph, which first came into use as a medium of news at a time when illustrations were unknown in newspapers and photographs could not be reproduced by mechanical methods. Under the commercial exploitation of Messrs. Currier and Ives in New York, the lithograph began to flourish before the Civil War. The pattern for these prints had been set by various French series which had depicted the landscapes and cities of America. Taken over by native artists, they now covered a wide range of subjects—scenes from rural life, typical sports, life on the Mississippi, in the whaler, in the gold camp, on the prairie. For the most part, Currier and Ives prints have no

other value than as documents or mementos; but occasionally, by some happy accident, a print of genuine aesthetic merit would emerge. The most interesting examples antedate the Civil War. In the eighties, they became crude and lifeless, and they lost graphic vitality as they sank in popular esteem. But the interests which had first been exploited by Currier and Ives were taken over by the illustrated magazines that were founded just before the Civil War, particularly by *Harper's Weekly*; and until photo-engraving took the place of wood-engraving a really excellent school of draughtsmen had grown up, headed by men like Timothy Cole, by whose work some of our less significant artists were more skilfully presented than they were by their own direct efforts.

The tradition of the itinerant portrait painter underwent a metamorphosis in the career of one of the last of them, George Fuller, while that of the colloquial illustrator reached its culmination in the more mature and competent draughtsmanship of Winslow Homer. In these two men one stands before the bridge which unites the older provincial tradition of American art with that which emerged during the Brown Decades.

III

Although Fuller's larger achievements as a painter belong to the seventies, he himself was a contemporary of Thoreau and Whitman; for he was born at Deerfield, Massachusetts, in 1822, the son of a New England farmer. There was an aesthetic tradition, of a sort, in his family; one of his uncles was an artist, and his mother's father, though a lawyer by profession, was an amateur painter, one of that group which left a precious record of the American scene in the days before the photograph came, a record whose very imperfections are revealing.

At fifteen, Fuller joined a surveying expedition to Illinois, and had a taste of the wild marauding life of the frontier; but already his aesthetic sensibilities were sufficiently developed to make him forget to shoot the deer and turkey, on a hunt, in his admiration over their forms. After two years in the West, Fuller returned home: he was not weaned from New England and its civil pursuits. In 1840 he went off with a half-brother who was a travelling artist, to make his living by painting portraits, too. In the years that followed, his work took him all over the country; he even made excursions to Charleston, Mobile, Augusta, one of that flock of shrewd Yankee merchants,

which included Bronson Alcott, the educator, who swarmed through the South, sometimes attracted almost as much by the leisurely and European air of culture on the great plantations as by the prospects of gain.

The death of Fuller's father in 1859 brought about a change in his life. His first move was to make a tour of the galleries of Europe. Unlike many other Americans during this period, he was stimulated rather than disconcerted by the experience; and he neither tried to resist European influences, as Hawthorne puritanically did, nor did he let himself be overwhelmed by them, any more than his younger contemporary, Ryder, did a generation later. "How I felt in such company?" Fuller writes. "If you ask, I shall confess that I grew with the occasion and was not put out of countenance in the least. It is only poor works that drive one to despair." He met the Pre-Raphaelites in London and Ruskin himself in Geneva, where, at the Hôtel des Bergues, they found themselves in singular agreement over the Italian masters.

After this trip, Fuller married and settled down on his parental farm. Did he like farming? No: he wanted to paint; but, unlike the Americans who were so rapidly "winning the West," in the way that a swarm of locusts wins the fruits of the countryside, he felt a loyalty for the soil his ancestors had cultivated. On Sundays, and during a good part of the winter, he painted in the studio he made for himself in the old chaise-house. Like many other farmers in the Connecticut Valley, Fuller had gone in for tobacco-growing; and, as with them, the panic of 1873 had brought him into bankruptcy. In 1876, Fuller took a dozen recently painted pictures to Boston with him on a business trip, in the hope of being able to sell them. The exhibition was an astonishing success. During the remaining eight years of his life, he worked constantly at his art.

What are Fuller's pictures? His later work, figures, portraits, landscapes, all suggest that nostalgia for beauty that haunted and plagued the severe Puritan mind. He gave in to the desire, and in the act of painting did his best to suppress it. Nothing comes out of the background sharply and boldly; but the world is seen through a pervasive mist, vague, tender, in which the forms are evanescent and only the atmosphere is stable. All these pictures are keyed low; there is no sense in which one can call the best of the painters of the Brown Decades colourists: colour was to be discovered in the eighties, seized on as a thing in itself, and reduced to superficial formulas in

the work of the American impressionists, seeking dash, vigour, similar signs of animatedness, forgetful of the fact that a truly vigorous spirit can be gay and strong, if necessary, in black and white.

There has been something wistful in the American character that shrinks from the harsh forms of reality: it appears in the work of another New Englander, Whistler, in his dim nocturnes; and it comes out a little later in Twachtman, who gave Fuller's autumnal palette the benefit of a bath in Monet. Fuller knew as well as any one the foreground of American life: its mean factory towns, its wild pioneer settlements, the gaunt scraggly growth of second cuttings of timber; but, lacking so many of the assurances of a cultivated existence, he could not face these things in the raw. Putting the ugliness of contemporary life at a distance, Fuller was constrained by the same logic to put all robust and fleshly realities at one remove, too: even the budding figure of a young girl could not be seen plain; for there was in Fuller a touch of that sentimental adolescence one finds equally in Thoreau, the impulse to seek the Ideal, not through the fuller richer use of what the body brings and signifies, but by its persistent disembodiment. If the popular spiritualist mediums of the seventies sought to make ghosts materialize, the artists tried rather to dematerialize matter-quite another thing from spiritualizing it, that is, enriching it with memory, allusion, symbol. At his weakest, Fuller was plainly the contemporary of the founder of Christian Science.

Though the impulse to turn his solid forms into mere plasmic suggestions weakened Fuller's work, it saved him from the photographic literalism which he properly abominated—all the more because his earlier patrons had doubtless insisted upon it to the last degree. In his best pictures, Fuller produced an effect that was warm, rich, tender; in his other moments he was a little gingerly, a little unwilling to give himself away, or, as the saying is, to show his hand. The biographer who praised him with the assertion that he had never painted a brutal head, gave the limit of his qualities and aspirations.

Fuller had the New England desire for purity, for an ideal world: a body purged of bone, sinew, intestines. Art, if it did not actually preach sermons, was to be the embodiment of a pure life. Such an aim may be carried to the point of fanaticism; and the rich grossness of later men like George Luks and George Bellows was a protest against its absurdity. But Fuller's aims did not lack a relation to

contemporary reality; for a Scotch observer, depicting The Americans at Home, declared after a visit in 1867 that "a beautiful Canadian or American girl comes nearer the popular idea of an angel than any being I ever beheld out of dreamland.... Every second or third face suggests delicacy and dyspepsia." This particular idea, this perversion if you will, is outside the frame of our present picture of life, with its striding Amazons who play tennis, swim, tramp, drive motor cars and airplanes; but it records a moment of adolescent consciousness that the American has peculiarly clung to. George Fuller objectified this feeling, and in his essentially sweet mind, it occasionally became art.

IV

Winslow Homer was quite another kind of man. Born in 1836 of old New England stock, Homer pursued his art steadily from his early boyhood. A pencil sketch of boys' figures, done from life at the age of eleven, marked him out for the career of illustrator which he pursued to the end of his life: the movement of his figures, the skilful foreshortening of the limbs, were extraordinary-and highly promising. His training did not encourage higher talents; for of examples of great art, the United States was then nearly destitute. The family lived in Cambridge, and Homer's father, after a visit to Paris, brought him back a complete set of woodcuts by Julien. At nineteen Homer became an apprentice in a lithographer's shop in Boston, and his first work was designing title pages for sheet music ordered by Oliver Ditson. He even did a series of portraits on stone of the entire Senate of the Commonwealth of Massachusetts. On his twenty-first birthday, he rented a studio for himself in Boston and began a series of drawings on Life in Harvard College.

Plainly, the mould of Homer's talent was set by the popular lithographs of the period, albeit John La Farge mentions also the slightly later influence of prints of the Barbizon school, whose work was early appreciated in Boston through the discipleship of William Morris Hunt. What is not, perhaps, so plain is that the commonplace gaucheries of a Currier and Ives print were carried by Homer into the realm of fine draughtsmanship, and that Homer's own talent was at his best in the pencil sketch and the lithograph. The occasion for Homer's work was presented by *Harper's Weekly*, which published his first drawings, Spring in the City, on April 17, 1858. During the war,

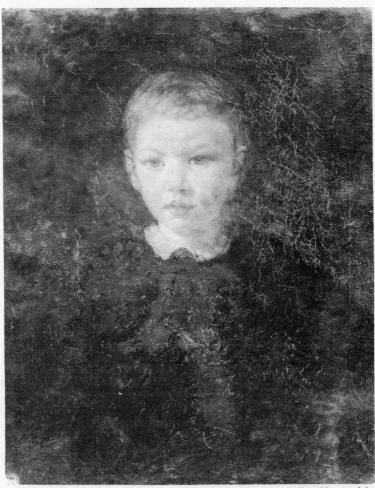

Metropolitan Museum of Art

BOY by George Fuller.

ON THE BLUFF AT LONG BRANCH by Winslow Homer. 1870.

this same weekly commissioned him as an artist-correspondent with the Northern Army; and Homer kept on drawing for its pages more or less regularly until 1875.

In characterization, in racy observation, in sheer exuberant masculinity, Homer never did anything on a more pretentious scale that surpassed his best drawings in Harper's. These journalistic illustrations of his, particularly after the Civil War, had great aesthetic vitality, whereas his more pretentious series of oil paintings of the Maine coast and the Maine woods and Indian guides and turbulent seas and moonlight on some rocky promontory have little solid aesthetic bottom: they are at best happy snapshots, mere illustrations, rather than imaginative reorganizations of experience. The full-page drawings that Homer contributed to Every Saturday, a short-lived Boston weekly, drawings such as "Shovelling Out" or "Cutting a Figure," if they lack the large intentions of his later canvases, have the virtue of achieving excellence at their own level. Homer was in fact an historian and illustrator of our society. He knew the country life of New England and the Catskills, he visited the plantations of Virginia and depicted the surviving life of the negroes there: such a rôle is honourable enough to require no extra aesthetic support: if the pictures are true to the imagination, too, as are the canvases of Breughel or Hogarth, that is just a happy gratuity. It is a great pity that Currier and Ives were on the downward path after the Civil War: had they had the sense to employ Homer, instead of inferior talents, both he and they would have gained by the association. Homer's rapid dramatic eye, again, is what gives value to the water colours he made in Nassau and the Bahamas: the finest products of his later years.

To say that Homer had an eye only for surfaces and the passing moment is to say both the best and the worst about his art. Within the limits of journalism, his reactions constituted a talent: they were combined with the photographer's patience, so that he would wait days to recover the exact tones and colours with which he had started on a canvas, and he even used a portable hut by the oceanside, so that he could get close to his subject in inclement weather. But to say this is to confess that little came from within. In his old age Homer kept on asking querulously: "Why should I paint?" The outer stimulus was becoming dull. He could react, but, with youth gone, he had lost the reason for reacting.

A crusty, taciturn hermit, living in his cottage at Prout's Neck on

the Maine coast, cooking his own meals, rebuffing visitors, settled and self-sufficient in his ways, Homer was the very prototype of those half-vulgar, half-aristocratic characters that E. A. Robinson has depicted in *Tilbury Town*. Homer's real significance for American art did not lie in the quality of his painting nor even in his queer personal integrity: it lay in the fact that he embraced the life about him and made what he could of it—the coast, the sea, the weatherbitten faces, all the homely decencies, heroisms, tensions, defeats, proving that these subjects were as much the repository of the ideal as angelic nonentities obviously badged with virtue. Homer's visit to Paris in 1867, or to England in 1881, or to the islands of the American tropics in later years all had their effects upon him; but neither they, nor his growing popularity in the New York galleries, could shake his proud stern provincialism.

With Homer, American illustration reached a temporary climax, and then abandoned its honours to photography—or became in itself photographic, as in Homer's later paintings. It remained for a group of later artists to pick it up at the point where the popular illustrators had left it in the seventies.

v

What Homer accomplished in the illustration, John La Farge, working somewhat against the dominant forces of his time, was to achieve in decoration. La Farge was the son of a French planter who had escaped the massacre in Santo Domingo in 1806 and had taken refuge in New York. From his birth, in 1835, La Farge was subject to the cosmopolitan influences of the great Port of New York and the tastes and interests of a cultivated French family. Such a mind could not be purely of the soil, any more than that of a born wanderer in hotels like Henry James: what he brought to American art, therefore, was not a rich sense of its own inherent experiences and symbols, but a wider and fuller knowledge of its common heritage in Western Civilization. La Farge was in fact the eclectic at his best, broad, humane, understanding, perceptive, making up for the lack of intensity and positive originality by his easy access to the culture of the past. In 1856 he visited his French relatives in Paris and studied with the inevitable Couture; and as early as 1863 he imported Japanese prints to America.

La Farge was equally responsive to every fruitful contemporary

interest. He understood Delacroix; he took over the fresh palette of the impressionists, of which there was no hint in his youthful studies of landscape, done in subdued greys and browns; he broke new paths in the decorative arts. While La Farge's final importance for America lay more in the fact that he made accessible and intelligible so much of the culture of Europe and the Orient, his immediate effect upon his own generation was due to his aid in re-awakening, with H. H. Richardson, the decorative arts. Whatever the destiny of the decorative arts in our own day—and in some form or another, they will doubtless survive, if only because their practice is so amusing and sanative—there was a need in La Farge's time for the sort of free manipulation of materials that glass-working, ceramics, stonecarving, and wood-working encourage.

La Farge turned to the design and manufacture of stained glass at the same time that De Morgan was turning to ceramics and Morris to furniture and tapestry. He did his first important window for Van Brunt in Memorial Hall at Harvard University; but as early as 1867 Richardson had seen some panels La Farge had done for a dining room, and promised him the first decorative work at his disposal: this turned out to be the windows for Trinity Church in Boston. La Farge had more than one opportunity to execute murals; and these constitute a more important part of his work than his easel pictures; but his most brilliant contribution came through the manufacture of glass. Though, remembering all its vulgar consequences, one cannot share his delight in the contrivance of opalescent glass, a notion that came to him during an illness, when he noticed the sunlight pouring through the cheap milky glass of a tooth-powder receptacle, he did more to restore the almost lost art of glass-making than any of his contemporaries.

Bing, the creator of the Art Nouveau movement, wrote a report on La Farge's glass for the French government in 1893; and had architecture continued along the originally romantic lines that Richardson had traced, La Farge's work would have been thoroughly important. By the time he died in 1910, he had made several thousand glass windows; and his interest in glass was reflected not alone in the innumerable stained-glass bathroom windows which are among the funnier tags of the architecture of the Brown Decades, but in the wider use of glass itself, as an entertaining and effective material, above all, in the earlier work of Mr. Frank Lloyd Wright. Perhaps the most viable outcome of La Farge's interest today is the

effect it had upon Henry Adams's magnificent interpretation of the glass in Chartres Cathedral, an understanding that he doubtless owed directly to his friend.

La Farge did in America what only an eclectic artist could do: he placed the American artist on a footing with his contemporaries in Europe, and overcame, through his keen criticism and excellent expositions, the touch of provincialism that would in the long run have proved a serious handicap to American art. Mr. Walter Pach has performed a similar function in our own day, with equal vigour and understanding; and one cannot question its utility. The artist who introduces the ideas and forms of other cultures may not be able to use them fully, for lack of that very narrowness and intensity which his knowledge robs him of; but the bee is as important to the flower as its own pistils and stamens; and the part that the pollenbearers play in a culture should not be underestimated.

How shall we assay this French influence, first brought into the Brown Decades by William Morris Hunt, who had sat at Millet's feet? It was, without doubt, a real advance when American painters turned from London, Rome, Düsseldorf, and Munich to Paris. Coming in contact with the French, they came into relations with a continuous tradition which, reaching back to the portrait painters of the sixteenth century, was still alive in the works of Degas, Daumier, Cézanne. Under this tutelage, the American learned the value of draughtsmanship and paint, distinguished between the literary subject and the graphic subject, and acquired the appetite for life one finds in the French painters, ceasing to be frozen by the requirements of gentility and "good taste."

The real difficulty in such tutelage and assimilation is that a healthy relation is possible only when the learner and student has a centre of his own. There was much more intelligence in Ryder's declaration that the galleries of Europe meant nothing to him than there was in the assumption that the galleries of Europe could be a final home and resting-place for the questing American. The influence of French art upon personalities not sufficiently strong to absorb it in accordance with their needs was to focus attention upon those elements in painting that respond directly to the eye and the hand: in short, it made minor copyists, who had acquired all the tricks of current French art, but had missed its original content, the formative experiences that had made it precisely what it was. The one notable exception was Mary Cassatt, for she assimilated the French scene

and French interests, and her etchings and pastels do not dishonour Edouard Degas, her master and friend.

It is not that one requires the American painter to be specifically American in the sense that he utilizes local colour, local scenery, local symbols: rather, one asks that his pictures should be a resolution or an interpretation of his total experience of life, and if he is an American that fact, along with many others, will be an inescapable element in his work. The only use of an American theme is that, with certain artists, like William Glackens, it seems to make accessible a richer experience; while with others, like Homer Martin, the painter loses nothing by his more casual relations with a foreign landscape.

VI

We now pass to an artist of more positive talent than La Farge, of superior grasp to Winslow Homer: Thomas Eakins. He was born in Philadelphia in 1844. After beginning at the study of art in his native city, he went to Paris in 1866 and placed himself in the studios of Bonnat and Gérôme, while he took special lessons from the sculptor Dumont. Eakins' continued interest in sculpture and his later study of anatomy at the Jefferson Medical College are important to remember in understanding his art: his realism had nothing to do with the fashionable impressionist photography of the period, but had its source in the conception of every object as a three-dimensional solid, whose surfaces must be fashioned in terms of expressible content and function, not superficially rendered as light and shade.

Eakins' visit to Spain during the Franco-Prussian War doubtless brought him into contact with Velasquez; indeed, one would suspect Velasquez and Rembrandt as direct influences from a study of his major portraits; but beyond his immediate aesthetic heritage, Eakins was open to all the new forces at work in his century, and he had that infinite curiosity and patience and exacting sense of workmanship which was common to its technicians and scientists. The time when Eakins painted, as Mr. Frank Jewett Mather has admirably put it, "was in a singular sense a moment of hesitation. Darwin, Huxley, Herbert Spencer, and Matthew Arnold were novelties, presenting urgent problems, with which thinking people had to cope. Everything in belief, and much in practice, had to beradically reconstructed, with a dire off-chance that only destruction was possible. There had been no time to think it through, nor yet to adopt the defeatist policy of letting it alone.... His gift was to

understand a generation, seeking grimly to find itself, and saddened by an uncertain quest." Eakins was in fact the mirror of his period, the object mirrored, and the aesthetic expression which resolves these terms.

The life of this man was quiet and obscure. It had, apparently, no inner need for dramatic displays and compensations, not even surreptitious ones. He taught art and anatomy from 1873 on; he painted numerous portraits and hoped to be paid money for them, although his disconcerted patrons, unpleased by his relentless honesty, often left the canvases in his studio, or hastily confined them to their own garrets. Though as early as 1879 a writer in *Harper's Monthly* mentioned Thomas Eakins along with Mary Cassatt as a painter of great promise, and though prizes and medals came to him occasionally all through his life, his house when he died in 1916 was filled with unsold canvases; and it needed his death, and a retrospective exhibition at the Metropolitan Museum, to make us realize the strength of Eakins—one of the two or three American artists who rank with the best painters of his period in Europe, in solid achievement, if not in the power of innovation.

The number of anecdotes about Eakins increases daily. He was, to begin with, the son of a writing-master, and his pictures are signed in the painstaking and undistinguished calligraphy his father must have taught him. He had an intense interest in science and in the men who pursued it. One of his big canvases, done shortly after returning to America, is that of the Gross Clinic, which depicts a great old-fashioned surgeon, expounding the principles of a pre-Listerian operation. The mild unflinching butchery of the surgeon, the abstract calculations of the physicist, the tense, dry, somewhat bleak faces of the scientific men of his period, crystallized once for all in his portrait of The Thinker-these subjects attracted Eakins and he interpreted them, not as a romantic visitor, but as a colleague or disciple. It even suited Eakins' sense of fitness to have Henry Rowland, the physicist, scratch the formulae connected with his name around the panel that framed his portrait: a piece of veracious iconolatry. Eakins himself was a graphic thinker. He had a blackboard hung in his dining room so that any one who cared could explain his conversation by diagram or outline. One reasonably suspects something more than a patter of polite banalities at the Eakins dinner table.

Along with Eakins' respect for science went a hearty contempt for

the hierarchies of caste and office, a feeling characteristically echoed by Thorstein Veblen's *Theory of the Leisure Class* which, published in 1898, belongs to the period of Eakins' maturity. Commissioned by the Union League Club of Philadelphia to do a portrait of President Hayes, Eakins seized his one opportunity with the President to capture him working in his shirt sleeves. The horrified committee consigned the portrait to limbo; and, I understand, it has never been found. Eakins admired the oarsmen in their shells on the Schuylkill; and he went back again and again to the prize ring. He seized the moment of pause, the return of the fighter to his corner, the oarsman resting on his oars, and he communicated, in these resting figures, a deeper sense of actuality than any snapshot of fleeting and combative moments.

Naturally, Eakins would sometimes be one of the group that would have dinner with Walt Whitman in Camden on Sundays. Indeed his work was a carrying into the graphic arts of those principles which Whitman had announced in his Preface to the Leaves of Grass, and expanded in his Democratic Vistas in 1870: science, democracy, plain men and women, the sacredness of the everyday fact, the miracle of the humblest phenomenon, the most ignorant human creature-all these beliefs Eakins plainly shared. If Eakins rescued his art from the superficialities of a photographic naturalism, he rescued it also from the weak dramatic symbolism of an Elihu Vedder, the adolescent sweetness of a Fuller, or the mere illustration of a Homer: above all, he made it face the rough and brutal and ugly facts of our civilization, determined that its values should grow out of these things, and should not look for its themes to the historic symbols of Europe. But there is in Eakins' work no false idealization of labour and brawn: Eakins respected the manual workers too much to pay them this inverted and disreputable compliment. On the contrary, the sensitive, intellectualized, acute, anxious faces of scholars and scientists dominate Eakins' gallery: he knew that the toughest and most stubborn encounter with reality might lie behind a mathematical equation.

"I never knew of but one artist, and that's Tom Eakins," said Walt Whitman, "who could resist the temptation to see what they think they ought to rather than what is," and again, speaking in defence of Eakins' slightly leering portrait of himself, Whitman said: "We must remember that Eakins' picture is severe—keeps close to nature—slurs nothing—faces the worst as well as the best." Here

was just the quality that was lacking in the literature of the Brown Decades, in the novels of Howells, as well as in its lesser manifestations. But no degree of refinement or sensitiveness was beyond Eakins' reach: his portrait of Señora Gomez or that of Arthur B. Frost discloses the inner drama. Eakins had a singular capacity of doing justice to his subject: he had no temptation to make his thinkers brawny or his prizefighters and oarsmen intellectual. He could meet them all on their own ground, and find in each subject his peculiar strength or his unconcealable weakness.

Eakins had the careful workmanship of the old-fashioned writingmaster, if not his meaningless flourishes. With all his tough masculine interests, and for all his love of sailing, horseback riding, duck shooting, he was at his best with human characters. The backgrounds of his portraits are frequently empty; if they are painted in at all, they are too often thin and unsatisfactory; but this weakness is the result only of the intensity and stress that has gone into the figure itself. Some of the unfinished portraits, incidentally, are superb in their own right, being finished in every sense at the moment that Eakins withdrew from them, although parts of the canvas might be left blank.

Eakins was once asked to give a lecture for a group of workers and explain to them the current Academy show. He answered: "The artist's appeal is a most direct one to the public through his art, and there is probably too much talk already. The working people, from their close contact with physical things, are apt to be more acute critics of pictures than the dilettanti themselves, and might justly resent patronage. In my own case I have not yet found time to examine the Academy Exhibit, and would be puzzled indeed to tell anybody why most of the pictures were painted."

A salty directness, an absence of pretence and sham, is present in all of Thomas Eakins' work. "All the sciences," he said, "are done in a simple way; in mathematics, the complicated things are reduced to the simple things. So it is in painting. You reduce the whole thing to simple factors; you establish these and work out from them, pushing them toward one another. This will make strong work. The old masters worked this way." Such words as these make one realize Whitman's wisdom when he said: "Eakins is not a painter, he is a force." Working in relative obscurity during the Brown Decades, though always drinking from the sources of contemporary life, Eakins, like his contemporary in philosophy, Charles Peirce, now

enters American culture as both a painter and a force. He stood outside the fashionable currents. The high-keyed palette, the slashing brushmark, as in Homer and Sargent, the refined and "beautiful" subject, as with Dewing, Tarbell, Brush, or the sunny impressionism of Childe Hassam and Alden Weir and John Twachtman, all these various symbols of popular esteem Eakins spurned. He never got nearer the colours of a sunny summer landscape than did Courbet; indeed, for all his colour indicated, he might have been painting in the Netherlands of the seventeenth century.

No matter. The Brown Decades are as far away from us now as the seventeenth century, and a world built up on the dull side of the palette, a world of slates and muds, became familiar to us again less than two decades ago in the paintings of Picasso, Braque, Derain, Duchamp. We are no longer deceived into believing that there is any ultimate rightness in the selection of colours on some scientific basis: it is not nature but the mind of man which establishes the aesthetic value of a certain colour scale, or set of tonal values: and if Eakins did not choose to experiment with the palette of the open-air school, that was his own business: so long as his health did not suffer, his practice casts no reflection upon his art!

Eakins avoided most of the pitfalls and ha-hahs that were in the path of the American painter in the Brown Decades. He showed that, with a little talent, and a little tenacity of purpose, provided one had no care for popular appreciation and immediate success, works of art could be created, even in a materialistic country that denied the value of an art unauthenticated by the efforts of brokers and auction rooms. Today the assured place of Thomas Eakins taunts the hasty efforts of those contemporaries who aimed at lesser goals.

VII

American history is haunted by nightbirds in the nineteenth century. One might almost divide cultures according to their habit of viewing the world in the hard sunlight of midday or in the murky vistas and undecipherable horizons of night; and the discovery of night, night sinister, night terrible, night mysterious and indefinitely potent, was one of the great attributes of the romantic movement. In the night, windmills are giants and the horns of elfland are always faintly blowing. Poe invokes the night, even in daylight: dismal tarns and dark mysterious shapes are always present to his imagination. Hawthorne spent the greater part of his youth in solitude, never

venturing abroad until night had fallen—and that 'experience bit deep into his imagination.

After the Civil War the shades of night fell, too, upon painting. In the mind of Albert Pinkham Ryder a dark, moon-ridden world, stirring with a strange beauty that indicated unexplored realities, deeper than the superficial levels of being, came into existence. In contrast to the firm tough prose of Eakins, Ryder's imagination was lyrical and poetic; but beneath his mysterious shapes, his haunting idealizations, were the familiar objects of his boyhood on Buzzard's Bay, the sea and little boats and moonlight and the gnarled branches of dwarf oaks and the porticoes of the great classic mansions on County Street in New Bedford where he was born on March 19, 1847. No one except Melville, who sailed to the South Seas from this same whaling port, had such a deep sense of the beauty and treachery of the sea as Ryder did; and no one, not even Melville, expressed this more completely and poignantly, suggesting in the fathomless ocean the fathomless mystery of life itself.

Even during his youth in New Bedford Ryder's life was not altogether destitute of aesthetic suggestion, crude and second-hand though it might be. Was not one of the most popular painters of American landscape, Albert Bierstadt, a wealthy citizen of New Bedford? Did not one of Ryder's aunts know how to paint, and sit in judgment on his first efforts? The aunt could not approve of Ryder's ability; but, with a blank canvas before him, he felt that he started at scratch with the great masters; and no outward discouragement could deter this gentle young man. When the whole family finally moved to New York in 1871, Ryder associated himself for a couple of years with W. E. Marshall, a portrait painter and engraver, who had studied under Couture; and for a very short while he studied at the Academy. At thirty-four Ryder set up a studio for himself on Washington Square; and except for an occasional trip to Cape Cod or to Europe he remained in this part of Manhattan for almost the remainder of his life. His best work was produced in the short period from 1873 to 1898. After that, Ryder devoted himself chiefly to reworking the canvases he had already painted-bringing some of them to perfection, and falling short, perhaps, in others, of his original aim.

With less turmoil and stress than Vincent Van Gogh—although, around fifty, Ryder seems for a time to have gone through a nervous crisis that roused concern in his friends—Ryder shared the same

saintly devotion to his calling: nothing tempted him aside from the path he chose to follow, and nothing could make him hasten his pace. His work had the approval of a few friends and patrons, like Daniel Cottier, the art dealer, and Thomas Clarke, an excellent and understanding patron of the arts: so Ryder found his own themes, established his own technique, created and peopled his own world, and painted with the majestic deliberation of a demiurge who had eternity before him. One may properly speak of Ryder as a mystic only if one realizes that, contrary to popular belief, the mystic does not leave the familiar world: if he has anything to give us, it is because he has penetrated deeper into its reality. Ryder, like Melville, was concerned with the depths, the part of experience that eludes statement, that must be hinted at, approached obliquely, rendered in parables. But he had the Yankee's canny hold on fact; and when he chose to portray the loneliness of the soul, he might convey the meaning through a little boat with a torn sail, swallowed by the ocean.

Ryder's compositions are often very simple, though they were studied out and readjusted with the same fine eye that the New England carpenter had used in making an aesthetic work out of the windows, walls, and roof-lines of the traditional farmhouse. Gradations of tone, simple juxtapositions of light and dark, serve in Ryder's lesser canvases for intricate contrapuntal masses and colours: such economy and simplicity was not, in Ryder's art, the result of the first happy stroke: he worked slowly, and by the slow considered perfection of each last detail, a finer and finer balance of masses, a more and more delicate line, finally reached his goal. Often, with the ordinary artist, we are delighted by the freshness of the sketch and disappointed in the finished picture. Ryder had just the opposite ability: his beginnings were dim, and he usually tore up his early sketches: but he had an exceptional ability to carry his work through. He approached perfection slowly; but he had the gift of approaching it: he was not in any sense a hit-or-miss painter.

Ryder's method reminds one a little of a modern poet, Robert Frost; there was the same slow mulling over the work, the same patient refinement of detail, the same effect of apparent simplicity gained only by the subordination of each separate stroke to the effect of the whole. Such intensity demands a strength that the user of bold adjectives and loud colours can only rarely achieve: for the

more facile artist tends to exhaust on the commonplace the emotion that the other holds in reserve for the supreme moment. There have been many forgeries of Ryder's pictures; but not one was worth the effort; for their careful composition, their rich enamelled depths, cannot be obtained quickly enough to reward the deceiver. While there are undoubtedly weak paintings by Ryder, there are no hasty ones.

In his technique, Ryder was lonely, experimental, in a sense, perverse. He would bathe his pictures in varnish, in order to increase the depth and lustre; he would paint over surfaces that had not completely dried, and paint over those again; he was careless as to the permanence of his colours: elementary principles which he would have learned in the studio of a competent master before he had advanced beyond the palette-scraping stage were never mastered by him-or were resolutely ignored. As a result, it is a rare Ryder that does not show cracks; and the classification of Ryder as a colourist by a contemporary critic, or the comparison of his work with that of the Persian miniaturists, is inexplicable today, except on the assumption that a good part of the original colour was lost, either through decomposition or through later re-paintingsalthough here and there a picture remains, like the Perette at the Tryon Gallery in Northampton, which gives us a hint of this aspect of Ryder. His paintings were never done. Frequently Ryder would recall a picture from a purchaser, in order to finish it; and to one of them, who said that he would have his own funeral procession stop at Ryder's studio to claim the picture, Ryder replied in kind: "And even then you would not get it unless it were finished!"

Ryder was a divine innocent. When reproached for the flaws that were already plain in the surfaces of his canvases, he said simply that anything that was originally beautiful, like the Venus of Milo, remained beautiful no matter what disfigurements it had suffered. So with his pictures: so with his life. A newspaper reporter who visited his studio found the room a mere litter of tables, chairs, trunks, packing boxes, old magazines and newspapers, dirty cups and dishes on the floor, with stale food still left on them, the long streamers of paper hanging from the ceiling, dust and cobwebs everywhere. But what did Ryder see? "I have two windows in my workshop that look out upon an old garden whose great trees thrust their greenladen branches over the casement sills, filtering a network of light and shadow on the bare boards of my floor. Beyond the low rooftops

of neighbouring houses sweeps the eternal firmament with its everchanging panorama of mystery and beauty. I would not exchange these two windows for a palace with less vision than this old garden with its whispering leafage."

Such a man could not be allured by current standards of pecuniary success. "The artist," Ryder said, "needs but a roof, a crust of bread and his easel, and all the rest God gives in abundance. He must live to paint, not paint to live. He cannot be a good fellow; he is rarely a wealthy man, and upon the potboiler is inscribed the epitaph of his art... The artist should not sacrifice his ideals to a landlord and a costly studio. A rain-tight roof, frugal living, a box of colours, and God's sunlight through clear windows keeps the soul attuned and the body vigorous for one's daily work."

One knows by its fruits what happened in that narrow intense world Ryder built up for himself behind those two windows under the sky, varied with the nightly walks he was forced to take, partly to nourish his art, partly because, as a result of an unfortunate vaccination, apparently, his eyes would ulcerate under the strain of sunlight or continuous use. There are two kinds of contemplative art: that which achieves its intensity by an abstraction akin to the methods of the Hindu mystic, and that which achieves a similar result by concretion, absorption, concentration, packing into the symbol infinitely more than is present to the eye or ear. It was the second kind that Ryder achieved in his great pictures, Jonah, The Flying Dutchman, Sieg fried and the Rhine Maidens, A Sea Tragedy. Into these paintings Ryder packed the suppressed emotional life of the hermit, the strains of Wagner's music, the poetry of Shakespeare's plays, particularly The Tempest and The Winter's Tale, his observations of old familiar boyhood scenes, his experience in a great city. One of the tragic commonplaces of New York life, the suicide of a waiter in his brother's hotel because of the loss of his entire savings on a horse race, was transmuted by Ryder into the picture of Death riding around a racetrack, a solitary rider in an interminable race.

The intense life of these pictures is the reflection of an equal intensity, harmonized and prolonged over many years, in the mind of Ryder himself. "Have you ever seen," he asked, "an inchworm crawling up a leaf or twig, and there clinging to the very end, revolve in the air, feeling for something, to reach something? That's like me. I am trying to find something out there beyond the place on which I have a footing." An admirable characterization: one has only to

add that in Ryder's best pictures that "something" was definitely touched. With all their literary associations, heightened by the fact that Ryder often accompanied his canvases with poems, not without a simple ballad music of their own, his paintings were never merely illustrative or decorative: they were profound revelations. One might call Ryder the Blake or the Melville or the Emily Dickinson of American painting, and thus define, after a fashion, one or another phase of his art; but the fact is that Ryder was Ryder. Like every great artist, he belonged to that rare class of which there is only one example.

Ryder asked for nothing better from life than what life actually had given him: should we demand more from his art? Though, as Mr. Roger Fry has well said, a more craftsmanlike method of painting would have been preferable, "we accept it none the less as it is, as something unique in its methods, but something in which the peculiar method is felt to be essentially bound up with the imaginative idea and to be justified by the perfection with which it renders that." In the case of Ryder, the life, the method, the pictures, are one: if the flaws are common to each, so, too, are the virtues which this harmonious personality imparted to everything he touched, to his relations with men no less than to his canvases. He spent his last years at the house of some old friends in Elmhurst, L.I., and he died in 1917. The aroma of his personality, so sweet, so gentle, so strong, and in all that matters in life, so unflinching, seems to sweeten in retrospect his whole generation.

That an art such as Ryder's should have grown up and survived in the midst of the massive materialism which characterized the Brown Decades is one of those ironic commentaries by which the spirit is forever mocking at the limitations of the flesh: but it is, of course, no more surprising and in fact no more unaccountable than the rise of the sanctities of Christianity in the orgiastic culmination of Roman imperialism. Nor can one altogether deny the brutal dominant force some of its share in the phenomenon: its existence perhaps provided the need for compensatory expressions on another plane, and the intensity of one has some relation to the crass exuberance of the other. At all events, Ryder belonged to the period in which he found a haven and a retreat as much as did his neglected contemporary, Eakins. Like Eakins, he transcended its limitations. As Melville and Whitman represent the antipodal poles of the American spirit in literature, so do Ryder and Eakins in painting.

J. H. Wade Collection, Cleveland Museum of Art

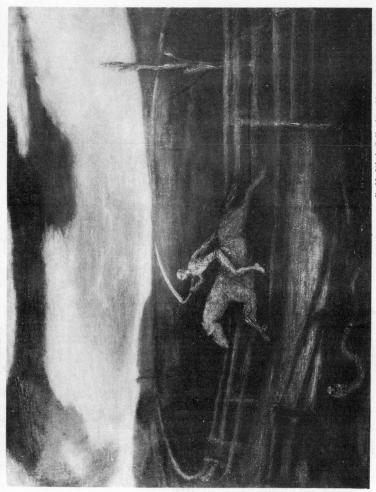

VIII

The Brown Decades had still another contribution to make to the arts: this was in the realm of photography. The daguerreotype had reached an early apogee in the portraits of Hill; but until the eighties he had nowhere found a worthy successor. It was in this decade that a young American, studying to be an engineer in the Polytechnic at Berlin, where John Roebling had studied before him, became interested in its photographic courses, and abandoned his chosen profession for photography. The name of this student was Alfred Stieglitz, and the fact that he approached photography from engineering, rather than from the graphic arts, only makes the example a more classic one, for photography, still and in motion, is one of the machine's chief contributions to human enjoyment, apart from some pragmatic use.

For the deliberate organization of the painter, the photographer must substitute another human quality: patience. In the course of a day, the eye beholds a thousand pictures; perhaps three or four of these have the elements of significant experience, fully organized, and perhaps one of them fulfils the relationships of position, sunlight, exposure, and angle necessary for the photo-chemical process itself. Stieglitz's records of America in the early nineties, some of which may still be examined in the pages of *Camera Work*, belong to the America of Eakins' portraits, the America of the Brooklyn Bridge: honest, sensitive, factual. For Stieglitz photography was not merely a matter of making pictures: it was an attitude toward life as a whole, an acknowledgment of the personalities and forces around him, an attempt to embrace them, hold them, comment upon them, interpret them, continue along the lines of their development.

Whether photography is an art or not did not concern him: indeed, why should it concern any one? If the result is interesting, the nomenclature is unimportant. Photography became for Stieglitz a major element in modern experience: it meant actuality: it meant light: it meant a human personality reacting to the world around it. His own pictures have a wide range, both in technique and in subject: the forms of immigrants, the shapes of ferryboats and trains in railroad yards and airplanes, the parts of the body and the abstraction of natural objects, the human face, aspects of mechanical instruments, and finally, in his later years, the sky and the clouds. Other men learned Stieglitz's lesson, his respect for the machine, his unwillingness to prettify its effects, his pleasure in the curious

veracity of light. The work of Paul Strand and Charles Sheeler stands close to Stieglitz's, at least in its resolute objectivity.

But Stieglitz's mission in photography was like Wright's in architecture: he was to demonstrate its manifold potentialities. He had faith in the photograph as a means of education; he foresaw the increasing importance of the photographically illustrated paper; he preached the lesson of the concrete symbol, the symbol beyond words, so necessary in an age that had closed half the world to itself by the great educational device of literacy. In Stieglitz's photographs one has the Sachlichkeit that Roebling was the first to express firmly in the Brooklyn Bridge. This quality is one of the distinguishing marks of modern civilization: first appearing in the engineer, it has made its way, step by step, into every other department of life. Stieglitz's uniqueness was to embody this Sachlichkeit without losing his sense of the underlying human attitudes and emotions. He did not achieve objectivity by displacing humanity but by giving its peculiar virtues and functions and interests the same place that he gives to steam engines, skyscrapers, or airplanes.

Objectivity by restriction is easy: objectivity by inclusion is a more arduous matter. To concentrate upon mechanical objects and symbols alone is one of the chief marks of weakness in our modern attempts to achieve equipoise in a world whose balance has been upset by machines and by large mechanical aggregates, institutions, habits, routines. Stieglitz, by his respect for human character, emotion and feeling, for sex and the great crises of life, has shown the way towards a more true and comprehensive objectivity—a *Sachlichkeit* which will not disguise an adolescent shrinking from reality or a shamefaced sentimentalism. Spanning the period from the Brown Decades to our own, he has carried over in his own person and work some of the most precious parts of that earlier heritage.

IX

One has only to examine the art of the last twenty years to see how rich and positive the main influences of the Brown Decades were; for the greater part of what is important today comes in direct line from Ryder, the poet, Eakins, the realist, Homer, the illustrator, and Stieglitz, the photographer and interpreter—if it does not come from those humane French sources, especially that of Renoir and Degas, which Mary Cassatt and La Farge introduced into the American scene, an influence renewed in our own time through the

work of Cézanne, Rodin, Matisse, and Picasso, and the other postimpressionists and cubists. Even where the connection between the Brown Decades and our own time is not direct, one is conscious of kindred impulses.

By 1895 the best of Ryder's painting was done; but a succession of young painters absorbed one or another lesson from the kindly old man, and even a writer like Stephen Crane sat at his feet. For a time painting, indeed, shared the fate of American architecture in the nineties: it seemed as if the scene might be dominated only by shallow technicians, incapable of grasping or carrying on the lessons of the genuine masters: Sargent was as far from Eakins as Stanford White was from Richardson. As for Alexander's murals in the Carnegie Institute, in which the mighty efforts of the steelmakers were depicted in paint which would hardly do justice to the efforts of a lollypop manufacturer—all one can say of them is that they were typical of the confusion between good taste and anaemia that has so often characterized American life.

But the best traditions of the Brown Decades were not dead; indeed, they suffered less in painting than in many of the other arts. Although Eakins had resigned as professor in the Pennsylvania Academy in 1885, as a result of the fuss made when he used a male and a female nude at the same time in his life class, his example and his special appetite for life were not lost. Towards the end of the century a group of young men had risen around Philadelphia, who shared Eakins' interest in the actualities they touched and saw and experienced in the crude environment of the industrial city. Most of these young men lacked Eakins' passionate scientific concern for form; and after going through the Academy they found a place for themselves as illustrators on the Philadelphia papers; but, like Norris, Dreiser, Herrick, and Sinclair, their contemporaries in literature, they confronted the life about them and became its commentators and reporters. For the most part, their aesthetic problems were subordinated to their human reactions, their pity or indignation or joviality; but whatever else they may have lacked in painting, they at least kept it in organic relationship with life and thought, a onesided view of life, a limited world of thought, perhaps: but their art did not suffer for lack of blood, bone, gristle.

The chief of the Philadelphia school, which included Luks, Shinn, Glackens, and Henri, was John Sloan. In him, Eakins' strong realism and Homer's quick eye for incident interfused: he took the

homely commonplaces of life, clothes flying in the wind, a ferryboat ploughing through the waters, scrubwomen in the library, parents and children fleeing before a thunderstorm, the nostalgic view of mysterious windows seen in passing from the street-he took these commonplaces, and invested them with energy, humour, pathos. In his later years, he has come under the influence of Renoir; he has painted many nude figures, and after a sojourn in New Mexico, he turned to the landscape, too; but none of his later painting equals in richness of perception and feeling the work that is closer both to the soil and to the Brown Decades themselves. It is perhaps a final comment on Sloan's paintings to say that his etchings make them almost unnecessary. If he has not assimilated the world of the subway and the skyscraper as thoroughly as he has that of McSorley's Bar and Pettipas' Restaurant and the hansom cab and the dingy hall bedroom, he remains for us one of the first to acclimate to our minds the atmosphere, in all its depression and murk, of the Brown Decades themselves. There are phases of George Bellows, George Luks, and William Glackens that complement Sloan's best work, and at least one member of the group briginally known as the Eight, Maurice Prendergast, definitely transcended the painting of any other members of the school in his clear and buoyant and elegant impressionism: but Sloan's art remains central.

Later painters, more sentimental in appeal, sometimes less sure in lifting their work out of naturalistic literalism, men like Charles Burchfield and Edward Hopper, have given us the mansard-roofed houses and the bleak forlorn streets of the Brown Decades: Hopper has indeed isolated an aesthetic moment of the period and hinted, in his clear persuasive blues and lavenders, that our notions of dinginess and sooty horror are a little exaggerated: or rather, more than that, that there is more solid interest in the gawkiest mansard roof or the worst exhibition of positive bad taste than there is in the more refined monstrosities of historic style that are now called Norman manors or Georgian villas. Hopper is right, too: a positive bad is to be preferred to a negative good: who would not, as Melville exclaims, prefer the vices of the Prince of Darkness himself to the virtues of some niggardly shopkeeper? Hopper shows us this strength in what we timidly dismissed as ugliness: so far good. But Sloan's contribution was less retrospective. With the group of artists, Robert Minor, Art Young, Boardman Robinson, H. Glintenkamp, Cornelia Barnes, who made the revolutionary monthly, The Masses, an impor-

tant part of our consciousness of American life between 1913 and 1917, Sloan turned illustration from passive commentary to a more vital social activity.

In our own day, this social impulse, so far from slackening, has widened and taken possession of other fields. The mural painting, so often a refuge for noble vacuity and historical poses, has recaptured, in the work of Boardman Robinson and Thomas Benton, some of the loud strength of the poster and the contemporaneity of the print: in the series of murals that Benton has outlined to cover the development of American life, the last phase of which he has presented in a room in the New School for Social Research, a fine talent, indigenous, humorous, satirical, moved by the actual tempo of modern life and savagely aware of its representative faces and attitudes, its hard metallic milieu, has created a valid expression. This particular vein that was opened in the Brown Decades is most notable, perhaps, at the two extremes of the print and the mural: one sees it equally in the lithographs of Mabel Dwight, Peggy Bacon, Wanda Gag.

There is still another element that one finds first in the Brown Decades and still discovers in American painting: that chastity, that emotional reserve, which is not so much love of ice for its coldness as a love of the crystalline forms that ice assumes. One finds this running like a thread through American painting from George Fuller and Elihu Vedder and James McNeill Whistler down to Preston Dickinson and Charles Sheeler. One finds it equally in the admirable factory buildings of Demuth and the mechanical abstractions which Henry Billings has embodied in mural decorations; there is even a little of it in the Panlike devotions of John Marin. This quality, as in Demuth's exquisite illustrations for Henry James, is not incompatible with wit and elegance. It is not Puritanism; it is not even a denial or an unconsciousness of sex; but it is a refusal to accept the earth and the sweat, the heavy tactile sense of flesh and muscle, that one finds in Rubens and Renoir. The result, so far as painting goes, is a certain tidiness of line, a certain orderliness of arrangement-the sort of tidiness and orderliness one might find in a bachelor's apartment.

The second important trail that leads out of the Brown Decades originates in the example of Albert Pinkham Ryder. He was one of that group of nineteenth century artists, a group which must include Monticelli, Redon, Van Gogh, and above all perhaps Blake, who consciously used the objects of the external world as symbols of the

emotions and feelings he sought to express. In a sense, no painter has ever done anything else; but the interest in the object and the satisfaction of optical relations are such important and amusing matters in themselves that the artist in the nineteenth century often sought to do by hand what the camera was capable of doing much more sincerely and handsomely in its own right—interpret the external world in its relations of sunlight and shade and texture. Representation of the object, instead of fusing the inner and outer world in a new relationship, namely, the picture, left the subjective world unsatisfied: the inner content, for the run of academic or naturalistic painters, was mediocre.

Ryder's point of view has become familiar during the last twenty years in the paintings of artists who were under the delusion that they were removing the human content from art and creating a world of pure aesthetics; but apart from men almost of his generation, like John Noble and Elliott Daingerfield, who absorbed some of the atmospheric effects of Ryder's paintings, this impulse continued most plainly in the work of John Marin and Georgia O'Keeffe. Marin's medium, pure water colour, swiftly and economically disposed, is just the opposite of Ryder's laborious enamels: Marin's beginnings as a pure colourist, lyrical and gemlike, in his first studies of the Tyrol are, too, just the opposite of Ryder's rather commonplace golden brown studies of rural haystacks and roads. But in the etchings and water colours of New York that Marin began to make around 1911, and in a whole series of marines and landscapes painted since, the colour became subjected to the expression of the whole, and the inner landscape of the artist himself interfuses with the outer landscape, accentuating its rhythms or counterpoising them. Just as in the musty darkness of a Ryder painting one can detect the underlying features of Cape Cod, so in the broken masses of Marin's seacoast or mountains one can discover in a new intensity of abstraction Maine or New Mexico.

Georgia O'Keeffe has carried the symbol both close to actuality and close to pure abstraction. She is the poet of womanhood in all its phases: the search for the lover, the reception of the lover, the longing for the child, the shrinkage and blackness of the emotions when the erotic thread has been lost, the sudden effulgence of feeling, as if the stars had begun to flower, which comes through sexual fulfilment in love: all these elements are the subjects of her painting. However remote the abstraction, it is always but a step from the

symbol to actuality: fruit and flowers, realistic fruit and stupendous magnified flowers, clam shells and seaweed, the lake and the mountain and tall buildings, shafts of light and spots of black—all these reminders of the external world are means wherewith she contrives to bring forth objectively the content of feeling, experiences that would be bare and fragmentary—an ache, a lust, a void—if hoarded within. Miss O'Keeffe has done more than paint: she has invented a language, and has conveyed directly and chastely in paint experiences for which language conveys only obscenities. Without painting a single nude, without showing a part of the human body, she has magnificently embodied passion, sexual life, womanhood, as physical elements and as states of soul.

The influence of the Brown Decades upon our own, or the parallel developments of their original artists and ours, can of course be exaggerated: but it is important, since the relationship is a reciprocal one, that we should recognize the solid foundation on which, consciously or unconsciously, we build. The generation that produced Ryder and Eakins also produced monuments of inanity and pretence: but we must suspect our own characters if it is the latter alone that we preserve and remember. The living past is always alive; and as for the dead past, it was never, even at the moment of its birth, anything else but dead.

Summary

THE Brown Decades began after the Civil War: they came to an end with the passing of the frontier. The colour of life in America changed after that. Electricity effected an improvement in our mechanical civilization: the neotechnic period dawned. New devices of spatial liberation, the automobile and the airplane and the radio, were invented: the atom revealed unsuspected complexities and psychology brought to light hitherto untouched depths in the mind. Alongside these vivid impulses to reflection and action were darker elements, as dark as anything generated by the Civil War: with the day of the industrial pioneer over, an aggressive imperialism started the search for new markets, and, by a steady centralization of power and wealth, monstrous cities came into existence: the regimentation of men and the culture of things followed. The Brown Decades ended: their creators and originators were neglected, tossed contemptuously aside; their hopes became insolvent; their monuments alone ironically defied time. We gained and we lost-who can fully point out where, who can estimate how much?

A definite change in our life took place around 1895, and there is something in back of it that is lost in a mere account of things, forces, machinery, institutions, events: something that eludes us and yet seems to hold a clue. Perhaps it was only a colour. But what was valid in the art and thought of the Brown Decades did not cease to exist, even though it was temporarily forgotten. If one emphasizes the neglected figures of the Brown Decades, it is not to disparage the accepted leaders or to belittle altogether their work: it is rather to place the whole sum of achievement in a better perspective, and to bring into the foreground the more illustrious names. When the creative artists are reckoned with—an Olmsted, a Roebling, a Richardson, a Ryder—the Brown Decades become in the arts what

the Golden Day was in literature: a fulfilment of the past and a starting point for the future. Does this work lead toward our own generation? In a measure, at least, yes. Toward even more solid achievement beyond our own? Let us hope so.

Sources and Books

UNTIL a few years ago almost all the important monuments of the Brown Decades survived in the following cities: Boston, Cambridge, Pittsburgh, Philadelphia, New York, Washington, Baltimore, and Chicago. Even the smaller centres are not without admirable examples: the Mary Hitchcock Memorial Hospital at Hanover, New Hampshire, by Rand and Taylor, for example, is one of the better products of the Brown Decades; the Richardsonian building at the Lawrenceville School in New Jersey is another. Nothing can take the place of actual observation of these buildings on the site: what is true of buildings is of course equally true of parks, cities, landscapes. For a catalogue of Olmsted's parks, and Eliot's, consult their biographies. Where possible, I have verified the dates of all buildings mentioned in the text.

In establishing various facts not obtainable in documents, I have relied upon the first-hand testimony or the ample authority of the following men: Mr. Charles Harris Whitaker, Mr. George G. Elmslie, Mr. Frank Lloyd Wright, Mr. H. Van Buren Magonigle, Mr. Alfred Stieglitz, and Mr. Thomas Beer: I take this opportunity to thank them for their courteous assistance. In 1918 I had the good fortune to make the acquaintance of Mr. William B. Bigelow, member of the original firm of McKim, Mead, and Bigelow. While I was unable to draw directly on him in the present work, my conversations with him on the art and life of the eighties were a useful foundation for this study; for he had a good memory, a very complete file of magazine articles on American history and architecture, and a helpful, kindly spirit.

CHAPTER ONE

GENERAL HISTORIES: The general histories of the period are useful for building up the political and economic background. In the field

116 The Brown Decades

of the arts, they are still relatively useless, for lack of sufficient first-hand data. Perhaps the best detailed study is: E. P. Oberholtzer's A History of the United States Since the Civil War, 3 vols., New York, 1917–1926. For a briefer survey consult Charles and Mary Beard's The Rise of American Civilization, 2 vols., New York, 1929, and Samuel Eliot Morison's The Oxford History of the United States, 2 vols., New York, 1928. The Rise of the Common Man, by Carl Russell Fish, New York, 1927, leads up to the Brown Decades, and The Emergence of Modern America, 1865–1878, by Allan Nevins, New York, 1927, takes one partly through the period. To assist in visualizing the spectacle of American life, the various volumes of the Pageant of America series, some of which are noted elsewhere, are useful, despite their deplorable format; see especially The March of Commerce, New York, 1927, and The Epic of Industry, New York, 1926, both by R. M. Keir.

BIOGRAPHIES: For the important figures in the period who have not yet been the subject of standard biographies, consult the National Cyclopedia of American Biography, and the Dictionary of American Biography. Only one volume of George Perkins Marsh's biography was published by Scribner in 1888: the second volume did not apparently reach the stage of manuscript. The story of the Roeblings has still to be written. The following biographies, not included under the special heads, are worthy of attention: The Life of Henry George, by Henry George, Jr., New York, 1900. Mary Baker Eddy, by E. F. Dakin, New York, 1930. The Education of Henry Adams, by Henry Adams, New York, 1918. Notes of a Son and Brother, by Henry James, New York, 1914. The Letters of William James, 2 vols., Boston, 1920. Life and Confessions of a Psychologist, by Stanley Hall, New York, 1923. The Autobiography of Nathaniel Southgate Shaler, New York, 1909. Emily Dickinson, by Genevieve Taggard, New York, 1930. Herman Melville, by Lewis Mumford, New York, 1929. Mark Hanna, by Thomas Beer, New York, 1929. The Ordeal of Mark Twain, by Van Wyck Brooks, New York, 1920. We still await the publication of the life and collected works of Charles Peirce.

INTERPRETATIONS: The actual documents, however carefully collated, do not exist as history until they are interpreted. The historian has sometimes flinched from this task, and part of the work of examining American culture has therefore been carried on, for lack of better means, by students who have sought to weave our experience into some sort of coherent pattern. The leader of this movement is

Sources and Books 117

without doubt Mr. Van Wyck Brooks. His The Wine of the Puritans and America's Coming of Age broke fresh ground. More strictly in the sequence of history were Sticks and Stones and The Golden Day. The chapter on Architecture in The Brown Decades in part contradicts, in part modifies, and in part merely complements my earlier interpretation of the period in Sticks and Stones. Mr. Thomas Beer's study of The Mauve Decade, New York, 1926, reveals his uncanny eye for neglected materials and sources. In his Portrait of the Artist as American, New York, 1930, Mr. Matthew Josephson has presented the literary side of the Brown Decades, and in American Humor, New York, 1931, Miss Constance Rourke has contributed an indispensable portrait of the national character: a work of great perspicuity and originality. For all its failures in literary evaluation, Vernon Parrington's Main Currents of American Thought, 3 vols., New York, 1926-1930, is the great monument in this field; and his picture of the Gilded Age is particularly good.

NOVELS: No interpretation of the Brown Decades would be complete without reference to either contemporary or retrospective pictures of its life in fiction. Perhaps the best of these are still two novels by William Dean Howells' *The Rise of Silas Lapham* and *A Hazard* of *New Fortunes*. *The Gilded Age*, by Mark Twain and Charles W. Warner, gave the name to the period; and Edward Bellamy's *Looking Backward* tells almost as much about his present as about the future he sought to prophesy. Among present-day writers, I would note Thomas Beer's *Sandoval* and Theodore Dreiser's *The Titan*.

CHAPTER TWO

J. Russell Smith's regional study of North America, New York, 1925, provides the best scientific introduction to this subject. Benton MacKaye's The New Exploration: A Philosophy of Regional Planning, New York, 1928, is the only satisfactory American introduction to the art of geotechnics; it is an indispensable book. Walden, Cape Cod, A Week on the Concord and the Merrimac, and the Notebooks by Henry David Thoreau are all important. George Perkins Marsh's treatise, Man and Nature, or Physical Geography as Modified by Human Action, was first published in 1864; in the third edition, ten years later, the title was changed to The Earth as Modified by Human Action. Mrs. G. P. Marsh's biography carries his life up to his career as Minister to Rome; but it does not include the writing of his geographic classic. N. S. Shaler's Man and the Earth, New York, 1905, recapitulates part

118 The Brown Decades

of Marsh's argument and brings it down to date, but curiously does not mention Marsh's contribution. A valuable study of Frederick Law Olmsted, Landscape Architect, was made by F. L. Olmsted Jr. and Theodora Kimball and published in two volumes in 1922: it contains much original data, and an exhaustive account of the design and building of Central Park. The writings of Olmsted's predecessor, Andrew Jackson Downing, on landscape architecture and cottage design, as well as Calvert Vaux's studies in architecture, give one a better sense of Olmsted's own originality. Olmsted's pamphlet on Public Parks and the Enlargement of Towns, American Social Science Association, 1870, has more than an historical interest. H. W. S. Cleveland published at Chicago in 1873 a brochure on Landscape Architecture as Applied to the Wants of the West: it in part accounts for Chicago's early start in park planning. The Life and Letters of Charles Eliot, 7r., compiled by his father, should be more widely known than it is. There are numerous magazine articles on the building of the Brooklyn Bridge. A book entitled on its back, New York and Brooklyn Bridge, and on its cover Opening Ceremonies of the New York and Brooklyn Bridge (no title page), is full of interesting sidelights: it contains the addresses of the speakers on this occasion. There is an account of John A. Roebling's life, which differs in some respects from that in the National Cyclopedia of American Biography, in An Account of the Ceremonies at the Unveiling of a Monument to His Memory, Trenton, 1908.

CHAPTER THREE

There is still no accurate, authentic, intelligent, and fairly exhaustive history of American architecture. T. S. Tallmadge's *The Story* of Architecture in America is uncritical and far from thorough. Fiske Kimball's American Architecture, New York, 1928, is a useful sketch; but the nearest approach to an impartial history is Talbot Hamlin's *The American Spirit in Architecture*, Vol. 13 in the Pageant of America series, New York, 1926. Even here, despite Mr. Hamlin's sympathy, skill, and excellent resources, some of the most important buildings are omitted and dates are lacking. Despite their inaccuracies, one must continue to recommend a German work, R. Vogel's *Das Amerikanische Haus*, Berlin, 1910, and to add another recent German survey: Amerika, by Richard Neutra in the recent Neues Bauen in der Welt series, Vienna, undated. The files of *The American Architect* and Building News are invaluable during the eighties: after that *The Architectural Record* is helpful, too. There is fortunately a fairly good history of the dwelling house, particularly during the Brown Decades: Homes in City and Country, by Russell Sturgis, John Root, and others, New York, 1893. The Real Estate and Builder's Guide, New York, 1897, has historical data-like Schuyler's article on hardware-that is unobtainable elsewhere. The best architectural criticism in America was that which Montgomery Schuyler contributed to The Architectural Record from its inception to his death in 1914. Some of this was included in American Architecture, New York, 1892. His appreciation of the Chicago school was bound together in the Architectural Record Company's Great American Architect Series, December 1895: this was called A Critique of the Works of Adler and Sullivan, D. H. Burnham and Company, and Henry Ives Cobb. Mrs. Schuyler van Rensselaer's monograph on Henry Hobson Richardson, New York, 1888. omits to mention the John H. Pray Building in Boston, just as the monumental monograph of the work of McKim, Mead, and White leaves out all their utilitarian office-buildings, to say nothing of the Baltimore church. Harriet Monroe's monograph on John Wellborn Root came out in 1896. Louis Sullivan still awaits a complete biography and criticism: The Autobiography of an Idea, New York, 1924, only lays the foundations. His Kindergarten Chats were never gathered together: Mr. C. H. Whitaker lent me a revised copy in Ms., and there is a complete file at the Art Institute of Chicago. The best monograph on the work of Frank Lloyd Wright was published by Wendingen in 1927. His Princeton University lectures on Modern Architecture, New York, 1931, are invaluable both as history and criticism. The Craftsman (1901-1916) published articles on Louis Sullivan's and Irving Gill's work; it presents a valuable picture of American taste during this period. A critical appraisal of the craftsman movement remains to be written.

CHAPTER FOUR

The only comprehensive critical and historical discussion of the arts in America is Art in America by Suzanne LaFollette, New York, 1930. This is also, to date, the best general history of American painting and sculpture: except for minor details, it supersedes C. H. Caffin's American Masters of Painting, Samuel Isham's History of American Painting, and Sadakichi Hartmann's two-volume History of American Art, published in 1902, to say nothing of Lorado Taft's History of American Sculpture. Even the treatment of architecture is, on the whole, more satisfactory than that of Kimball or Tallmadge:

120 The Brown Decades

an admission I can make all the more freely because I differ from Miss LaFollette in my interpretation of Richardson and Sullivan quite as much as I differ from Mr. Kimball-albeit for different reasons. The history of American paniting which Mr. Virgil Barker now has in preparation will perhaps finally answer the need for a detailed and nicely evaluated study of that subject. Art in America: a Critical and Historical Sketch, by S. G. W. Benjamin, New York, 1880, is significant less for its actual data than for the light it throws upon taste and criticism during the Brown Decades. Two books by James Jackson Jarves should not be neglected: The Art-Idea, New York, 1864, and Art Hints, New York, 1869; these two books, taken along with John Bascom's Aesthetics: or the Science of Beauty, Boston, 1862, are, apart from Emerson's essays, the first groping in America towards a philosophic understanding of the arts: works that were later to be crowned, in effect, by George Santayana's The Sense of Beauty and Reason in Art.

A biography of Thomas Eakins is now in preparation. Mr. Frederic Fairchild Sherman's excellent monograph on Albert Pinkham Ryder, New York, 1920, is the chief source of data on Ryder. The same author's Landscape and Figure Painters of America, New York, 1917, is valuable for its essays and reproductions of the work of some of the lesser men. See also the Life and Works of Winslow Homer, by William Howe Downes, New York, 1911, Homer Martin, by Mrs. Elizabeth G. Martin, New York, 1904, and George Fuller: His Life and Works, edited by Josiah B. Millet, New York, 1886, and John La Farge, by Royal Cortissoz, New York, 1911. There is a partial catalogue of the works of Currier and Ives in Lithographs of N. Currier and Currier and Ives, by Warren A. Weaver, New York, 1925. The files of Harper's Weekly and The Century are particularly valuable for examples of excellent wood-engraving in the seventies and eighties. A series of interesting articles on Mary Cassatt, the Philadelphia School, and Thomas Eakins have appeared in The Arts during the last decade. Perhaps the best compendium of the modern movement in America is Camera Work, published by Alfred Stieglitz from 1902 to 1917. The articles, the republished reviews, the original photographs, and the illustrations are a mine of valuable data, particularly from 1908 onwards. The American Spirit in Art, by Frank Jewett Mather, Vol. 12, in the Yale Pageant of America Series, New York, 1927, is a highly useful handbook. Mr. Paul Rosenfeld's Port of New York, New York, 1925, has some admirable portraits of contemporary

Sources and Books 121

artists and many penetrating reflections on their work and social relationships. The Re-Discovery of America: An Introduction to a Philosophy of American Life, by Waldo Frank, New York, 1929, shows a genuine understanding of both our past and our potentialities. His earlier interpretation, Our America, is a useful introduction to it.

Index

Adams, Charles Francis, 7 Adams, Henry, 8 Adler and Sullivan, 57 Adult Education, post-Civil War, 7 Advertising testimonials, 7 agriculture, shiftless character of, 28 Albany cathedral, 53 Aldrich, Thomas Bailey, 10 Alexander, 107 Altoona, 28 American Girl, in Brown Decades and now, 90 American settlement, as mushroom hunt, 30 American taste, retrogression in, 64 Americans, disoriented, 7-8 Ancient Society, 18 Architecture, ante-bellum condition of, 49; for industrial society, 50; new orientation in, 79 Art Museum, 85 Art School, 85 Auditorium Building and Theatre, 67 Audubon, 30 Austin Hall, 54 Babb, Cooke and Willard, 57 Bacon, Peggy, 109 Baltimore, First Methodist Church, 58 Barnes, Cornelia, 108 Bascom, John, as esthetician, 83 bathroom, 81 Battery, the, 39 Beecher, Mrs. Henry Ward, 7 Bellamy, Edward, 21 Bellows, George, 89 Bennett, James Gordon, as forerunner of tabloids, 7

Benton, Myron, 31

Benton, Thomas H., 109

Bethlehem, 28

Bibliography, 115–121

Bierce, Ambrose, 13

Billings, Henry, 109 Bogardus, James, 50

Boston Public Library, 85

Bragdon, Claude, 69

bridge, as work as art, 48

Brookings School, 18

Brooklyn Bridge, 44; 45–46; Montgomery Schuyler's estimate of, 46

Brown Decades, The, 1; physiognomy of, 8; preoccupation with infirmities of, 9; genuine successes in, 11; utopia of, 21–23; as part of usable past, 25; conclusion of, 113; perspective on, 113–114

brownstone, 3

Bryant, William Cullen, 39

Buffington, L. H., 53, 63

Burchfield, Charles, 1, 108

Burgess, Professor, 6

Buried Renaissance, 23

Burnham and Root, 60

Burroughs, John, Whitman's influence on, 14

Business Enterprise, Theory of, exemplified in Chicago, 68

Canals, as improvements of landscape, 27

Carson, Pirie and Scott, 70

Cassatt, Mary, 3, 94

cast-iron fronts, 50

Catskill School, the, 31

Cedar Rapids Bank, 73

123

124 Index

Centennial Exhibition, 6 Century, The, 24 Charleston, S. C., 39 Chase, Stuart, 7 Chicago Exposition, as turning point of architecture, 64 city development, 27 city planning, contemporary, 43 Civil Disobedience, 31 Civil War, effects of, 2 Clark University, 19 Cleveland, Horace, 35 Clopet, M., influence on Sullivan, 66 Cole, Timothy, 87 Colonial Architecture, 7; present day caricatures of, 24 colonization, land, disastrous effects of, 29 Connecticut Academy, 18 Conservation, physical, 35 constipation, as result of sanitation, 77 Corliss engine, 6 Cottier, Daniel, 101 country banks, Sullivan's, 72 Croton water system, 27 Crystal Palace, New York, 17 Currier and Ives, 86 Daingerfield, Elliott, 110 Davis, Mrs. Rebecca Harding, quoted, 5 Democratic Vistas, as post-war product, 10 Demuth, Charles, 109 department store, Sullivan's design for, 70 De Stijl group, 80 De Vinne Press Building, 57 Dickinson, Emily, 12, 13, 24 Dickinson, Preston, 109 disorder, challenge of, 17 Divine Comedy, 3 Downing, Andrew Jackson, 16 dropsical architecture, 53 Drum Taps, 13 Dwight, Mabel, 109 Eakins, Thomas, influenced by con-

temporary mood, 4; birth of, 95; studies in Paris, 95; characterization of by F. J. Mather, 95; interest in

science, 96; contempt for hierarchies, 96-97; relations with Whitman, 97; comments on by Whitman, 97; capacity as painter, 98; Eddy, Mrs. Mary Baker, 11, 20 Eiffel Tower, 47 Eight, The, 108 Eliot, Charles, Jr., 42 Eliot, Charles, 18; his elective system, 18 Elmslie, George G., as Sullivan's associate, 73 Emerson, R. W., his disappointment over results of war, 6 Emerson, W. R., 53 engineer, influence on architecture of, 81 engineering, aesthetic relations of, 48 Equality, successor of Looking Backward, 22 First Methodist Church, Baltimore, 58 Fiske, John, 17 Ford Plant, 81 Forest Planting in the Great Plains, 35 Frame house, as forerunner of steel cage, 62 Freeman, The, 8 French painters, influence on American art, 94 Frontier, implications of passing of, 21 Frost, Robert, comparison of with Ryder, 101 Fry, Roger, on Ryder, 104 Fuller, George, birth of, 87; early experience, 87; stimulation by Europe, 88; exhibition, 88; shrinkage from reality, 89; sentimental adolescence of, 89; his ideal world, 89 Furness, Frank, 65 Gag, Wanda, 109 Gage Building, 68 Gandhi, Mahatma, 31 Garden City, English, 43 Geddes, Patrick, 18 George, Henry, 20 German methods, American imitation,

of, 18–19 Gibbs, Josiah Willard, 18 Gilded Age, insidious deflation of, 10

Gill, Irving, 80

- Gilman, Daniel Coit, 18
- Glackens, William, 95
- Glessner House, 54
- Glintenkamp, H., 108
- Goethe, J. W., as first biological philosopher, 31
- Golden Day, influence of in Brown Decades, 11-15

Grant's administration, 6

- Hall, Stanley, 17
- Harper's Weekly, 24, 87
- High Bridge, 27
- Higher Learning, The, 19
- Holland Tunnel ventilators, 81
- Home Insurance Building, 62
- Homer, Winslow, birth of, 90; apprenticeship, 90; influences, 90; as artistcorrespondent in Civil War, 91; limitations of talent, 91; provincialism, 91-92
- Hopper, Edward, 1, 108
- Housing problem, upper class, 50
- Howells, William Dean, 10
- Hull House speech, F. L. Wright's, 78
- Hunt, R. M., 50
- Hunt, William Morris, 94

Ideology of business, 40

- industrial arts, shift to after Civil War, 15
- industrial pollution, 28
- industrialism, ugliness of, 43
- Inness, George, 31
- Institute of Politics, 6
- invention, necessity for, 15
- iron, application to building, 50
- James, William, 10
- Jarves, James Jackson, 83; on contemporary art, 83; as critic of revivalism, 84 Jenney, William Le Baron, 62
- Johns Hopkins, 18
- to de l'Alexandre de company
- Kaiser Wilhelm Gedächtnis Kirche, 53
 Kindergarten Chats, 55–56
 King, Clarence, 17
- Knights of Labour, 9
- Ku Klux Klan, origin of, 9

- La Farge, John, birth of 92; French culture of, 92; as designer of stained glass, 93; influence on Art Nouveau, 93; function in introducing ideas, 94
 Lancaster, 28
- land, influence of, 26; continued culture of, 27
- land-hunger, 28
- Land and Loan Office, Algona, Iowa, 73
- Le Corbusier, 80
- Lernfreiheit, 18
- Lewis, Sinclair, 72
- Lincoln, death of signalizes change, 3
- Literature, early culmination in, 15
- lithographs, popular, 86
- London Exposition, 43
- Looking Backward, 21-23
- Luks, George, 89
- Machine Age, faith in, 7
- machine, application to architecture, 75
- MacKaye, Benton, 31
- Maine coast, Eliot's warnings about, 42 Marin, John, 110
- Mark Twain, 8
- Marsh, George Perkins, his birth, 32; his political career, 33; his facility with languages, 33; years in Asia Minor, 33; publication of *Man and Nature*, 33; leading ideas, 33–35; influence of, 35
- Martin, Homer, 95
- The Masses, 108
- Maybeck, Bernhard, 80
- McKim, Charles Follen, 57
- Mechanics' Institutes, 7
- mediocrities, literary, 11
- Minor, Robert, 108
- modern architecture, beginnings of, 51
- Modern experience, photography as element in, 105
- modern house, requirements of, 82
- modernique, ruin of factory production by, 81
- Monadnock Building, 61-62
- Monographs, contemporary in Brown Decades, 25
- Montgomery Schuyler, on Root, 61; on success of Monadnock Building, 62

126 Index

- Moore, Charles, on Richardson, 55 Morgan, Lewis, 18 Morse, S. F. B., as painter, 86 Muir, John, 29
- National Parks, their foundation, 35 Neue Sachlichkeit, Richardson as founder
- of, 57
- Newburgh, 28
- Newman, Robert Loftin, 23
- Newport villas, 16
- New School for Social Research, The, 108
- Nightbirds in American culture, 99
- Nine Hundred Broadway, 58
- Noble, John, 110
- Norton, Charles Eliot, 19

Objectivity, 106

- office-building, theory of, 68
- O'Keeffe, Georgia, 110-111
- Olmsted, Frederick Law, 35; his birth, 37; his education, 37; his travels and books, 38; his picture of the antebellum South, 38; his venture in publishing, 38; as superintendent of Central Park, 38; partnership with Calvert Vaux, 38; ideas of Park development, 40–41; principles of planning, 41–42; crowning task, 42; death, 42

organic architecture, 76

- ornament, as Sullivan's claim to originality, 70
- Our Land and Land Policy, National and State, 20
- Owatonna Bank, 73
- Pach, Walter, 94
- park, as symbol of aristocracy, 39; opposition to, 39
- park design, 41-42
- park programme, 40
- Parks, National, 35
- Parrington, Vernon, picture of Gilded Age, 8
- Patrons of Husbandry, 9
- Paxton, Joseph, 43
- Peirce, Charles, letters of, 24; publication of complete papers, 24

Perette, 102

Philadelphia School, 107-108

Pierre, 12

- photography, 105-106
- plastic arts, shift to after Civil War, 15
- Ponkapog Papers, 11
- portrait tradition, 86
- Post-war motives, unconscious revelation of, 4
- Powderly, Terence, 9
- prairie houses, 23
- Pray, John H., store of, 57
- Prendergast, Maurice, 108
- Progress and Poverty, 21

Prudential Building, 68

- public domain, squandering of, 20 Pumpelly, Raphael, 17
- rumpeny, reaphaer, r
- Radburn, N. J., 42
- railroad stations, Richardson's, 53
- railroad transportation, 27-28
- Rensselaer, Mrs. Schuyler van, 56
- Richardson, Henry Hobson, birth of, 52; preparation for architecture, 52; appetites and physical characteristics, 52; first experience in architecture, 52; influence on contemporary architects, 53; relation to Europeans, 53; attitude toward modern life, 53; rejection of Victorian compromise, 53; as functionalist, 54; circular to clients, 54; employment of other artists by, 55; as designer of office buildings, 57; influence of on Brown Decades, 57–58
- Richardson's architecture, romantic criticism of, 54; Royal Cortissoz on, 56; mark of adaptation of, 55; Sullivan's appreciation of, 56; its potentialities, 58; its influence on McKim and White, 57; anticipation of transition to steel, 59; failure of later work to impress contemporaries, 59
- Robinson, Boardman, 108
- Rodin, Auguste, on America's Renaissance, 85
- Roebling, John, lack of biography of, 25
- Roebling, John A., birth of, 44; education, 44; emigration to U. S., 44; foundation of Saxonburg by, 44; invention of steel cable by, 44; personal characteristics of, 45; design of Brooklyn Bridge by, 45; death, 45

Roebling, Washington A., birth of, 44; Civil War career of, 45; physical characteristics of, 45; heroic efforts, 45; succumbs to caisson disease, 46; his death, 48

Roland Park, 42

Root, John, birth of, 60; training with Renwick, 60; partnership with Burnham, 60; consciousness of mission, 60; criticism of new architecture by, 61

Royal Polytechnic School in Berlin, 44 rural life, unstable basis of, 28

Ryder, Albert Pinkham, birth of, 100; influence of local landscape on, 100; removal to New York, 100; span of work, 100; nervous crisis, 100; mysticism, 101; characteristics of paintings, 101; as colourist, 102; on life of artist, 103; his great pictures, 103; his death, 104

Ryerson, Martin, 57

Sanitation, weakness of, 77

Sargent, 85

Sachlichkeit, 57, 62, 106

scenery, American varities of, 42

Schlesinger and Mayer Building, 70

Schiller Building, 68

Schuyler, Montgomery, estimate of Brooklyn Bridge, 46; of Root, 61

Scranton, 28

sexual intercourse, 77

Shaler, Nathaniel S., on soil-mining, 29

Sheeler, Charles, 106

Sitte, Camillo, 43

skyscraper, social weakness of, 63; formulation of aesthetics of, 63

skyscraper, Sullivan's analysis of, 68-69

Sloan, John, 107-109

soil, denudation of, 28

- Sources on Brown Decades, 115
- Soviet Russia, likeness to Looking Backward, 22
- specialist, as product of Brown Decades, 19

specialization, low level of, 19

Stearns, Harold, 8

Stedman, Edmund Clarence, quoted, 3

steel frame construction, 62

Stevens, J. Watts, 57

Stieglitz, Alfred, 105–106

stimulus of inventions, 16 Strand, Paul, 106

Sullivan, Louis, Kindergarten Chats. of, 65; Autobiography of an Idea by, 65; characterization of by Wright, 65; as Whitman of American architecture, 65; birth of, 65; architectural training, 65; part in World's Fair, 67; award of French medal to, 67; partnership with Adler, 66; work on Auditorium Building, 67; as designer, 67–71; as social critic, 72; as designer of country banks, 72; contribution to vernacular, 73; contribution to architecture, 74; accepts engineering point of view, 74; on skyscraper, 74; as connecting link, 75

Sumner, William Graham, 17

Thayer, Abbott, 85

- Thoreau, Henry David, his exploration of the environment, 30; his political acumen, 31; his relevance to the machine age, 32
- Thought, American, new life stirring in, 9

Three Minutes' War, 7

Tiffany Mansion, 57

Tom O'Leary, 28

Transportation Building, 4

Trinity Church, Boston, 93

Turner, Professor Frederick J., 21

Tweed Ring, 6

Two Hour War, 7

Uncle Vanya, 29 Universities, after Civil War, 18–19 usable past, 25

Veblen, Thorstein, 19; Theory of Business Enterprise, 68 Victorian compromise in architecture, 53

Viele, General Egbert, 41

Wainwright Building, 68 War, reaction from tension of, 6 Ward, Lester, 17 Warfare, its aftermath, 5 Wells, Joseph Morrill, 58 West Publishing Company, 57 Whistler, 85

128 Index

- White, Andrew, 18
- White, Stanford, 57
- Whitman, Walt, his characterization of post-war society, 1; his influence, 14
- Wilby, Ernest, 81

wilderness, desecration of by romantic taxpayer, 29

Winona Bank, 73

Wood, Halsey, 53

wood-and-water economy, 27

- wood-engraving, excellence of in Brown Decades, 87
- working class, enslavement in Brown Decades, 22

Wright, Chauncy, 17

Wright, Frank Lloyd, birth of, 76; treatment of dwelling house, 76; motto of, 76; sense of human needs, 77; early designs for type houses, 77; tradition of experiment maintained by, 78; advocacy of machine, 78; command over materials, 78; lessons derived from, 78; as seedbed of new architecture, 80 Weight Hongy 42

Wright, Henry, 42

Yale and Towne Lock Co., 67 Young, Art, 108 Youth, absence after Civil War, 4

A CATALOGUE OF SELECTED DOVER BOOKS IN ALL FIELDS OF INTEREST

A CATALOGUE OF SELECTED DOVER BOOKS IN ALL FIELDS OF INTEREST

RACKHAM'S COLOR ILLUSTRATIONS FOR WAGNER'S RING. Rackham's finest mature work—all 64 full-color watercolors in a faithful and lush interpretation of the *Ring*. Full-sized plates on coated stock of the paintings used by opera companies for authentic staging of Wagner. Captions aid in following complete Ring cycle. Introduction. 64 illustrations plus vignettes. 72pp. 85% x 11¼. 23779-6 Pa. \$6.00

CONTEMPORARY POLISH POSTERS IN FULL COLOR, edited by Joseph Czestochowski. 46 full-color examples of brilliant school of Polish graphic design, selected from world's first museum (near Warsaw) dedicated to poster art. Posters on circuses, films, plays, concerts all show cosmopolitan influences, free imagination. Introduction. 48pp. 9% x 12¼. 23780-X Pa. \$6.00

GRAPHIC WORKS OF EDVARD MUNCH, Edvard Munch. 90 haunting, evocative prints by first major Expressionist artist and one of the greatest graphic artists of his time: *The Scream, Anxiety, Death Chamber, The Kiss, Madonna*, etc. Introduction by Alfred Werner. 90pp. 9 x 12. 23765-6 Pa. \$5.00

THE GOLDEN AGE OF THE POSTER, Hayward and Blanche Cirker. 70 extraordinary posters in full colors, from Maitres de l'Affiche, Mucha, Lautrec, Bradley, Cheret, Beardsley, many others. Total of 78pp. 9% x 121/4. 22753-7 Pa. \$5.95

THE NOTEBOOKS OF LEONARDO DA VINCI, edited by J. P. Richter. Extracts from manuscripts reveal great genius; on painting, sculpture, anatomy, sciences, geography, etc. Both Italian and English. 186 ms. pages reproduced, plus 500 additional drawings, including studies for *Last* Supper, Sforza monument, etc. 860pp. 7% x 10%. (Available in U.S. only) 22572-0, 22573-9 Pa., Two-vol. set \$15.90

THE CODEX NUTTALL, as first edited by Zelia Nuttall. Only inexpensive edition, in full color, of a pre-Columbian Mexican (Mixtec) book. 88 color plates show kings, gods, heroes, temples, sacrifices. New explanatory, historical introduction by Arthur G. Miller. 96pp. 11% x 8½. (Available in U.S. only) 23168-2 Pa. \$7.50

UNE SEMAINE DE BONTÉ, A SURREALISTIC NOVEL IN COLLAGE, Max Ernst. Masterpiece created out of 19th-century periodical illustrations, explores worlds of terror and surprise. Some consider this Ernst's greatest work. 208pp. 8½ x 11. 23252-2 Pa. \$5.00

DRAWINGS OF WILLIAM BLAKE, William Blake. 92 plates from Book of Job, Divine Comedy, Paradise Lost, visionary heads, mythological figures, Laocoon, etc. Selection, introduction, commentary by Sir Geoffrey Keynes. 178pp. 8½ x 11. 22303-5 Pa. \$4.00

ENGRAVINGS OF HOGARTH, William Hogarth. 101 of Hogarth's greatest works: Rake's Progress, Harlot's Progress, Illustrations for Hudibras, Before and After, Beer Street and Gin Lane, many more. Full commentary. 256pp. 11 x 13%. 22479-1 Pa. \$7.95

DAUMIER: 120 GREAT LITHOGRAPHS, Honore Daumier. Wide-ranging collection of lithographs by the greatest caricaturist of the 19th century. Concentrates on eternally popular series on lawyers, on married life, on liberated women, etc. Selection, introduction, and notes on plates by Charles F. Ramus. Total of 158pp. 9% x 12¼. 23512-2 Pa. \$5.50

DRAWINGS OF MUCHA, Alphonse Maria Mucha. Work reveals draftsman of highest caliber: studies for famous posters and paintings, renderings for book illustrations and ads, etc. 70 works, 9 in color; including 6 items not drawings. Introduction. List of illustrations. 72pp. 9% x 12¼. (Available in U.S. only) 23672-2 Pa. \$4.00

GIOVANNI BATTISTA PIRANESI: DRAWINGS IN THE PIERPONT MORGAN LIBRARY, Giovanni Battista Piranesi. For first time ever all of Morgan Library's collection, world's largest. 167 illustrations of rare Piranesi drawings—archeological, architectural, decorative and visionary. Essay, detailed list of drawings, chronology, captions. Edited by Felice Stampfle. 144pp. 9% x 12¼. 23714-1 Pa. \$7.50

NEW YORK ETCHINGS (1905-1949), John Sloan. All of important American artist's N.Y. life etchings. 67 works include some of his best art; also lively historical record—Greenwich Village, tenement scenes. Edited by Sloan's widow. Introduction and captions. 79pp. 8% x 11¼. 23651-X Pa. \$4.00

CHINESE PAINTING AND CALLIGRAPHY: A PICTORIAL SURVEY, Wan-go Weng. 69 fine examples from John M. Crawford's matchless private collection: landscapes, birds, flowers, human figures, etc., plus calligraphy. Every basic form included: hanging scrolls, handscrolls, album leaves, fans, etc. 109 illustrations. Introduction. Captions. 192pp. 87/8 x 113/4.

23707-9 Pa. \$7.95

DRAWINGS OF REMBRANDT, edited by Seymour Slive. Updated Lippmann, Hofstede de Groot edition, with definitive scholarly apparatus. All portraits, biblical sketches, landscapes, nudes, Oriental figures, classical studies, together with selection of work by followers. 550 illustrations. Total of 630pp. 9½ x 12¼. 21485-0, 21486-9 Pa., Two-vol. set \$14.00

THE DISASTERS OF WAR, Francisco Goya. 83 etchings record horrors of Napoleonic wars in Spain and war in general. Reprint of 1st edition, plus 3 additional plates. Introduction by Philip Hofer. 97pp. 9% x 8¼.

21872-4 Pa. \$3.75

THE EARLY WORK OF AUBREY BEARDSLEY, Aubrey Beardsley. 157 plates, 2 in color: Manon Lescaut, Madame Bovary, Morte Darthur, Salome, other. Introduction by H. Marillier. 182pp. 8½ x 11. 21816-3 Pa. \$4.50

THE LATER WORK OF AUBREY BEARDSLEY, Aubrey Beardsley. Exotic masterpieces of full maturity: Venus and Tannhauser, Lysistrata, Rape of the Lock, Volpone, Savoy material, etc. 174 plates, 2 in color. 186pp. 8½ x 11. 21817-1 Pa. \$4.50

THOMAS NAST'S CHRISTMAS DRAWINGS, Thomas Nast. Almost all Christmas drawings by creator of image of Santa Claus as we know it, and one of America's foremost illustrators and political cartoonists. 66 illustrations. 3 illustrations in color on covers. 96pp. 8% x 11¼. 23660-9 Pa. \$3.50

THE DORÉ ILLUSTRATIONS FOR DANTE'S DIVINE COMEDY, Gustave Doré. All 135 plates from Inferno, Purgatory, Paradise; fantastic tortures, infernal landscapes, celestial wonders. Each plate with appropriate (translated) verses. 141pp. 9 x 12. 23231-X Pa. \$4.50

DORÉ'S ILLUSTRATIONS FOR RABELAIS, Gustave Doré. 252 striking illustrations of *Gargantua and Pantagruel* books by foremost 19th-century illustrator. Including 60 plates, 192 delightful smaller illustrations. 153pp. 9 x 12. 23656-0 Pa. \$5.00

LONDON: A PILGRIMAGE, Gustave Doré, Blanchard Jerrold. Squalor, riches, misery, beauty of mid-Victorian metropolis; 55 wonderful plates, 125 other illustrations, full social, cultural text by Jerrold. 191pp. of text. 9% x 12¹/₄. 22306-X Pa. \$6.00

THE RIME OF THE ANCIENT MARINER, Gustave Doré, S. T. Coleridge. Dore's finest work, 34 plates capture moods, subtleties of poem. Full text. Introduction by Millicent Rose. 77pp. 9¼ x 12. 22305-1 Pa. \$3.00

THE DORE BIBLE ILLUSTRATIONS, Gustave Doré. All wonderful, detailed plates: Adam and Eve, Flood, Babylon, Life of Jesus, etc. Brief King James text with each plate. Introduction by Millicent Rose. 241 plates. 241pp. 9 x 12. 23004-X Pa. \$5.00

THE COMPLETE ENGRAVINGS, ETCHINGS AND DRYPOINTS OF ALBRECHT DURER. "Knight, Death and Devil"; "Melencolia," and more—all Dürer's known works in all three media, including 6 works formerly attributed to him. 120 plates. 235pp. 83% x 11¼.

22851-7 Pa. \$6.50

MAXIMILIAN'S TRIUMPHAL ARCH, Albrecht Dürer and others. Incredible monument of woodcut art: 8 foot high elaborate arch-heraldic figures, humans, battle scenes, fantastic elements-that you can assemble yourself. Printed on one side, layout for assembly. 143pp. 11 x 16. 21451-6 Pa. \$5.00

THE COMPLETE WOODCUTS OF ALBRECHT DURER, edited by Dr. W. Kurth. 346 in all: "Old Testament," "St. Jerome," "Passion," "Life of Virgin," Apocalypse," many others. Introduction by Campbell Dodgson. 285pp. 8½ x 12¼. 21097-9 Pa. \$6.95

DRAWINGS OF ALBRECHT DURER, edited by Heinrich Wolfflin. 81 plates show development from youth to full style. Many favorites; many new. Introduction by Alfred Werner. 96pp. 8½ x 11. 22352-3 Pa. \$4.00

THE HUMAN FIGURE, Albrecht Dürer. Experiments in various techniques—stereometric, progressive proportional, and others. Also life studies that rank among finest ever done. Complete reprinting of *Dresden Sketchbook*. 170 plates. 355pp. 8% x 11¼. 21042-1 Pa. \$6.95

OF THE JUST SHAPING OF LETTERS, Albrecht Dürer. Renaissance artist explains design of Roman majuscules by geometry, also Gothic lower and capitals. Grolier Club edition. 43pp. 7% x 10% 21306-4 Pa. \$2.50

TEN BOOKS ON ARCHITECTURE, Vitruvius. The most important book ever written on architecture. Early Roman aesthetics, technology, classical orders, site selection, all other aspects. Stands behind everything since. Morgan translation. 331pp. 5% x 8½. 20645-9 Pa. \$3.75

THE FOUR BOOKS OF ARCHITECTURE, Andrea Palladio. 16th-century classic responsible for Palladian movement and style. Covers classical architectural remains, Renaissance revivals, classical orders, etc. 1738 Ware English edition. Introduction by A. Placzek. 216 plates. 110pp. of text. 9½ x 12¾. 21308-0 Pa. \$7.50

HORIZONS, Norman Bel Geddes. Great industrialist stage designer, "father of streamlining," on application of aesthetics to transportation, amusement, architecture, etc. 1932 prophetic account; function, theory, specific projects. 222 illustrations. 312pp. 7% x 10%. 23514-9 Pa. \$6.95

FRANK LLOYD WRIGHT'S FALLINGWATER, Donald Hoffmann. Full, illustrated story of conception and building of Wright's masterwork at Bear Run, Pa. 100 photographs of site, construction, and details of completed structure. 112pp. 9¼ x 10. 23671-4 Pa. \$5.00

THE ELEMENTS OF DRAWING, John Ruskin. Timeless classic by great Viltorian; starts with basic ideas, works through more difficult. Many practical exercises. 48 illustrations. Introduction by Lawrence Campbell. 228pp. 5% x 8½. 22730-8 Pa. \$2.75

GIST OF ART, John Sloan. Greatest modern American teacher, Art Students League, offers innumerable hints, instructions, guided comments to help you in painting. Not a formal course. 46 illustrations. Introduction by Helen Sloan. 200pp. 5% x $8\frac{1}{2}$. 23435-5 Pa. \$3.50

THE ANATOMY OF THE HORSE, George Stubbs. Often considered the great masterpiece of animal anatomy. Full reproduction of 1766 edition, plus prospectus; original text and modernized text. 36 plates. Introduction by Eleanor Garvey. 121pp. 11 x 14¾. 23402-9 Pa. \$6.00

BRIDGMAN'S LIFE DRAWING, George B. Bridgman. More than 500 illustrative drawings and text teach you to abstract the body into its major masses, use light and shade, proportion; as well as specific areas of anatomy, of which Bridgman is master. 192pp. $6\frac{1}{2} \times 9\frac{1}{4}$. (Available in U.S. only) 22710-3 Pa. \$2.50

ART NOUVEAU DESIGNS IN COLOR, Alphonse Mucha, Maurice Verneuil, Georges Auriol. Full-color reproduction of *Combinaisons ornementales* (c. 1900) by Art Nouveau masters. Floral, animal, geometric, interlacings, swashes—borders, frames, spots—all incredibly beautiful. 60 plates, hundreds of designs. 9% x 8-1/16. 22885-1 Pa. \$4.00

FULL-COLOR FLORAL DESIGNS IN THE ART NOUVEAU STYLE, E. A. Seguy. 166 motifs, on 40 plates, from *Les fleurs et leurs applications decoratives* (1902): borders, circular designs, repeats, allovers, "spots." All in authentic Art Nouveau colors. 48pp. 93% x 1214.

23439-8 Pa. \$5.00

A DIDEROT PICTORIAL ENCYCLOPEDIA OF TRADES AND IN-DUSTRY, edited by Charles C. Gillispie. 485 most interesting plates from the great French Encyclopedia of the 18th century show hundreds of working figures, artifacts, process, land and cityscapes; glassmaking, papermaking, metal extraction, construction, weaving, making furniture, clothing, wigs, dozens of other activities. Plates fully explained. 920pp. 9 x 12.

22284-5, 22285-3 Clothbd., Two-vol. set \$40.00

HANDBOOK OF EARLY ADVERTISING ART, Clarence P. Hornung. Largest collection of copyright-free early and antique advertising art ever compiled. Over 6,000 illustrations, from Franklin's time to the 1890's for special effects, novelty. Valuable source, almost inexhaustible.

Pictorial Volume. Agriculture, the zodiac, animals, autos, birds, Christmas, fire engines, flowers, trees, musical instruments, ships, games and sports, much more. Arranged by subject matter and use. 237 plates. 288pp. 9 x 12. 20122-8 Clothbd. \$13.50

Typographical Volume. Roman and Gothic faces ranging from 10 point to 300 point, "Barnum," German and Old English faces, script, logotypes, scrolls and flourishes, 1115 ornamental initials, 67 complete alphabets, more. 310 plates. 320pp. 9 x 12. 20123-6 Clothbd. \$13.50

CALLIGRAPHY (CALLIGRAPHIA LATINA), J. G. Schwandner. High point of 18th-century ornamental calligraphy. Very ornate initials, scrolls, borders, cherubs, birds, lettered examples. 172pp. 9 x 13.

20475-8 Pa. \$6.00

ART FORMS IN NATURE, Ernst Haeckel. Multitude of strangely beautiful natural forms: Radiolaria, Foraminifera, jellyfishes, fungi, turtles, bats, etc. All 100 plates of the 19th-century evolutionist's Kunstformen der Natur (1904). 100pp. 9% x 12¼. 22987-4 Pa. \$4.50

CHILDREN: A PICTORIAL ARCHIVE FROM NINETEENTH-CEN-TURY SOURCES, edited by Carol Belanger Grafton. 242 rare, copyrightfree wood engravings for artists and designers. Widest such selection available, All illustrations in line. 119pp. 8% x 11¼.

23694-3 Pa. \$3.50

WOMEN: A PICTORIAL ARCHIVE FROM NINETEENTH-CENTURY SOURCES, edited by Jim Harter. 391 copyright-free wood engravings for artists and designers selected from rare periodicals. Most extensive such collection available. All illustrations in line. 128pp. 9 x 12.

23703-6 Pa. \$4.00

ARABIC ART IN COLOR, Prisse d'Avennes. From the greatest ornamentalists of all time—50 plates in color, rarely seen outside the Near East, rich in suggestion and stimulus. Includes 4 plates on covers. 46pp. 9% x 12¼. 23658-7 Pa. \$6.00

AUTHENTIC ALGERIAN CARPET DESIGNS AND MOTIFS, edited by June Beveridge. Algerian carpets are world famous. Dozens of geometrical motifs are charted on grids, color-coded, for weavers, needleworkers, craftsmen, designers. 53 illustrations plus 4 in color. 48pp. 8¹/₄ x 11. (Available in U.S. only) 23650-1 Pa. \$1.75

DICTIONARY OF AMERICAN PORTRAITS, edited by Hayward and Blanche Cirker. 4000 important Americans, earliest times to 1905, mostly in clear line. Politicians, writers, soldiers, scientists, inventors, industrialists, Indians, Blacks, women, outlaws, etc. Identificatory information. 756pp. 9¼ x 12¾. 21823-6 Clothbd. \$40.00

HOW THE OTHER HALF LIVES, Jacob A. Riis. Journalistic record of filth, degradation, upward drive in New York immigrant slums, shops, around 1900. New edition includes 100 original Riis photos, monuments of early photography. 233pp. 10 x 7%. 22012-5 Pa. \$6.00

NEW YORK IN THE THIRTIES, Berenice Abbott. Noted photographer's fascinating study of city shows new buildings that have become famous and old sights that have disappeared forever. Insightful commentary. 97 photographs. 97pp. 11% x 10. 22967-X Pa. \$4.50

MEN AT WORK, Lewis W. Hine. Famous photographic studies of construction workers, railroad men, factory workers and coal miners. New supplement of 18 photos on Empire State building construction. New introduction by Jonathan L. Doherty. Total of 69 photos. 63pp. 8 x 10³/₄. 23475-4 Pa. \$3.00

THE DEPRESSION YEARS AS PHOTOGRAPHED BY ARTHUR ROTH-STEIN, Arthur Rothstein. First collection devoted entirely to the work of outstanding 1930s photographer: famous dust storm photo, ragged children, unemployed, etc. 120 photographs. Captions. 119pp. 9¼ x 10¾. 23590-4 Pa. \$5.00

CAMERA WORK: A PICTORIAL GUIDE, Alfred Stieglitz. All 559 illustrations and plates from the most important periodical in the history of art photography, Camera Work (1903-17). Presented four to a page, reduced in size but still clear, in strict chronological order, with complete captions. Three indexes. Glossary. Bibliography. 176pp. 83% x 11¼. 23591-2 Pa. \$6.95

ALVIN LANGDON COBURN, PHOTOGRAPHER, Alvin L. Coburn. Revealing autobiography by one of greatest photographers of 20th century gives insider's version of Photo-Secession, plus comments on his own work. 77 photographs by Coburn. Edited by Helmut and Alison Gernsheim. 160pp. 8½ x 11. 23685-4 Pa. \$6.00

NEW YORK IN THE FORTIES, Andreas Feininger. 162 brilliant photographs by the well-known photographer, formerly with *Life* magazine, show commuters, shoppers, Times Square at night, Harlem nightclub, Lower East Side, etc. Introduction and full captions by John von Hartz. 181pp. $9\frac{1}{4} \times 10\frac{3}{4}$. 23585-8 Pa. \$6.00

GREAT NEWS PHOTOS AND THE STORIES BEHIND THEM, John Faber. Dramatic volume of 140 great news photos, 1855 through 1976, and revealing stories behind them, with both historical and technical information. Hindenburg disaster, shooting of Oswald, nomination of Jimmy Carter, etc. 160pp. 8¼ x 11. 23667-6 Pa. \$5.00

THE ART OF THE CINEMATOGRAPHER, Leonard Maltin. Survey of American cinematography history and anecdotal interviews with 5 masters— Arthur Miller, Hal Mohr, Hal Rosson, Lucien Ballard, and Conrad Hall. Very large selection of behind-the-scenes production photos. 105 photographs. Filmographies. Index. Originally *Behind the Camera*. 144pp. 8¼ x 11. 23686-2 Pa. \$5.00

DESIGNS FOR THE THREE-CORNERED HAT (LE TRICORNE), Pablo Picasso. 32 fabulously rare drawings—including 31 color illustrations of costumes and accessories—for 1919 production of famous ballet. Edited by Parmenia Migel, who has written new introduction. 48pp. 9% x 12¼. (Available in U.S. only) 23709-5 Pa. \$5.00

NOTES OF A FILM DIRECTOR, Sergei Eisenstein. Greatest Russian filmmaker explains montage, making of *Alexander Nevsky*, aesthetics; comments on self, associates, great rivals (Chaplin), similar material. 78 illustrations. 240pp. 5% x 8½. 22392-2 Pa. \$4.50

HOLLYWOOD GLAMOUR PORTRAITS, edited by John Kobal. 145 photos capture the stars from 1926-49, the high point in portrait photography. Gable, Harlow, Bogart, Bacall, Hedy Lamarr, Marlene Dietrich, Robert Montgomery, Marlon Brando, Veronica Lake; 94 stars in all. Full background on photographers, technical aspects, much more. Total of 160pp. 8% x 11¼. 23352-9 Pa. \$5.00

THE NEW YORK STAGE: FAMOUS PRODUCTIONS IN PHOTO-GRAPHS, edited by Stanley Appelbaum. 148 photographs from Museum of City of New York show 142 plays, 1883-1939. Peter Pan, The Front Page, Dead End, Our Town, O'Neill, hundreds of actors and actresses, etc. Full indexes. 154pp. 9½ x 10. 23241-7 Pa. \$4.50

MASTERS OF THE DRAMA, John Gassner. Most comprehensive history of the drama, every tradition from Greeks to modern Europe and America, including Orient. Covers 800 dramatists, 2000 plays; biography, plot summaries, criticism, theatre history, etc. 77 illustrations. 890pp. 5% x 8½. 20100-7 Clothbd. \$10.00

THE GREAT OPERA STARS IN HISTORIC PHOTOGRAPHS, edited by James Camner. 343 portraits from the 1850s to the 1940s: Tamburini, Mario, Caliapin, Jeritza, Melchior, Melba, Patti, Pinza, Schipa, Caruso, Farrar, Steber, Gobbi, and many more—270 performers in all. Index. 199pp. 8% x 11¼. 23575-0 Pa. \$6.50

J. S. BACH, Albert Schweitzer. Great full-length study of Bach, life, background to music, music, by foremost modern scholar. Ernest Newman translation. 650 musical examples. Total of 928pp. 5% x 8½. (Available in U.S. only) 21631-4, 21632-2 Pa., Two-vol. set \$9.00

COMPLETE PIANO SONATAS, Ludwig van Beethoven. All sonatas in the fine Schenker edition, with fingering, analytical material. One of best modern editions. Total of 615pp. 9 x 12. (Available in U.S. only) 23134-8, 23135-6 Pa., Two-vol. set \$13.00

KEYBOARD MUSIC, J. S. Bach. Bach-Gesellschaft edition. For harpsichord, piano, other keyboard instruments. English Suites, French Suites, Six Partitas, Goldberg Variations, Two-Part Inventions, Three-Part Sinfonias. 312pp. 8½ x 11. (Available in U.S. only) 22360-4 Pa. \$5.50

FOUR SYMPHONIES IN FULL SCORE, Franz Schubert. Schubert's four most popular symphonies: No. 4 in C Minor ("Tragic"); No. 5 in B-flat Major; No. 8 in B Minor ("Unfinished"); No. 9 in C Major ("Great"). Breitkopf & Hartel edition. Study score. 261pp. 9% x 12¼.

23681-1 Pa. \$6.50

THE AUTHENTIC GILBERT & SULLIVAN SONGBOOK, W. S. Gilbert, A. S. Sullivan. Largest selection available; 92 songs, uncut, original keys, in piano rendering approved by Sullivan. Favorites and lesser-known fine numbers. Edited with plot synopses by James Spero. 3 illustrations. 399pp. 9 x 12. 23482-7 Pa. \$7.95

PRINCIPLES OF ORCHESTRATION, Nikolay Rimsky-Korsakov. Great classical orchestrator provides fundamentals of tonal resonance, progression of parts, voice and orchestra, tutti effects, much else in major document. 330pp. of musical excerpts. 489pp. 6½ x 9¼. 21266-1 Pa. \$6.00

TRISTAN UND ISOLDE, Richard Wagner. Full orchestral score with complete instrumentation. Do not confuse with piano reduction. Commentary by Felix Mottl, great Wagnerian conductor and scholar. Study score. 655pp. 8½ x 11. 22915-7 Pa. \$12.50

REQUIEM IN FULL SCORE, Giuseppe Verdi. Immensely popular with choral groups and music lovers. Republication of edition published by C. F. Peters, Leipzig, n. d. German frontmaker in English translation. Glossary, Text in Latin. Study score. 204pp. 9% x 12¹/₄.

23682-X Pa. \$6.00

COMPLETE CHAMBER MUSIC FOR STRINGS, Felix Mendelssohn. All of Mendelssohn's chamber music: Octet, 2 Quintets, 6 Quartets, and Four Pieces for String Quartet. (Nothing with piano is included). Complete works edition (1874-7). Study score. 283 pp. 93% x 121/4.

23679-X Pa. \$6.95

POPULAR SONGS OF NINETEENTH-CENTURY AMERICA, edited by Richard Jackson. 64 most important songs: "Old Oaken Bucket," "Arkansas Traveler," "Yellow Rose of Texas," etc. Authentic original sheet music, full introduction and commentaries. 290pp. 9 x 12. 23270-0 Pa. \$6.00

COLLECTED PIANO WORKS, Scott Joplin. Edited by Vera Brodsky Lawrence. Practically all of Joplin's piano works—rags, two-steps, marches, waltzes, etc., 51 works in all. Extensive introduction by Rudi Blesh. Total of 345pp. 9 x 12. 23106-2 Pa. \$13.50

BASIC PRINCIPLES OF CLASSICAL BALLET, Agrippina Vaganova. Great Russian theoretician, teacher explains methods for teaching classical ballet; incorporates best from French, Italian, Russian schools. 118 illustrations. 175pp. 5% x 8½. 22036-2 Pa. \$2.00

CHINESE CHARACTERS, L. Wieger. Rich analysis of 2300 characters according to traditional systems into primitives. Historical-semantic analysis to phonetics (Classical Mandarin) and radicals. 820pp. 6¹/₈ x 9¹/₄.

21321-8 Pa. \$8.95

EGYPTIAN LANGUAGE: EASY LESSONS IN EGYPTIAN HIERO-GLYPHICS, E. A. Wallis Budge. Foremost Egyptologist offers Egyptian grammar, explanation of hieroglyphics, many reading texts, dictionary of symbols. 246pp. 5 x 7½. (Available in U.S. only)

21394-3 Clothbd. \$7.50

AN ETYMOLOGICAL DICTIONARY OF MODERN ENGLISH, Ernest Weekley. Richest, fullest work, by foremost British lexicographer. Detailed word histories. Inexhaustible. Do not confuse this with *Concise Etymological Dictionary*, which is abridged. Total of 856pp. 6½ x 9¼.

21873-2, 21874-0 Pa., Two-vol. set \$10.00

A MAYA GRAMMAR, Alfred M. Tozzer. Practical, useful English-language grammar by the Harvard anthropologist who was one of the three greatest American scholars in the area of Maya culture. Phonetics, grammatical processes, syntax, more. 301pp. 5% x 8½. 23465-7 Pa. \$4.00

THE JOURNAL OF HENRY D. THOREAU, edited by Bradford Torrey, F. H. Allen. Complete reprinting of 14 volumes, 1837-61, over two million words; the sourcebooks for *Walden*, etc. Definitive. All original sketches, plus 75 photographs. Introduction by Walter Harding. Total of 1804pp. 8½ x 12¼. 20312-3, 20313-1 Clothbd., Two-vol. set \$50.00

CLASSIC GHOST STORIES, Charles Dickens and others. 18 wonderful stories you've wanted to reread: "The Monkey's Paw," "The House and the Brain," "The Upper Berth," "The Signalman," "Dracula's Guest," "The Tapestried Chamber," etc. Dickens, Scott, Mary Shelley, Stoker, etc. 330pp. 5% x 8½. 20735-8 Pa. \$3.50

SEVEN SCIENCE FICTION NOVELS, H. G. Wells. Full novels. First Men in the Moon, Island of Dr. Moreau, War of the Worlds, Food of the Gods, Invisible Man, Time Machine, In the Days of the Comet. A basic science-fiction library. 1015pp. 5% x 8½. (Available in U.S. only)

20264-X Clothbd. \$8.95

ARMADALE, Wilkie Collins. Third great mystery novel by the author of *The Woman in White* and *The Moonstone*. Ingeniously plotted narrative shows an exceptional command of character, incident and mood. Original magazine version with 40 illustrations. 597pp. 5% x 8½.

23429-0 Pa. \$5.00

MASTERS OF MYSTERY, H. Douglas Thomson. The first book in English (1931) devoted to history and aesthetics of detective story. Poe, Doyle, LeFanu, Dickens, many others, up to 1930. New introduction and notes by E. F. Bleiler. 288pp. 5% x 8½. (Available in U.S. only)

23606-4 Pa. \$4.00

FLATLAND, E. A. Abbott. Science-fiction classic explores life of 2-D being in 3-D world. Read also as introduction to thought about hyperspace. Introduction by Banesh Hoffmann. 16 illustrations. 103pp. 5% x 8½. 20001-9 Pa. \$1.50

THREE SUPERNATURAL NOVELS OF THE VICTORIAN PERIOD, edited, with an introduction, by E. F. Bleiler. Reprinted complete and unabridged, three great classics of the supernatural: *The Haunted Hotel* by Wilkie Collins, *The Haunted House at Latchford* by Mrs. J. H. Riddell, and *The Lost Stradivarious* by J. Meade Falkner. 325pp. 5% x 8½.

22571-2 Pa. \$4.00

AYESHA: THE RETURN OF "SHE," H. Rider Haggard. Virtuoso sequel featuring the great mythic creation, Ayesha, in an adventure that is fully as good as the first book, *She*. Original magazine version, with 47 original illustrations by Maurice Greiffenhagen. 189pp. 6½ x 9¼.

23649-8 Pa. \$3.00

UNCLE SILAS, J. Sheridan LeFanu. Victorian Gothic mystery novel, considered by many best of period, even better than Collins or Dickens. Wonderful psychological terror. Introduction by Frederick Shroyer. 436pp. 5% x 8½. 21715-9 Pa. \$4.00

JURGEN, James Branch Cabell. The great erotic fantasy of the 1920's that delighted thousands, shocked thousands more. Full final text, Lane edition with 13 plates by Frank Pape. 346pp. $5\% \times 8\%$.

23507-6 Pa. \$4.00

THE CLAVERINGS, Anthony Trollope. Major novel, chronicling aspects of British Victorian society, personalities. Reprint of Cornhill serialization, 16 plates by M. Edwards; first reprint of full text. Introduction by Norman Donaldson. 412pp. 5% x 8½. 23464-9 Pa. \$5.00

KEPT IN THE DARK, Anthony Trollope. Unusual short novel aboutVictorian morality and abnormal psychology by the great English author.Probably the first American publication. Frontispiece by Sir John Millais.92pp. 6½ x 9¼.23609-9 Pa. \$2.50

RALPH THE HEIR, Anthony Trollope. Forgotten tale of illegitimacy, inheritance. Master novel of Trollope's later years. Victorian country estates, clubs, Parliament, fox hunting, world of fully realized characters. Reprint of 1871 edition. 12 illustrations by F. A. Faser. 434pp. of text. 5% x 8½. 23642-0 Pa. \$4.50

YEKL and THE IMPORTED BRIDEGROOM AND OTHER STORIES OF THE NEW YORK GHETTO, Abraham Cahan. Film Hester Street based on Yekl (1896). Novel, other stories among first about Jewish immigrants of N.Y.'s East Side. Highly praised by W. D. Howells—Cahan "a new star of realism." New introduction by Bernard G. Richards. 240pp. 5% x 8½. 22427-9 Pa. \$3.50

THE HIGH PLACE, James Branch Cabell. Great fantasy writer's enchanting comedy of disenchantment set in 18th-century France. Considered by some critics to be even better than his famous Jurgen. 10 illustrations and numerous vignettes by noted fantasy artist Frank C. Pape. 320pp. $5\% \times 8\%$. 23670-6 Pa. \$4.00

ALICE'S ADVENTURES UNDER GROUND, Lewis Carroll. Facsimile of ms. Carroll gave Alice Liddell in 1864. Different in many ways from final Alice. Handlettered, illustrated by Carroll. Introduction by Martin Gardner. 128pp. 5% x 8½. 21482-6 Pa. \$2.00

FAVORITE ANDREW LANG FAIRY TALE BOOKS IN MANY COLORS, Andrew Lang. The four Lang favorites in a boxed set—the complete *Red*, *Green*, *Yellow* and *Blue* Fairy Books. 164 stories; 439 illustrations by Lancelot Speed, Henry Ford and G. P. Jacomb Hood. Total of about 1500pp. 5% x 8½. 23407-X Boxed set, Pa. \$14.00

HOUSEHOLD STORIES BY THE BROTHERS GRIMM. All the great Grimm stories: "Rumpelstiltskin," "Snow White," "Hansel and Gretel," etc., with 114 illustrations by Walter Crane. 269pp. 5% x 8½.

21080-4 Pa. \$3.00

SLEEPING BEAUTY, illustrated by Arthur Rackham. Perhaps the fullest, most delightful version ever, told by C. S. Evans. Rackham's best work. 49 illustrations. 110pp. 7% x 10%. 22756-1 Pa. \$2.00

AMERICAN FAIRY TALES, L. Frank Baum. Young cowboy lassoes Father Time; dummy in Mr. Floman's department store window comes to life; and 10 other fairy tales. 41 illustrations by N. P. Hall, Harry Kennedy, Ike Morgan, and Ralph Gardner. 209pp. 5% x 8½. 23643-9 Pa. \$3.00

THE WONDERFUL WIZARD OF OZ, L. Frank Baum. Facsimile in full color of America's finest children's classic. Introduction by Martin Gardner. 143 illustrations by W. W. Denslow. 267pp. 53% x 8½.

20691-2 Pa. \$3.50

THE TALE OF PETER RABBIT, Beatrix Potter. The inimitable Peter's terrifying adventure in Mr. McGregor's garden, with all 27 wonderful, full-color Potter illustrations. 55pp. 4¼ x 5½. (Available in U.S. only) 22827-4 Pa. \$1.10

THE STORY OF KING ARTHUR AND HIS KNIGHTS, Howard Pyle. Finest children's version of life of King Arthur. 48 illustrations by Pyle. 131pp. 6¹/₈ x 9¹/₄. 21445-1 Pa. \$4.00

CARUSO'S CARICATURES, Enrico Caruso. Great tenor's remarkable caricatures of self, fellow musicians, composers, others. Toscanini, Puccini, Farrar, etc. Impish, cutting, insightful. 473 illustrations. Preface by M. Sisca. 217pp. 83% x 11¼. 23528-9 Pa. \$6.00

PERSONAL NARRATIVE OF A PILCRIMAGE TO ALMADINAH AND MECCAH, Richard Burton. Great travel classic by remarkably colorful personality. Burton, disguised as a Moroccan, visited sacred shrines of Islam, narrowly escaping death. Wonderful observations of Islamic life, customs, personalities. 47 illustrations. Total of 959pp. 5% x 8½.

21217-3, 21218-1 Pa., Two-vol. set \$10.00

INCIDENTS OF TRAVEL IN YUCATAN, John L. Stephens. Classic (1843) exploration of jungles of Yucatan, looking for evidences of Maya civilization. Travel adventures, Mexican and Indian culture, etc. Total of 669pp. 5% x 8½. 20926-1, 20927-X Pa., Two-vol. set \$6.50

AMERICAN LITERARY AUTOGRAPHS FROM WASHINGTON IRVING TO HENRY JAMES, Herbert Cahoon, et al. Letters, poems, manuscripts of Hawthorne, Thoreau, Twain, Alcott, Whitman, 67 other prominent American authors. Reproductions, full transcripts and commentary. Plus checklist of all American Literary Autographs in The Pierpont Morgan Library. Printed on exceptionally high-quality paper. 136 illustrations. 212pp. 9¹/₈ x 12¹/₄. 23548-3 Pa. \$7.95

AN AUTOBIOGRAPHY, Margaret Sanger. Exciting personal account of hard-fought battle for woman's right to birth control, against prejudice, church, law. Foremost feminist document. 504pp. 5% x 8½.

20470-7 Pa. \$5.50

MY BONDAGE AND MY FREEDOM, Frederick Douglass. Born as a slave, Douglass became outspoken force in antislavery movement. The best of Douglass's autobiographies. Graphic description of slave life. Introduction by P. Foner. 464pp. 5% x 8½. 22457-0 Pa. \$5.00

LIVING MY LIFE, Emma Goldman. Candid, no holds barred account by foremost American anarchist: her own life, anarchist movement, famous contemporaries, ideas and their impact. Struggles and confrontations in America, plus deportation to U.S.S.R. Shocking inside account of persecution of anarchists under Lenin. 13 plates. Total of 944pp. 5% x 8½. 22543-7, 22544-5 Pa., Two-vol. set \$9.00

LETTERS AND NOTES ON THE MANNERS, CUSTOMS AND CON-DITIONS OF THE NORTH AMERICAN INDIANS, George Catlin. Classic account of life among Plains Indians: ceremonies, hunt, warfare, etc. Dover edition reproduces for first time all original paintings. 312 plates. 572pp. of text. 6¹/₈ x 9¹/₄. 22118-0, 22119-9 Pa.. Two-vol. set \$10.00

THE MAYA AND THEIR NEIGHBORS, edited by Clarence L. Hay, others. Synoptic view of Maya civilization in broadest sense, together with Northern, Southern neighbors. Integrates much background, valuable detail not elsewhere. Prepared by greatest scholars: Kroeber, Morley, Thompson, Spinden, Vaillant, many others. Sometimes called Tozzer Memorial Volume. 60 illustrations, linguistic map. 634pp. 5% x 8½.

23510-6 Pa. \$7.50

HANDBOOK OF THE INDIANS OF CALIFORNIA, A. L. Kroeber. Foremost American anthropologist offers complete ethnographic study of each group. Monumental classic. 459 illustrations, maps. 995pp. 5% x 8½. 23368-5 Pa. \$10.00

SHAKTI AND SHAKTA, Arthur Avalon. First book to give clear, cohesive analysis of Shakta doctrine, Shakta ritual and Kundalini Shakti (yoga). Important work by one of world's foremost students of Shaktic and Tantric thought. 732pp. 53% x 8½. (Available in U.S. only)

23645-5 Pa. \$7.95

AN INTRODUCTION TO THE STUDY OF THE MAYA HIEROGLYPHS, Syvanus Griswold Morley. Classic study by one of the truly great figures in hieroglyph research. Still the best introduction for the student for reading Maya hieroglyphs. New introduction by J. Eric S. Thompson. 117 illustrations. 284pp. 5% x 8½. 23108-9 Pa. \$4.00

A STUDY OF MAYA ART, Herbert J. Spinden. Landmark classic interprets Maya symbolism, estimates styles, covers ceramics, architecture, murals, stone carvings as artforms. Still a basic book in area. New introduction by J. Eric Thompson. Over 750 illustrations. 341pp. 83% x 11¼. 21235-1 Pa. \$6.95

GEOMETRY, RELATIVITY AND THE FOURTH DIMENSION, Rudolf Rucker. Exposition of fourth dimension, means of visualization, concepts of relativity as Flatland characters continue adventures. Popular, easily followed yet accurate, profound. 141 illustrations. 133pp. 5% x 8½. 23400-2 Pa. \$2.75

THE ORIGIN OF LIFE, A. I. Oparin. Modern classic in biochemistry, the first rigorous examination of possible evolution of life from nitrocarbon compounds. Non-technical, easily followed. Total of 295pp. 5% x $8\frac{1}{2}$.

60213-3 Pa. \$4.00

PLANETS, STARS AND GALAXIES, A. E. Fanning. Comprehensive introductory survey: the sun, solar system, stars, galaxies, universe, cosmology; quasars, radio stars, etc. 24pp. of photographs. 189pp. 5% x 8½. (Available in U.S. only) 21680-2 Pa. \$3.00

THE THIRTEEN BOOKS OF EUCLID'S ELEMENTS, translated with introduction and commentary by Sir Thomas L. Heath. Definitive edition. Textual and linguistic notes, mathematical analysis, 2500 years of critical commentary. Do not confuse with abridged school editions. Total of 1414pp. 5% x 8½. 60088-2, 60089-0, 60090-4 Pa., Three-vol. set \$18.00

DIALOGUES CONCERNING TWO NEW SCIENCES, Galileo Galilei. Encompassing 30 years of experiment and thought, these dialogues deal with geometric demonstrations of fracture of solid bodies, cohesion, leverage, speed of light and sound, pendulums, falling bodies, accelerated motion, etc. 300pp. 5% x 8½. 60099-8 Pa. \$4.00

Prices subject to change without notice.

Available at your book dealer or write for free catalogue to Dept. GI, Dover Publications, Inc., 180 Varick St., N.Y., N.Y. 10014. Dover publishes more than 175 books each year on science, elementary and advanced mathematics, biology, music, art, literary history, social sciences and other areas.